MASTERPIECES OF GERMAN EXPRESSIONISM

MASTERPIECES OF GERMAN EXPRESSIONISM

BY HORST UHR

Foreword by Frederick J. Cummings, Director

Published by

HUDSON HILLS PRESS, NEW YORK

in Association
with The Detroit Institute of Arts

MASTERPIECES OF GERMAN EXPRESSIONISM

AT THE DETROIT INSTITUTE OF ARTS

First Edition

Published in the United States by Hudson Hills Press, Inc.
Suite 4323, 30 Rockefeller Plaza, New York, N. Y. 10112.
Distributed by Viking Penguin Inc.

FOR HUDSON HILLS PRESS

EDITOR AND PUBLISHER Paul Anbinder

COPY-EDITOR Harriet Schoenholz Bee

DESIGN Betty Binns Graphics/Betty Binns

COMPOSITION U.S. Lithograph, Inc.

FOR THE DETROIT INSTITUTE OF ARTS

COORDINATOR OF PUBLICATIONS Andrea P. A. Belloli

EDITORS Terry Neff and Rollyn Krichbaum

Manufactured in Japan by Toppan Printing Co.

Library of Congress Cataloguing in Publication Data

Detroit Institute of Arts.
 Masterpieces of German expressionism at the Detroit
Institute of Arts.
 Bibliography: p.218
 Includes index.
 1. Expressionism (Art)—Germany—Catalogs. 2. Art,
German—Catalogs. 3. Art, Modern—20th century—Germany
—Catalogs. 4. Art—Michigan—Detroit—Catalogs.
5. Detroit Institute of Arts—Catalogs. I. Uhr, Horst,
1934– . II. Title.
N6868.5.E9D39 709'.43'074017434 82-3049
ISBN 0-933920-26-1 AACR2

CONTENTS

FOREWORD by Frederick J. Cummings 6

PREFACE 7

INTRODUCTION 10

MASTERPIECES OF GERMAN EXPRESSIONISM 29

ERNST BARLACH	30	OSKAR KOKOSCHKA	118
MAX BECKMANN	38	GEORG KOLBE	128
HEINRICH CAMPENDONK	48	KÄTHE KOLLWITZ	134
LOVIS CORINTH	54	WILHELM LEHMBRUCK	142
OTTO DIX	60	AUGUST MACKE	150
LYONEL FEININGER	64	FRANZ MARC	154
GEORGE GROSZ	70	PAULA MODERSOHN-BECKER	158
ERICH HECKEL	76	OTTO MUELLER	162
CARL HOFER	84	EMIL NOLDE	170
WASSILY KANDINSKY	88	MAX PECHSTEIN	188
MAX KAUS	92	CHRISTIAN ROHLFS	194
ERNST LUDWIG KIRCHNER	96	KARL SCHMIDT-ROTTLUFF	202
PAUL KLEE	110		

NOTES 217

SELECTED BIBLIOGRAPHY 218

INDEX 222

FOREWORD

MASTERPIECES OF GERMAN EXPRESSIONISM AT THE DETROIT INSTITUTE OF ARTS is the first publication to present one of the most outstanding American collections of German avant-garde art from the early decades of this century. Detroit's large selection of German Expressionist paintings, sculptures, watercolors, drawings, and prints was assembled for the most part by the Institute's first director, Dr. William R. Valentiner, in the 1920s and '30s. In order to bring this fine collection to the attention of a wider public, we asked Dr. Horst Uhr, Professor of Art History at Wayne State University and a specialist in German Expressionist art, to study sixty-eight of these works and to present each one in terms of its relationship to the Expressionist movement as a whole and to the career of each artist. His fine introduction places the movement in its aesthetic, historical, and social context, and chronicles as well the fascinating story of the formation of the collection in Detroit.

It is our sincere hope that this book will be of interest to scholars and laypersons alike, and that it will stimulate interest in the Institute's Expressionist works, which form an especially rich and varied part of the museum's holdings. We also hope that this book will inspire many visitors to come to Detroit to view these masterpieces of German art. We are indebted to the National Endowment for the Arts and the Philip L. Graham Fund for grants in support of this publication.

Frederick J. Cummings
DIRECTOR, THE DETROIT INSTITUTE OF ARTS

PREFACE

It has been my aim throughout this book to discuss each work within the context of both the individual artist's development and German Expressionism as a whole, always seeking to address myself to the synthesis of content and form that lies at the heart of the communicative spirit of the movement. To have included all the works in the German Expressionist collection of The Detroit Institute of Arts would have required a book far larger than the present one. Especially among the drawings, watercolors, and prints, the examples chosen constitute a mere fraction of the museum's holdings. On the other hand, the dimensions of the Institute's collection necessarily determined the weight given to certain artists and to time periods within their oeuvres. The Detroit Institute of Arts, for example, is richer in works by members of Die Brücke than of Der Blaue Reiter and is especially strong in works executed upon the full maturation of a given artist's development. In my decision to include such artists as Paula Modersohn-Becker, Lovis Corinth, Käthe Kollwitz, and Georg Kolbe, whose names are not normally associated with Expressionism proper, I have been guided by the generally recognized fact that their most outstanding achievements link their work to the Expressionist period.

Among the past and present members of the curatorial staff of The Detroit Institute of Arts I wish to thank John Neff and Ellen Sharp for their assistance in selecting the works that are discussed, Marilyn Symmes for patiently responding to many of my queries, and Terry Neff and Susan Rossen for their editorial suggestions. I remember with gratitude and special fondness the enthusiasm with which Rollyn Krichbaum of the Institute's Publications Department greeted the individual parts of the manuscript as it was in the process of completion.

H. U.
DETROIT, FEBRUARY 1982

MASTERPIECES OF GERMAN EXPRESSIONISM

MASTERPIECES OF GERMAN EXPRESSIONISM

INTRODUCTION

Ranging from the representational to the non-objective, the works that have come to be grouped under the label "German Expressionism" are as varied as the term itself is vague. For German Expressionism was less a unified style than an attitude, a state of mind that in the early years of the twentieth century existed among young artists in a number of different places—in Dresden, Berlin, and Munich, as well as in various cities in the Rhineland and northern Germany. Profoundly critical of the materialism of modern life, these artists probed man's spiritual condition in search of a new harmonious relationship between him and his environment. And though their methods differed, depending on the inclination of a given group or on individual temperament, all subordinated nature to a transcription of their subjective reactions to the world. Opting for the universal and prototypical rather than the specific and anecdotal, and for a deliberate antinaturalism manifested in intensified color and simplified form, they were less concerned with resemblance than with artistic vision, and sought to penetrate appearances in order to lay bare what they perceived to be the inner essence of things.

The term *expressionism* and the concept of self-expression in art, however, originated not in Germany but in France. More precisely, it originated in the atelier of Gustave Moreau. Moreau, one of the chief precursors of Symbolist painting, taught at the École des Beaux-Arts from 1892 to 1898, encouraging his students to express themselves according to their individual sensibilities. Moreau's advice was not lost on his most gifted pupil Henri Matisse, who studied with him between 1892 and 1897. In the first decade of the twentieth century, Matisse used the term *expression* repeatedly in conversations with his own students, stressing that pictorial results must always be based on the dictates of one's temperament and personal interpretation of nature.

The term *expressionist* is first documented as having been used in Germany in connection with the visual arts in April 1911. This occurred at the twenty-second exhibition of the Berlin Secession where, in a separate gallery specifically labeled "Expressionists," a group of French artists—associates of Matisse in Paris and members of the original Fauve group—showed some of their recent pictures; Pablo Picasso, represented by pre-Cubist works, exhibited with them. The term continued to be confined to contemporary French painting in both *Der Sturm*, an influential weekly founded in Berlin in 1910 by the enterprising Herwarth Walden, and in the first exhibition Walden organized at Der Sturm Gallery in 1912, even though this exhibition included German artists who have since been recognized as leaders of the German Expressionist movement. That year, at the famous Sonderbund exhibition in Cologne—the first truly international survey of contemporary European developments and the direct model for the 1913 Armory Show in New York—the term *expressionism* was applied to all Post-Impressionist work distinguished by the subjective use of color and form. This encompassed not only the work of pioneers like Paul Cézanne, Paul Gauguin, and Vincent van Gogh but also virtually every modern trend, including paintings and sculpture by the young Germans.

Only with Paul Fechter's book *Der Expressionismus (Expressionism)*, published in Munich in 1914, was the term explicitly linked to the artists of Die Brücke (The Bridge), organized in Dresden in 1905, and of Der Blaue Reiter (The Blue Rider), founded in Munich in 1911. Identifying Dresden and Munich as the true birthplaces of Expressionism, Fechter not only discussed Die Brücke and Der Blaue Reiter as representative of two distinct German Expressionist directions, but also interpreted the movement as a typically Germanic phenomenon. Moreover, he saw the Expressionist

not only as an artist who communicates his own feelings but also as one who gives expression to the conflicts and aspirations of his time.

Even today there is agreement neither on the chronological limits of Expressionism nor on its precise nature. Since the publication of Fechter's book, the term has been applied to the art of the early twentieth century as a whole, seen as an alternative to Cubist-derived abstraction, and equated with manifestations of German art from the Ottonian period in the tenth century to the present. Generally, however, Expressionism has come to be understood as designating a period in German culture spanning the years from 1905 to the rise of National Socialism in 1933, although as early as 1920 a reaction against Expressionism had begun to set in, and Max Beckmann, widely hailed as one of the chief exponents of the German Expressionist movement, continued to work in an Expressionist-derived idiom in America until the time of his death in 1950.

While all Expressionists were pursuing the same general goal, the development of each artist varied in accordance with local and personal conditions. Indeed, the context of the evolution of Expressionist conceptions of color and form differed considerably in northern, southern, and central Germany. Whereas in Dresden and Munich close-knit friendships and associations of artists encouraged the formation of a cohesive outlook and style, no such groups developed in northern Germany, where expressions of striking individuality tended to be the rule. On the other hand, it is impossible to view the art of Die Brücke and Der Blaue Reiter collectively. For while the Munich group in southern Germany was decisively influenced by Wassily Kandinsky's aesthetics and contemporary French developments, the work of both Edvard Munch and Van Gogh had a pervasive effect on the young artists of Dresden in central Germany.

The founding of Die Brücke in 1905 by Ernst Ludwig Kirchner, Fritz Bleyl, Erich Heckel, and Karl Schmidt-Rottluff, all of whom had originally gone to Dresden to study architecture, was as much an act of defiance of conventional bourgeois notions of success and respectability as it was the result of a burning desire for a type of creative and intellectual freedom that architecture did not allow. Indeed, the group's early years together were marked not only by the obsessive search for an intuitive form of pictorial expression, but also by a truly revolutionary belief in a new kind of man. In keeping with this spirit, the name of the group, "The Bridge," was intended as a metaphoric image signifying its members' pursuit of a new and inward-searching art, as well as their common quest for a new life. In 1906 Kirchner, who regarded himself as the spokesman of Die Brücke, made a woodcut of the group's emblem (fig. 1) and reproduced in bold letters cut into wood the association's challenging manifesto (fig. 2):

With faith in growth and in a new generation of creators and those who enjoy, we call all young people together, and as the youth that bears the future within it we shall create for ourselves elbowroom and freedom of life as opposed to the well-entrenched older forces. Everyone who renders directly and honestly whatever drives him to create is one of us.

The various studios of the Brücke artists, decorated with brightly colored wall hangings and hand-carved furniture, were the scenes of a truly bohemian life. Discussions about Friedrich Nietzsche, Feodor Dostoevsky, and Walt Whitman alternated with spurts of frenzied activity, as the young artists rushed from one pictorial idea to another, constantly urging each other on. Their group spirit resulted in marked resemblances among their works, especially in their graphic production which from the very beginning was especially lively.

In 1906 Emil Nolde and Max Pechstein joined

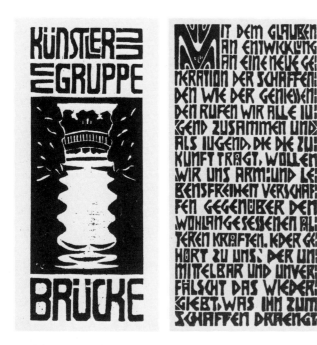

Fig. 1 Ernst Ludwig Kirchner (German, 1880–1938). *Künstlergruppe Brücke (Brücke Artists' Group)*, 1906. Woodcut

Fig. 2 Ernst Ludwig Kirchner. *Manifesto of Die Brücke*, 1906. Woodcut

Die Brücke. Nolde was then well on his way to developing an independent style, and Pechstein, a graduate of the Academy of Fine Arts, Dresden, was more accomplished in terms of technical knowledge than the other members. Also new to the group that year were the Swiss Cuno Amiet and the Finn Axel Gallén-Kallela, although the two restricted themselves to occasional participation in the group's exhibitions. Nolde, always a loner at heart, withdrew after about a year and a half, while Bleyl resigned from the association in 1909 to return to the practice and teaching of architecture. The Dutchman Kees van Dongen, who had exhibited with the Fauves in the famous Salon d'Automne of 1905 in Paris, entered into an informal relationship with the German artists in

1908. The last important artist to join their circle was Otto Mueller, who became associated with the group in 1910.

The first artistically important period for the members of Die Brücke was the years between 1906 and 1911, when they exhibited extensively as a group. They made their debut in 1906 in the showroom of a suburban lamp manufacturer in Löbtau, a suburb of Dresden. Beginning in 1907, Die Brücke exhibitions were held in Dresden in Emil Richter's gallery (see p. 79) and in the Ernst Arnold Gallery. By 1910 the list of exhibition sites included such major cities as Hamburg, Frankfurt, Leipzig, and Hannover, as well as Copenhagen and Prague. Nonetheless, the Brücke painters did not find themselves widely accepted. On the contrary, their work usually met with hostility and resistance. In 1910 several works by Pechstein were rejected by the Berlin Secession, which until then had been a fairly liberal forum for the European avant-garde. In response Pechstein founded the Neue Sezession (New Secession) and organized a counter-exhibition in one of the city's private galleries. Among the twenty-seven artists exhibiting with Pechstein were Kirchner, Heckel, and Schmidt-Rottluff. Seeking to preserve the unity of their artistic aims, however, the members of Die Brücke withdrew from the Neue Sezession the following year, pledging to exhibit their work in the future only as a group.

By 1911 all the Brücke artists had settled in Berlin, attracted by the cultural life of the metropolis and the prospect of finding acceptance among the city's potentially more broadminded critics and public. They contributed illustrations to *Der Sturm* and in the spring of 1912 had their first major exhibition in Berlin at the well-known gallery of Fritz Gurlitt, an event that finally brought them to the attention of several leading art journals. While Kirchner, Heckel, Schmidt-Rottluff, and Mueller received less than favorable comments,

Pechstein was singled out as the leader of the group. All the Brücke painters also participated in the Sonderbund exhibition in Cologne that year.

Shortly after the Gurlitt show in Berlin, however, Pechstein was expelled from the association, apparently for having rejoined the Berlin Secession independently, thereby violating the group's pledge to exhibit only together. Die Brücke was officially dissolved in 1913, when Kirchner's subjective editing of a chronicle the artists had intended to publish that year was repudiated by the other members. Yet the controversy over the chronicle was probably hardly more than an excuse for the group's breakup. Not only had Pechstein's defection the previous year signaled recognition that the artists' youthful dreams of an artistic community could not be maintained forever, but also their work had long ceased to be characterized by a collective style, since in Berlin each artist had developed an increasingly personal form of expression. While henceforth they were to work and develop independently, the Brücke painters nonetheless remained friends, with the exception of Kirchner, who refused to exhibit with his former associates in later years and in 1919 even denied that Die Brücke had ever had anything to do with his own early progress. Yet in 1926, at his mountain retreat in Switzerland, he painted from memory a nostalgic group portrait (fig. 3) of the artists of Die Brücke as the membership existed at the time of its dissolution in 1913: the three founders are shown standing, with Kirchner and the bespectacled Schmidt-Rottluff seen in profile, the balding Heckel from the front, while the latecomer to the group, the enigmatic Mueller, is seated on a low stool to the left.

The aims and origins of Der Blaue Reiter, founded in 1911 in Munich by Kandinsky and Franz Marc, differed sharply from those of Die Brücke. While Kandinsky and Marc shared with their colleagues in Berlin a tendency toward inwardness, being similarly bent on a subjective interpretation of the visible world, the members of the Munich circle possessed a far greater intellectual openness. Not only did they readily accept and acknowledge international trends, but, unlike the close-knit Brücke, where communal activity in the early years had given rise to works of striking similarity, they never developed a unified style. Moreover, while Die Brücke was committed to social change, having been conceived as a revolutionary youth group, the basic ideology of

Fig. 3 Ernst Ludwig Kirchner. *A Group of Artists: Otto Mueller, Kirchner, Erich Heckel, Karl Schmidt-Rottluff*, 1926–27. Oil on canvas. Wallraf-Richartz-Museum, Cologne

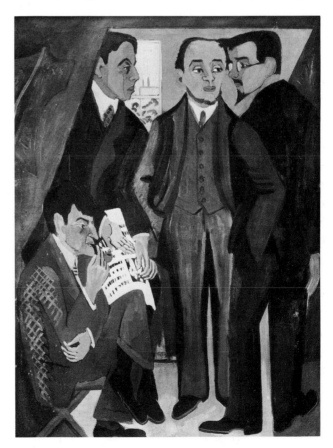

Der Blaue Reiter was philosophical. At issue here was not the individual as a social being, but man's relationship to the innermost secrets of nature.

By the time Der Blaue Reiter was founded, Kandinsky, who had left Russia in 1896, had played an active role on the Munich art scene for some years, first through the pioneering exhibitions of Phalanx, an independent exhibition association he created in 1901, and subsequently through the Neue Künstlervereinigung (New Artists' Association), organized under his chairmanship in 1909 and intended, like Phalanx, as a forum for the European avant-garde. It was in response to ideological rifts developing within the Neue Künstlervereinigung in 1911 that Kandinsky, his friend Gabriele Münter, and Marc seceded from the group, and Marc immediately started to make preparations for the first Blaue Reiter exhibition, which opened at the Thannhauser Gallery in Munich on December 18 of that year. In addition to Kandinsky, Münter, and Marc, the major artists included in the show were Heinrich Campendonk, August Macke, the Russian brothers Vladimir and David Burliuk, and the French painter Henri Rousseau; the Austrian composer Arnold Schönberg was represented by a number of intriguing oil sketches.

Of major importance for the Munich artists were five works submitted by the Parisian Robert Delaunay, who as early as 1909 had developed an independent form of Cubism, combining expressive color with Cubist analysis of form. By 1911–12, fascinated by the rhythmic structure of medieval and contemporary architecture and the movement of the modern city, he was working on a series of window views in which he had virtually eliminated representational images in favor of interpenetrating, transparent planes of prismatic color and the predominant structural elements of the composition (fig. 4). Having separated color and form from

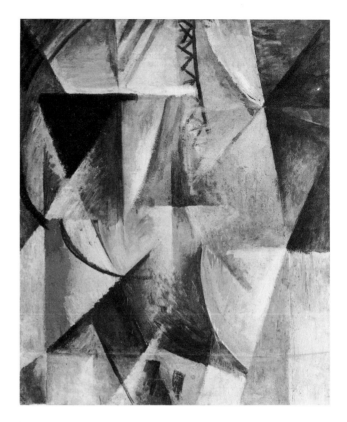

Fig. 4 Robert Delaunay (French, 1885–1941). *A Window*, 1912. Oil on canvas. Musée National d'Art Moderne, Paris

description, Delaunay subsequently developed a conception of abstract painting in which he used pulsating color harmonies to reflect the intangible rhythms that pervade all of nature, a notion that not only had consequences for the development of the art of Macke and Marc (p. 157) but ultimately affected the pictorial thinking of Lyonel Feininger (p. 67) as well.

Exactly why the name "The Blue Rider" was chosen for the Munich group is not known. Kandinsky, when asked for an explanation many years later, jokingly replied that Marc liked horses and he himself riders, and that both of them had always been rather fond of the color blue. The

horse and rider motif, first found in Kandinsky's work in a decorative painting of about 1901 (fig. 5), represents, in fact, the most persistent theme in the Russian painter's oeuvre and one that he gradually transformed from a material representation to an abstract configuration (fig. 6; p. 91). Based on such images as the medieval crusader-knight and the legendary warrior Saint George, both the theme and the name "The Blue Rider" were, like "The Bridge," doubtless intended metaphorically, signifying the conquest of the visible world in what was to become for Kandinsky, as well as for Marc, a dematerialized and thus spiritual art.

The first Blaue Reiter exhibition closed in Munich in January 1912, after which it toured several major cities. Inaugurating Walden's Der Sturm Gallery in Berlin in March, the exhibition was augmented by works by Alfred Kubin, Alexey Jawlensky, Marianne von Werefkin, and Paul Klee. The year 1912 also saw the publication of Kandinsky's trail-blazing book *Concerning the Spiritual in Art (Über das Geistige in der Kunst)*

and of the anthology *Der Blaue Reiter*, a collection of essays edited by Kandinsky and Marc which, in addition to important contributions by the two editors, contained articles by Macke, David Burliuk, Schönberg, and others. Testifying to the group's enthusiasm for all artistic expressions untainted by convention, the anthology featured a remarkable series of illustrations, ranging from works by leading Post-Impressionists to peasant paintings, drawings by children, medieval illuminations, sculpture, prints, and various forms of non-European art.

Lyonel Feininger joined Der Blaue Reiter when the group participated in Walden's First German Autumn Salon in Berlin in 1913. The last exhibition of Der Blaue Reiter took place at Der Sturm Gallery the following year. Shortly afterward the association disbanded. The outbreak of World War I forced Kandinsky to return to Russia. Macke, one of the first to be called up for active military service, died on a French battlefield only weeks after the beginning of the war. Marc was killed in action near Verdun in France in 1916.

Fig. 5 Wassily Kandinsky (Russian, 1866–1944). *Dusk*, c. 1901. Tempera, crayon, and gold and silver paint on cardboard. Städtische Galerie im Lenbachhaus, Munich

Fig. 6 Wassily Kandinsky. *Der Blaue Reiter*, 1911. Woodcut. Vignette for first Blaue Reiter exhibition

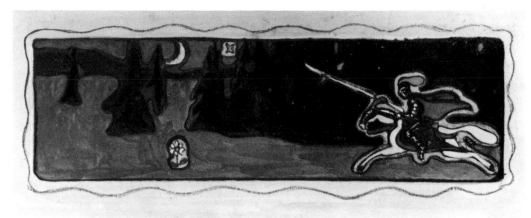

Although those Expressionists who have talked or written about their work have generally tended to guard the individuality of their achievements by denying any direct indebtedness to either tradition or contemporary models, it can be demonstrated that their art was not evolved without precedents. On the contrary, in their efforts to push aside the veil of visible reality they found helpful ideas in the immediate past.

As early as 1885 Gauguin had begun to turn inward from the exterior world. Convinced that pictorial harmonies can act upon the human soul the way music does, he believed in the psychological power of color and line, equating pictorial properties with emotional states. Indeed, he considered painting to be superior to music, since it can achieve a unity of expression that transmits itself to the senses in one instant, whereas music must be experienced over time. In his pictures, luminous colors unite with simplified and sweeping curves to form a decorative whole that defines the mood of a given composition (fig. 7). A similar awareness of the emotional power of color was to manifest itself in the art of Der Blaue Reiter (p. 91), and a feeling for rhythmic compositions symbolically uniting man and nature became characteristic of many early works of Die Brücke (p. 191).

Seeking a second, artistic reality beneath optical truth, Van Gogh, too, had intensified color in order to convey what he felt, giving status to color as a purely expressive means. But it was not only the brilliance of his palette that appealed to the young

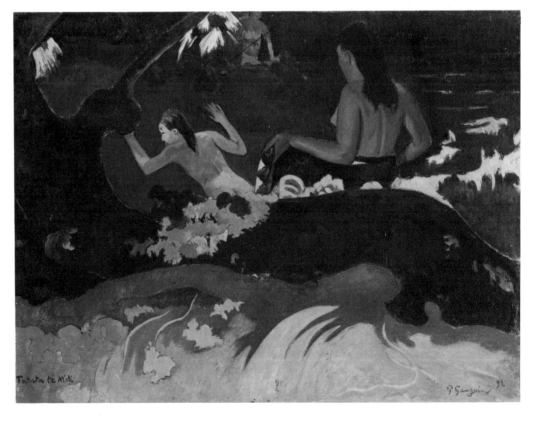

Fig. 7 Paul Gauguin (French, 1848–1903). *Fatata te Miti (By the Sea)*, 1892. Oil on canvas. National Gallery of Art, Washington, D.C., Chester Dale Collection

Germans; his depth of feeling and empathy with his fellowman stirred them as profoundly. The austere yet poignant peasant pictures of Paula Modersohn-Becker (p. 161) are unthinkable without the context of both the mood and deliberately primitive form of *La Berceuse* (fig. 8), a painting Van Gogh did in Arles in 1889, showing Madame Roulin, the wife of the local postman, seated at her infant's cradle. Van Gogh painted five versions of this picture, intending it as a prototypical image of maternal consolation for all who are lonely and sad.

Although he provided an important impetus to the revival of the woodcut among the artists of Die Brücke, Munch influenced the German Expressionists even more as a kindred spirit. Having experienced a difficult youth, Munch felt keenly the emotional tensions that modern society inflicts upon the individual and for many years was unable to escape the torments of his own psychic maladjustment. What he wanted to paint were pictures expressive of states of mind, an idea he eventually developed in *Frieze of Life*, a series of canvases on the theme of human suffering. His subject matter—love, hate, life and death, illness, and the pain of loneliness—greatly appealed to the artists of Die Brücke. The brooding woman in *Melancholy* (fig. 9), for example, may be seen as the spiritual antecedent of the vulnerable and frail creatures of Heckel and Max Kaus (pp. 83, 95).

By the time Munch painted *Melancholy* in 1899, German artists were also advocating an art of spiritual significance. Their ideas sprang from the fertile ground of the international arts and crafts

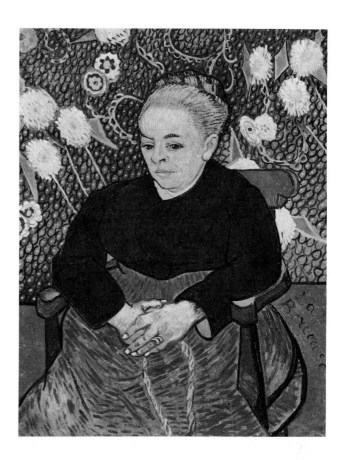

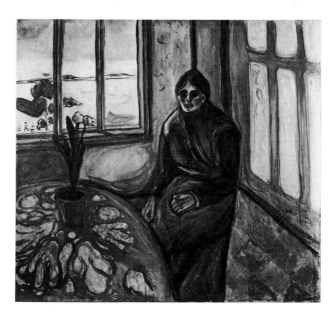

Fig. 8 Vincent van Gogh (Dutch, 1853–1890). *La Berceuse*, 1889. Oil on canvas. Museum of Fine Arts, Boston

Fig. 9 Edvard Munch (Norwegian, 1863–1944). *Melancholy*, 1899. Oil on canvas. Munch Museet, Oslo

movement as it developed in Munich. There it was dubbed "Jugendstil," following the founding in 1896 of *Jugend*, a Munich weekly that popularized the new style. One of the earliest supporters of the movement and its most vigorous spokesman was the designer Hermann Obrist. By the mid-1890s he had developed a vast vocabulary of decorative forms which, while based on nature, were transformed into evocative, semiabstract shapes. A wall hanging embroidered around 1895 with one of his designs, originally titled *Cyclamen*, became famous as *Whiplash* (fig. 10), since the configuration seemed less an image of a flower than a subjective expression of energy, an abstract representation of feeling. Obrist exercised a profound influence on August Endell, Munich's leading Jugendstil architect, who as early as 1897 had prophesied the development of abstract art in speaking of "forms that signify nothing, represent nothing, and recall nothing, but that will be able to

excite our souls as deeply as only music has been able to do with tones."[1] The expressive properties of Obrist's forms as well as his ideas directly touched the future Expressionists. From 1903 to 1904 Kirchner attended the Teaching and Experimental Studio for Applied and Fine Art that Obrist had founded with Wilhelm von Debschitz in 1901. Kandinsky became a close friend of Obrist in 1904. Indeed, nearly all the Expressionists went through a period of experimentation with the abstracted natural forms of Jugendstil (see figs. 1, 5), and Jugendstil's concepts of pure line, color, and form were fully developed by Kandinsky in *Concerning the Spiritual in Art*.

German Expressionism, in short, emerged from developments of the last quarter of the nineteenth century, a time in which the description of natural fact had increasingly come to be replaced by the artist's efforts to find a pictorial equivalent for personal experience. German Expressionism is also

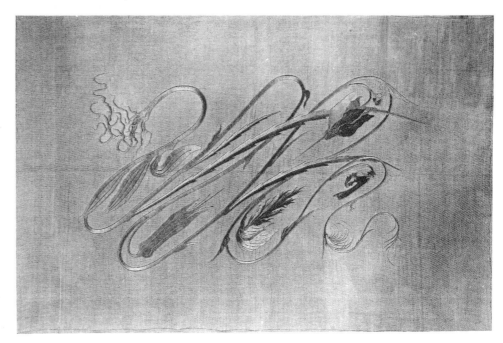

Fig. 10 Hermann Obrist (German, 1863–1927). *Whiplash*, c. 1895. Gold silk embroidery on gray wool, executed by Berthe Ruchet. Münchner Stadtmuseum, Munich

connected with the work of the Fauves, which not only matured contemporaneously with that of Die Brücke, but also was inspired by some of the same sources, such as the brilliant and emotional color of Van Gogh's work and Gauguin's evocatively "musical" art. Despite the striking stylistic similarities that can be observed in works of both groups prior to 1911, the expressive purposes of the French and German artists differed fundamentally. The French, under the leadership of Matisse, were primarily committed to problems of pictorial design, while the Germans expressed a far greater concern for the social and psychological situation of modern man. Of the French, only Georges Rouault revealed in his work a comparably serious, indeed tragic, view of life.

The essential Fauve position is well illustrated in Matisse's *The Open Window, Collioure* (fig. 11), one of the highly controversial paintings he exhibited at the historic Salon d'Automne in 1905. Having applied vigorous Impressionist and Post-Impressionist touches of the primaries red, yellow, and blue in the actual window view, he carefully balanced the vibrant center of the picture with fairly even hues of the complementaries pink, purple, and green inside the room, allowing the color zones on the periphery to frame the composition. Matisse fully believed in the instinctual basis of art, equating pictorial expression with the artist's innermost feelings. Of equal importance to him, however, was the harmony that can be achieved in a work of art if emotion is tempered by conscious reflection, a view he explained best in his famous "Notes of a Painter," published in 1908:

Expression to my way of thinking does not consist of the passion mirrored upon a human face or betrayed by a violent gesture. The whole arrangement of my picture is expressive. The place occupied by figures or objects, the empty spaces around them, the proportions, everything plays a part. Composition is the art of

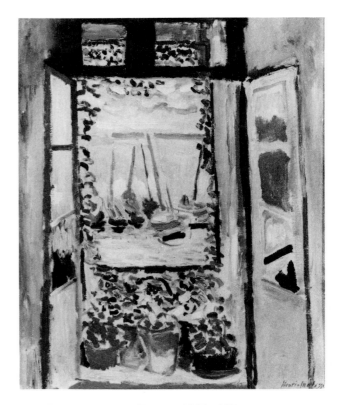

Fig. 11 Henri Matisse (French, 1869–1954).
The Open Window, Collioure, 1905. Oil on canvas.
Collection of Mr. and Mrs. John Hay Whitney, New York

arranging in a decorative manner the various elements at the painter's disposal for the expression of his feelings.... What I dream of is an art of balance, of purity and serenity devoid of troubling and depressing subject matter, an art which might be for every mental worker, be he businessman or writer, like an appeasing influence, like a mental soother, something like a good armchair in which to rest from physical fatigue.[2]

While Matisse strove for an art of pictorial harmony, the German Expressionists sought to address themselves in their art to the spiritual needs of the time, needs rooted in their country's immediate past. Unlike England and France, which could look back on a well-established tradition of economic and political organization, Germany in the

last quarter of the nineteenth century found itself faced with a belated industrial revolution, having been transformed in 1871 from a semifeudal collection of principalities into a nation state. Virtually overnight, commerce and industry began to grow at a dizzying rate, corporations and banks multiplied, and immense private fortunes were amassed. In 1872, just one year after the old Hohenzollern residence had officially been declared the capital of the newly founded empire, no fewer than forty new construction firms commenced operation in Berlin alone, gradually extending the city's perimeter farther westward. Before long, vast blocks of workers' tenements rose near Alexanderplatz in bleak contrast to the palatial villas of the Tiergarten quarter and the splendid façades of elegant shops and apartments on Kurfürstendamm.

Whatever the immediate material benefits, the accelerated changeover from an agrarian to an industrial society was bound to bring about a cultural shock. Young German intellectuals became increasingly distrustful of the crass materialism of the age and revolted against their own middle-class roots. Stage plays of family conflict, such as Walter Hasenclever's drama *The Son*, 1914 (see p. 121), Frank Wedekind's tragic play about adolescent sexuality, *Spring's Awakening*, 1891, as well as Heinrich Mann's satires of bourgeois smugness and hypocrisy, all grew from a profound awareness of the dislocation of modern man.

Evident in the art of many Expressionists and their associates is a similar disenchantment with material values and sympathy for the alienated and downtrodden, often combined with an idealistic plea for the transformation of the existing social order. This informs the proletarian themes of Kollwitz (p. 137), the joyless dancers of Heckel (p. 81), and Kirchner's anxiety-ridden city views, inhabited by men and women whose stylish appearance is matched only by their soulless indifference to each other (fig. 12).

Accompanying the Expressionist criticism of modern industrialized society was a conscious effort to become uncivilized, a yearning for an unspoiled form of existence originating in Nietzsche's vision of a Dionysian return to the wellsprings of nature. At the turn of the century, national organizations like the Wandervögel (Birds of Passage) encouraged communal hikes into the countryside, while members of groups such as the Jugendbewegung (Youth Movement) or practitioners of *Freikörperkultur* (nudism) dedicated themselves to man's physical and spiritual renewal through contact with the out-of-doors. This new

Fig. 12 Ernst Ludwig Kirchner. *Berlin Street Scene*, 1913. Oil on canvas. Brücke-Museum, Berlin

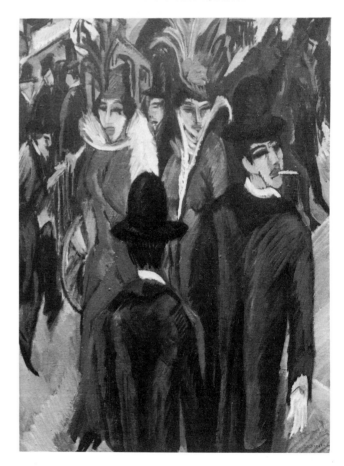

cult of primitive vitality was also part of the early communal lifestyle of the members of Die Brücke, who left their studios in the city during the summer months for the idyllic Moritzburg lake district near Dresden and the more distant beaches of the Baltic and the North Sea. There, accompanied by a number of women friends, they lived nude in tents and spent their days bathing, lolling about on the grass, and making love. They also painted and drew. Rejecting the pose of the professional model as artificial and sterile, they studied the nude human body moving freely in natural surroundings. While Pechstein's hedonistic bathers conjure up an image of primeval vigor (p. 191), Mueller's wistful nudes (p. 165) recall the mythical world of the nineteenth-century German painter Hans von Marées, whose clearly structured compositions are pervaded by a similarly nostalgic air (fig. 13). Since 1908, when two large retrospective exhibitions of his work were held at the Munich and Berlin Secessions, Marées had become a major source of inspiration for the younger generation. They not only admired his ability to subordinate anecdotal detail to the rhythm of the composition, but also discovered a kindred spirit in the nostalgic mood of his art.

Indeed, as the open countryside became an antidote to urban life for the Expressionists, they increasingly invested nature with a transcendental significance reminiscent of the nineteenth-century German Romantic tradition. In the late 1790s the philosopher Friedrich von Schelling had postulated the existence of a world-soul stirring in all animate and inanimate things, though productively conscious only in the mind of the artist. Nowhere is this pantheistic notion more eloquently expressed than in the haunting landscapes of Caspar David Friedrich, who had been virtually rediscovered at the centennial exhibition of German painting in Berlin in 1906 after decades of neglect. For Friedrich nature was only the physical manifesta-

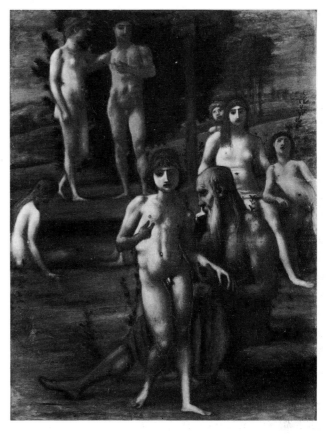

Fig. 13 Hans von Marées (German, 1837–1887). *The Golden Age*, 1879–85. Oil on canvas. Bayerische Staatsgemäldesammlungen, Munich

tion of his own inner vision. Though based on topographical fact, his landscapes are almost visionary in character. The quasi-religious, intensely spiritual communication of Friedrich's compositions, in which human figures, singly or in pairs, stand transfixed before nature, seemingly yearning to become one with the universe (fig. 14), is apparent in the work of the German Expressionists. Kirchner's coastal landscapes from Fehmarn (p. 101) and grandiose mountain views from Switzerland (pp. 103, 107) are similarly subjective projections of empathy with the mysterious forces of nature, as are Nolde's luminous seascapes and flower pictures from the north German plain (pp.

181, 185). Marc and Klee also developed pictorial parallels to the rhythm they perceived flowing through all of nature. While the former found accord between living beings and their environment in his animal pictures (p. 157), the latter combined color and form into poetic metaphors of the very processes of organic growth (p. 113).

Their quest for a state of existence untouched by the strictures of modern life led many Expressionists to a new appreciation of primitive art. The tribal craftsman, they felt, not only lived in true harmony with nature, but also worked intuitively, guided solely by religious and spiritual goals. Kirchner played an important role in introducing the other members of Die Brücke to the rich collection of the Ethnological Museum in Dresden where, in 1904, he had encountered African sculptures and masks as well as painted carvings from the South Sea Islands (fig. 15). Most Brücke painters eventually not only owned primitive art themselves but also, as a substitute for Gauguin's life among the natives, adorned their studios with pseudo-primitive wall decorations and statues of their own design. On the eve of World War I Nolde and Pechstein actually traveled to the South Pacific, and from the mid-1920s on Mueller carried on his search for the primitive among the Gypsy colonies of central Europe (p. 169). Yet, while they deeply admired primitive art as a genuine form of expression, the artists of Die Brücke never slavishly copied their sources of inspiration. Primitive art served, rather, as an encouragement to explore the expressive possibilities of color and form, resulting, as in Nolde's *Two Peasants* (p. 183) or

Fig. 14 Caspar David Friedrich (German, 1774–1840). *Woman Contemplating the Setting Sun*, c. 1818. Oil on canvas. Museum Folkwang, Essen

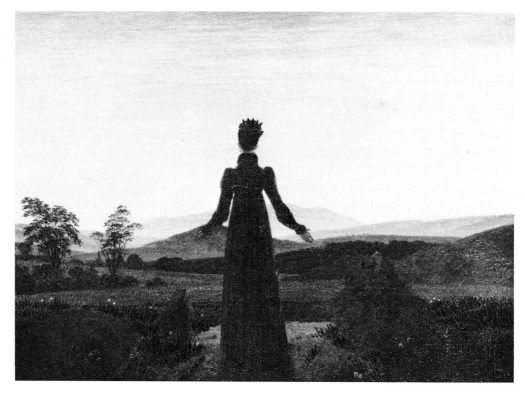

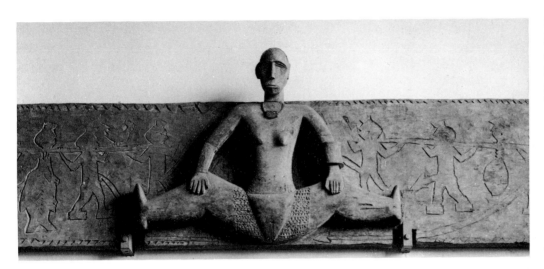

Fig. 15 Unknown artist, Palau Islands. *Carved Roof Beam*, detail, nd. Wood with remnants of paint. Hamburgisches Museum für Völkerkunde

Schmidt-Rottluff's *Evening by the Sea* (p. 205), in a generalized evocation of the elemental and archaic.

The painters of Der Blaue Reiter embraced a wider range of primitive art than did the artists of Die Brücke. Campendonk's development, for example, is unthinkable without his contact with the Bavarian peasant tradition of painting on glass (fig. 16; pp. 51, 53), while Klee explored the linear drawing techniques of children (p. 115). "I want to be as though newborn," Klee wrote in 1902, stating what was to become a fundamental Expressionist belief, "knowing absolutely nothing about Europe, ignoring poets and fashions, to be almost primitive."[3]

Neither did the Expressionists ignore German art of the late Middle Ages. The angular forms, arbitrary proportions, and compressed space in late fifteenth- and early sixteenth-century paintings and prints appealed to them, since here, too, artists had obeyed their inner visions, using nature only as a point of departure. The willfully expressive style of Matthias Grünewald, in particular, became the touchstone of their own efforts to achieve a new synthesis of content and form. For them, Grünewald had used pictorial means entirely in

the service of feeling, plumbing the very depths of human misery (fig. 17). An analogous attitude toward the art of the Middle Ages is found in Wilhelm Worringer's book *Problems of Form in Gothic*, 1912, in which the author made a distinction between classical and Gothic art, explaining the former as the result of a harmonious relationship between the artist and his environment and the latter as having sprung from conflict between

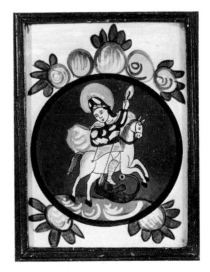

Fig. 16 Unknown artist, Bavaria, Germany. *Saint George*, 19th century. Paint on glass. Bayerisches Nationalmuseum, Munich

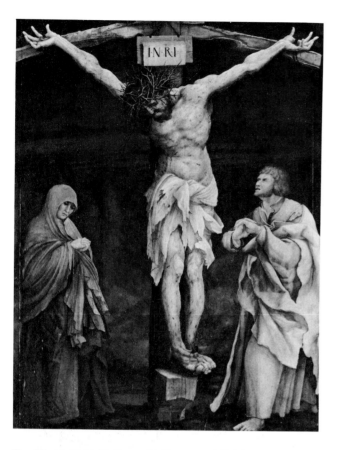

Fig. 17 Matthias Grünewald (German, 1470/75–1528). *Crucifixion*, c. 1525. Panel. Staatliche Kunsthalle, Karlsruhe

man and his world. Interestingly, many Expressionists were drawn to religious subjects at various points in their careers, motivated not by any conventionally orthodox considerations, but by the sense of disaffection which, according to Worringer, had given rise to Gothic art. For Nolde, biblical themes offered a refuge from rational existence (p. 177), and Ernst Barlach's religious imagery stemmed from an intense longing for a new relationship between man and God (p. 37). Especially during the bitter years of World War I and the period following immediately thereafter, when questions of life and death touched millions and—

if humanity were to survive—man's spiritual reorientation became more urgent than ever, themes of guilt and atonement through suffering took on a universal significance. In Christ's Passion, Beckmann found a surrogate for his own anguish. Schmidt-Rottluff, Pechstein, and Christian Rohlfs turned to the Old and New Testaments in search of symbols with which to express their sympathy for their fellowmen (pp. 193, 197).

By the time war broke out in 1914, Expressionism had emerged as a major force in German art. Four cruel years later Marc and Macke were dead, and Kandinsky, Jawlensky, and Kirchner had left Germany. Some of the idealism, however, which had given direction to many works of both Der Blaue Reiter and Die Brücke prior to the war surfaced anew in the optimistic program of the Novembergruppe (November Group), founded in Berlin in the fall of 1918 under the leadership of Pechstein and the painter and stage designer César Klein in order to help rebuild German society after the chaos of the war. During its brief span of existence in the very center of cultural life in Berlin, the Novembergruppe sought to explore possibilities of cooperation between artists and the socialist state of the nascent Weimar Republic. Through its Workers Council for Art, established in 1919, the group addressed itself to such issues as state support for the arts and the artist's responsibility toward society; through exhibitions, concerts, lectures, and evening classes for working people, it not only strengthened public acceptance of modern art, but also convinced many that social conditions could indeed be improved by an appropriate visual milieu.

The creation of an environment in which man's life achieves dignity and meaning was also the noble objective of the Bauhaus. Founded by the architect Walter Gropius in Weimar in 1919, this school was the only institution to come close to realizing the

idealistic goal of placing the various arts collectively in the service of society. Named in analogy to the medieval *Bauhütte*, the cathedral workshop in which artists and artisans worked together to construct one mighty edifice, the Bauhaus was devoted to the investigation of principles of design and structure in the arts and crafts, especially with respect to objects intended to be mass-produced by modern industrial methods. In keeping with the school's lofty aims, Feininger, the first painter to join the Bauhaus staff, illustrated the cover of the initial announcement of the school's program with a woodcut depicting a soaring cathedral illuminated by radiant stars (fig. 18).

Not all artists, however, shared the idealistic aspirations of the Novembergruppe and the Bauhaus. Deeply scarred by the experience of war, men such as Otto Dix, Beckmann, and George Grosz met the physical and moral collapse of German society in the immediate postwar years with disillusionment and cynicism, taking refuge in a harsh and unsentimental form of expression (pp. 41, 73).

At the same time, Expressionism was beginning to reach a wider public, and several of its leading exponents found themselves sought after as teachers. Kandinsky, having returned from Russia, joined Feininger and Klee on the staff of the state-supported Bauhaus. Several artists were appointed to positions at the academies in Dresden (Oskar Kokoschka), Breslau (Mueller), Düsseldorf (Campendonk), and Berlin (Carl Hofer, Pechstein, Schmidt-Rottluff).

But, as the demands for social renewal gradually diminished and youthful ardor was replaced by mature reflection, Expressionism inevitably lost its former urgency. Increasingly preoccupied with problems of pictorial structure from the early 1920s on, the pioneers of the movement began to subordinate the expressive features of their art to aesthetic considerations (pp. 105, 123, 213) and

eventually committed themselves to a more traditional interpretation of nature (pp. 127, 215). Ironically, German Expressionism in its most authentic form was already a thing of the past when it was ruthlessly suppressed by the National Socialists. Nonetheless, having extolled subjectivity and freedom of expression, it did not fit Hitler's dream of a controlled society, and he had hardly acceded to

Fig. 18 Lyonel Feininger (American, 1871–1956). *Cathedral of Socialism*, 1919. Woodcut from Bauhaus program

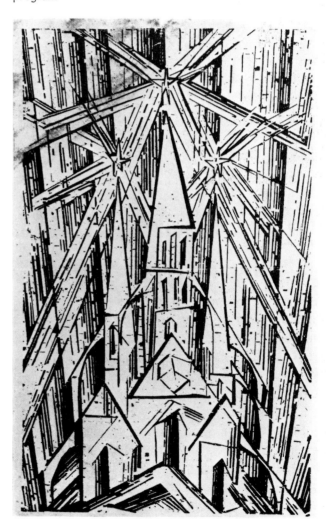

power in January 1933 when he began his fanatic campaign of vilification against all forms of modern art. The doors of the Bauhaus were closed by the police in March, while Campendonk, Pechstein, Schmidt-Rottluff, and others were either summarily dismissed from their teaching positions or forced to resign before the year was up—a fate that subsequently befell many more. Henceforth, these artists were not only prevented from exhibiting their work, but some, like Schmidt-Rottluff and Nolde, were actually forbidden to paint. At the same time Nazi ideologues were trying to redefine what constituted "healthy" modern German art, opting for a hybrid of realism and bombastic classicism that celebrated the imagined virtues of an allegedly superior Nordic race.

The first exhibition to attack the enlightened art policies of the Weimar Republic was held in Karlsruhe in 1933 under the title *Government Art from 1918 to 1933*, followed shortly by the exhibitions *Cultural Bolshevism* and *Art in the Service of Demoralization* in Mannheim and Stuttgart, respectively. The National Socialist assault on modernism climaxed in 1937 with the confiscation of nearly 17,000 sculptures, paintings, drawings, and prints, many of which were exposed to public ridicule at the *Degenerate "Art"* exhibition which opened in Munich in July of that year (fig. 19). The largest and most infamous of its kind, the exhibition featured not only the leading members of Die Brücke and Der Blaue Reiter, but also Symbolists, Cubists, and Fauves, as well as anyone whose work could be labeled unheroic, racially inferior, abstract, or Expressionist. The accompanying exhibition guide equated the pieces displayed with the art of the insane (fig. 20) and attributed the decline of modern German art to Jewish influence.

The sheer number of works that museums and galleries were forced to surrender as part of the general "cleansing" of German cultural life is stag-

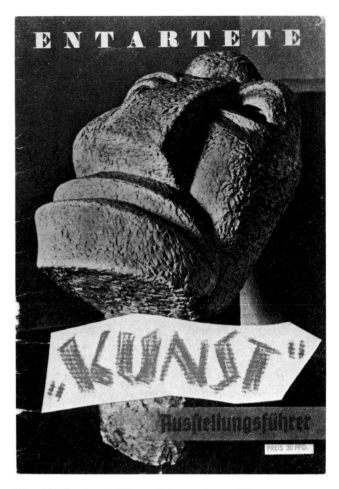

Fig. 19 *Entartete "Kunst" Ausstellungsführer (Degenerate "Art" Exhibition Guide)*, Munich, 1937. Offset lithography. The Detroit Institute of Arts

gering. The National Socialists confiscated more than 200 works each by Dix, Grosz, and Corinth; between 300 and 400 each by Hofer, Barlach, Pechstein, Feininger, and Mueller; approximately 400 by Kokoschka; 500 by Beckmann; nearly 650 each by Schmidt-Rottluff and Kirchner; 700 by Heckel; and more than 1,000 by Nolde. In March 1939 more than 1,000 paintings and close to 4,000 watercolors, drawings, and prints were set aflame in the courtyard of the main Berlin fire station. A

small number of works was sold at auction in Lucerne in June, while still more were allowed to be exported by specially selected dealers.

Although several museums have been successful since the end of World War II in buying back some of the confiscated works, the cultural loss to Germany was irreparable. Much of the work that escaped destruction found its way to other countries, particularly to the United States. Thus, The Detroit Institute of Arts today owns three works of major importance that are known to have been expro-

Fig. 20 Page 31 of *Entartete "Kunst" Ausstellungs-führer* comparing two prints by Oskar Kokoschka (Austrian, 1886–1980) with a drawing by an inmate of an insane asylum. The Detroit Institute of Arts

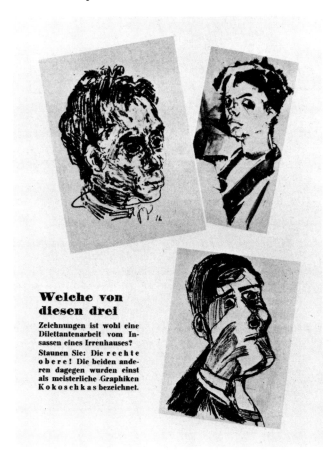

priated from German museums in 1937: Dix's stunning *Self-Portrait* (p. 63) once hung in the Kunstmuseum in Düsseldorf; Kirchner's magnificent *Winter Landscape in Moonlight* (p. 103) was owned by the Kaiser-Friedrich-Museum in Magdeburg; Modersohn-Becker's *Old Peasant Woman* (p. 161) was formerly one of the prized possessions of the Kunsthalle in Hamburg.

It is most appropriate that these three displaced masterpieces should have found their permanent home in Detroit, for by the time German museums and galleries were being despoiled of their treasures, the Detroit museum had become an important repository of German Expressionist art in America, largely through the efforts of one man, William R. Valentiner, director of the museum from 1924 to 1945 (see p. 211). Valentiner was born in Karlsruhe in 1880, and was thus an exact contemporary of Kirchner and Marc. Indeed, it was Marc who first introduced Valentiner, a leading authority on seventeenth-century Dutch painting, to German Expressionism in 1915, while both were serving in the German army. Following the war, Valentiner joined the Novembergruppe and in 1919 became one of the founders of the Workers Council for Art. As chairman of the Council, he came into contact with virtually all the leading Expressionists, many of whom remained his lifelong friends. He, in turn, became one of their earliest and most ardent champions in the United States. As early as 1921, having been appointed advisor to The Detroit Institute of Arts, he encouraged the museum to purchase a group of important works by such artists as Feininger, Heckel, Kirchner, Kokoschka, Kolbe, Mueller, Pechstein, and Schmidt-Rottluff (pp. 67, 83, 101, 123, 165, 191, 207). This was not only the first major acquisition of German Expressionist art by an American museum, but also a remarkably bold step, considering that the first Expressionist exhibition in America, organ-

ized by Valentiner at the Anderson Galleries in New York, did not take place until 1923. In 1931, Valentiner helped Alfred H. Barr, Jr., to organize the pioneering exhibition *Modern German Painting and Sculpture* at The Museum of Modern Art in New York, the most extensive show of its kind in the United States up to that time and one which was to lead to a greater appreciation of Expressionism in this country.

During his tenure as director of The Detroit Institute of Arts, Valentiner not only continued to acquire for the museum important Expressionist works—the first painting by Beckmann to enter an American museum was purchased by the Institute in 1929 (p. 43)—but also encouraged local collectors to enrich their own collections with major examples of modern German sculpture, painting, drawing, and printmaking. Many works which prominent patrons of the arts such as Ralph H. Booth, Dr. and Mrs. George Kamperman, John S. Newberry, and Robert H. Tannahill purchased on Valentiner's advice from the early 1920s on were subsequently donated or bequeathed to the museum.

At a time when the Expressionists were being defamed in their own country, Valentiner's untiring efforts to acquaint the American public with the work of the leading exponents of the movement offered these German artists both moral and material support. Drawings by modern German sculptors were exhibited by the museum in 1935, Expressionist watercolors in 1936, and a survey of modern German art in 1938. One-man shows, in most cases their first in the United States, were organized by Valentiner at the Institute for Rohlfs in 1936; for Kirchner, Feininger, and Corinth in 1937; for Klee, Hofer, and Gerhard Marcks in 1939.

Tannahill, who assembled his own extensive collection of twentieth-century art under Valentiner's guidance, in his capacity as chairman of the Detroit Society of Arts and Crafts organized in 1936 a one-man show of paintings and watercolors by Schmidt-Rottluff—the first comprehensive exhibition in America of this artist's work. In 1937, having attended, with Valentiner, the *Degenerate "Art"* show in Munich earlier in the year, Tannahill brought together for the Society an exhibition of modern German art drawn entirely from local collections. Featuring works by some of the same artists who were being exposed to public ridicule in Munich, this exhibition provided the Detroit public with an opportunity to judge for themselves whether these painters and sculptors were indeed "degenerate."

It is not surprising that Schmidt-Rottluff considered Valentiner—and, one is tempted to add, Detroit—one of the best and most loyal friends the Expressionists ever had. The German Expressionist collection of The Detroit Institute of Arts remains to this day a testimony not only to that friendship, but also to that freedom of expression which, emerging out of the conflicts of the modern age, was sustained by faith in a new and better world.

EDITOR'S NOTE The works featured in this book are arranged alphabetically by artist and chronologically within each artist's oeuvre. All dimensions are given in centimeters and inches; height precedes width precedes depth. In cases where the title of the work has been changed by the author, the change is based on titles given in studies that are the standard sources for the artist's oeuvre. Translations from German sources are all by the author unless otherwise indicated. The margins of the works on pages 53, 173, 177, and 179 have been cropped at the bottom for reproduction, and therefore only partial inscriptions are visible.

MASTERPIECES OF GERMAN EXPRESSIONISM

ERNST BARLACH

Best known as a sculptor, Ernst Barlach was also a powerful draftsman and printmaker, as well as a prolific playwright whose dramas occupy an important place in German Expressionist literature. Born January 2, 1870, in the small town of Wedel, near Hamburg, Barlach grew up on the windswept plains of Schleswig-Holstein and throughout most of his life, like Nolde, remained in close communion with the austere north German countryside and its people. At an early age he began to draw, write verse, and make figures out of clay, and from 1888 to 1891 attended the School of Arts and Crafts in Hamburg. Between 1891 and 1895 he continued his studies at the Dresden academy and the following winter and spring, while on a visit to Paris, enrolled briefly at the Académie Julian. Upon his return to Germany, Barlach divided his time among Wedel, Hamburg, and Berlin, supporting himself by assisting in the execution of a number of public monuments and accepting such commercial work as bronze reliefs and headstones for tombs, portrait plaques, and small clay figurines commissioned as models by a ceramics manufacturer. In 1904 he spent several months in the hills of the Westerwald, teaching at a trade school for ceramics at Höhr.

Barlach's early works range from naturalistic genre figures to decorative statues and reliefs permeated by the mellifluous rhythm of Jugendstil. Not until 1906, during a two-month trip to southern Russia, did he discover the spiritual direction that was to give his art its ultimate form. In the vast Russian landscape he first perceived the human figure in all its simplicity, while in the Russian peasants, seemingly wedded to the soil and exposed to the infinity of nature, he found embodied most strongly the uncertainty and fundamental tragedy of life. Thereafter, Barlach divested the human form of all incidental detail, concentrating on generalized

and compact figures which, singly or in pairs, communicate a wide range of emotions through emphatic postures, gestures, and facial expressions.

In 1910 Barlach settled permanently in the north German town of Güstrow, east of Lübeck. During the late 1920s he completed a number of memorials dedicated to the fallen soldiers of World War I, the finest of which was a hovering angel in bronze, an unforgettable symbol of eternal silence. Formerly in the cathedral of Güstrow, the original, like Barlach's other war memorials in Kiel, Magdeburg, and Bremen, was dismantled by the Nazis when his art was condemned as "degenerate." A later cast is in the church of the Antonites in Cologne.

Since his works, symbolizing the physical and emotional frailty of man, did not meet Hitler's demand that art conjure up the vision of a healthy and successful society, Barlach was attacked by the National Socialists as early as 1933. By 1937 nearly 400 of his works had been confiscated from German museums, and Barlach found himself accused of having no roots in the German national character. He suffered intensely from the destruction of his reputation and in the summer of 1938, ostracized by his neighbors and unable to work, resolved to leave Güstrow, hoping to find peace and quiet by moving to some remote place. But a heart ailment, from which he had suffered most of his adult life, had undermined his health too far to permit him to realize his plans. In September Barlach's condition became so severe that he was forced to enter a hospital in nearby Rostock. He died there a few weeks later, on October 24, at the age of sixty-eight.

THE AVENGER 1914 (cast 1930)

In depicting the human figure, Barlach was interested neither in the particular appearance of a given individual nor in surface details. Far from seeing in the human form a mere stimulation to the eye, he looked upon it as a key to man's inner life. He wanted to express archetypal states of human experience, epitomized in statues of men and women which, through the eloquence of their gestures and general bearing, externalize a wide range of feelings, from mute sorrow and loneliness to terror, anger, and joy. As a rule, his figures are strongly silhouetted and distinguished by both massive weight and a flow of form that links each part of a given work to its adjoining part, creating the structure as a whole. In *The Avenger*, for instance, one of Barlach's most famous works, the sculptor avoided virtually all abrupt contrasts of light and shadow in order not to weaken the kinetic thrust of the piece. The impression of powerful motion in space rests upon the simplified, fanlike folds of the flowing robe and the figure's striking posture, with one leg supporting the weight of the body, while the other, stiffly outstretched, reinforces the forward direction of the torso. Having transformed the entire body into a powerful projectile, Barlach subordinated the narrative component of the work—a man clutching a mighty sword in a gesture of violent aggression—to the dynamics of the sculptural mass.

Like some of the most expressive figures of Auguste Rodin, Barlach's statues are vessels of human emotion. Also noteworthy, in both form and conception, is their relationship to late medieval German sculpture, an inspiration Barlach readily acknowledged. His indebtedness is evident not only in his practice of concealing the body under heavy garments, but also in the spirituality his figures express. Their movements and actions seem less determined by muscles or human will than by a calling that lies beyond the grasp of the individual.

The Avenger in Detroit was the first in a projected, but never completed, series of ten bronzes of the work to be cast in 1930 for the Berlin dealer Alfred Flechtheim from the original plaster model made sometime between September and October 1914 (Barlach Estate, Güstrow). Heroic, even noble, in conception and monumental in effect despite its relatively modest size, the statue testifies to the enthusiasm with which the sculptor, like so many other German artists and intellectuals, welcomed the outbreak of World War I, not only believing its cause to be just, but also embracing the international conflict as a spiritually cathartic experience. Indeed, a lithograph by Barlach, based on the original plaster model and titled *Holy War*, was featured in 1914 in an issue of *Kriegszeit (War Time)*, a propaganda broadsheet published by the art dealer Paul Cassirer in Berlin during the early years of the war. Given Barlach's compassionate and deeply humanistic nature, however, his patriotism was bound to be short-lived. By the time he returned to the same theme two years later he had come to detest war as evil and to look upon it as Europe's greatest shame. In both a drawing and a subsequent lithograph of 1916, titled *Episode from a Modern Dance of Death*, he transformed the idealized avenger into a grotesque and murderous figure, wielding a sledgehammer above an hourglass and a heap of human bones.

Bronze, 44.5 x 21.6 x 59.7 cm (17½ x 8½ x 23½ in.)
Signed and numbered on left side above base: *E. Barlach 1/10*
Gift of Mrs. George Kamperman in memory of her husband, Dr. George Kamperman (64.260)

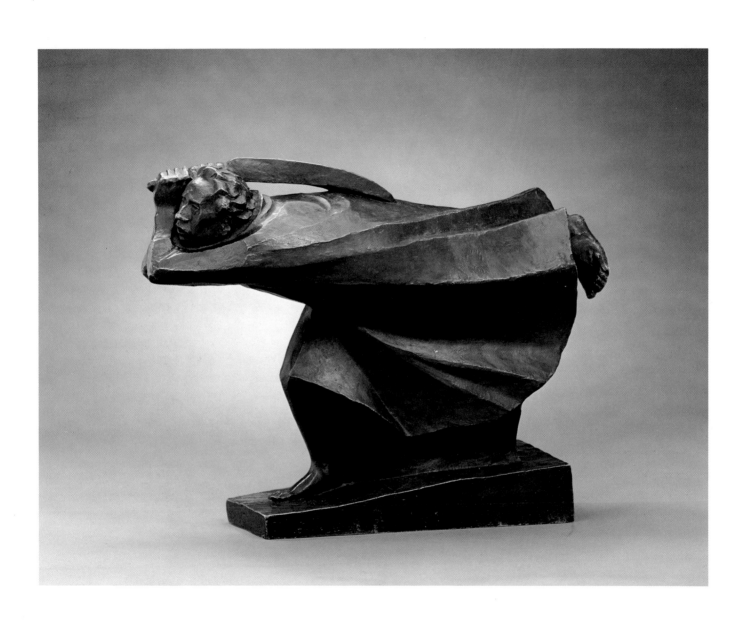

ECSTATIC WOMAN c. 1920 (cast 1930)

Nearly all of Barlach's figures seem to belong to two different worlds. Firmly wedded to the soil—an impression reinforced by the massive base that in most instances forms an integral part of the artist's conception—they appear to be possessed by a peculiar restlessness, the origins of which lie in the conflict between the human spirit and the body that imprisons it. This agitation may be concentrated in the expression of a face, in a single drapery fold, or in the unsteady searching of an outstretched hand. Or, as in *Ecstatic Woman*, it may permeate the entire figure. Here, as in Barlach's *The Avenger*, an inner disturbance breaks through the outer form with tremendous force, determining both the dramatic outline and the movement of the statue. As if still half-rooted in the earth, the woman braces herself against the ground. Straining under the weight of her massive body, she sways in the grip of some uncontrollable rapture. The disequilibrium of her posture causes her dress to stretch in a series of diagonal folds, setting in motion a gestural line that surges upward into the shoulders and ultimately finds release in the grimacing expression of the upturned face.

In its earthy vigor and mixture of the comic and the bizarre, Barlach's bronze shares unmistakable affinities with works by Nolde, who, in his own search for greater emotional and spiritual expression, rejected conventional notions of beauty and grace in favor of roughness and raw strength (see p. 183). Both artists, in their typically Expressionist yearning for the inner truth of things, looked for the archaic and primitive in man and, in their pursuit, frequently exploited the ugly and the grotesque.

The *Ecstatic Woman* in Detroit was the first in a planned series of ten bronzes to be cast in 1930 from the original plaster model done around 1920 or possibly even earlier (Barlach Estate, Güstrow). Commissioned by Flechtheim, the series, like that of *The Avenger*, was never executed in its entirety, and, despite the numbering on the base, only a few casts are known.

Speaking in jest, Barlach once referred to the original model of *Ecstatic Woman* as "lascivious woman," an epithet that subsequently gave rise to the title *Procuress*, by which the work is still frequently known. Yet, in contrast to a two-figure group Barlach did in 1920 showing an old woman in the process of unveiling the nude body of a beautiful young girl, nothing in the Detroit work suggests that the sculptor intended here to create an illustrative genre figure within a specific narrative context. *Ecstatic Woman*, while ostensibly based on the human form, is a prototypical image of the human condition, a symbol rather than a representation. A contrast between exaltation and earthiness, between man's earthbound nature and paradoxical longing to escape from the world, forms the essence of the work. Omitting everything incidental, Barlach transformed the entire statue into an embodiment of exalted feeling.

Bronze, 37.5 x 24.1 x 16.8 cm (14¾ x 9½ x 6⅝ in.)
Signed and numbered: on left side of base, *E Barlach*; on back, *1/10*
Bequest of Robert H. Tannahill (70.211)

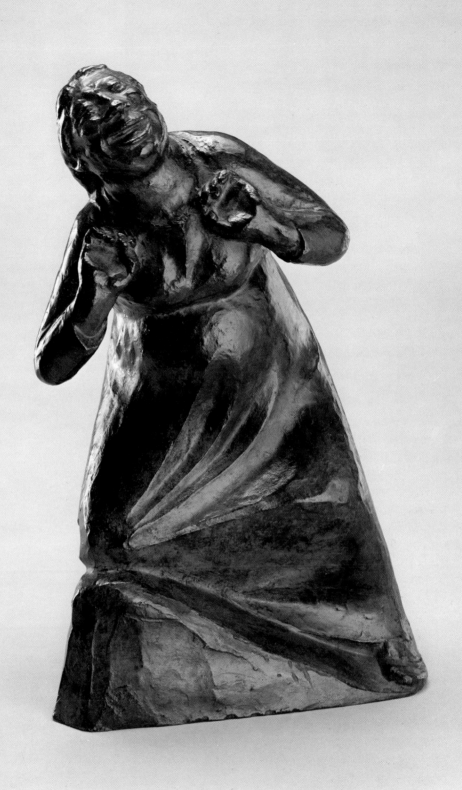

Although Barlach made many drawings and lithographs, he found his favorite graphic medium in the woodcut. Like all the Expressionists, he admired the emotional potential inherent in bold contrasts of black and white. As a sculptor who always strove to render what is most essential in the human figure, he possessed a particular affinity for the woodblock, the refractory nature of which not only demanded strict discipline in the process of execution but also encouraged the kind of universal expression he sought to achieve in his three-dimensional works. Barlach's woodcuts are imbued with the same elemental power as his simplified, rhythmically conceived sculptures, so much so, in fact, that often he was able to adapt the imagery from one medium to the formal requirements of the other. The hovering figure of God, for example, in Barlach's 1920 woodcut, *The First Day*, was cast in stone two years later and in 1927 served as a prototype for the floating angel in bronze the sculptor made for the cathedral in Güstrow. Enveloped by a ring of swirling clouds, Barlach's Creator is massive and blocklike, sculptural rather than linear in conception. He emerges from the surrounding void, noble and magnanimous, with rays of light emanating from his outstretched hands.

Barlach's print, which illustrates the well-known passage in Gen. 1: 3, "And God said, Let there be light: and there was light," is the first in a cycle of seven woodcuts published in 1921 by Cassirer in Berlin under the title *The Transformations of God (Die Wandlungen Gottes)*. The arrangement of the set, beginning with *The First Day* and ending with *The Seventh Day*, seems to imply the seven days of Creation. Except for the first and the last prints, however, Barlach did not adhere to the sequence of events as told in Genesis, but created an allegory of the complex relationship between the divine spirit and man.

Although Barlach refused to give an interpretation of the individual woodcuts that comprise the cycle, he indicated that they are grouped around a unifying central concept. Underlying this concept was his belief in the fundamental unity of God and the world and the conviction that even in the process of change this unity is never lost, although the creative spirit may be at work in different forms—in joy and suffering, birth and death, in man's spiritual strength and his moral frailty.

Woodcut, 32.4 x 44.8 cm (12¾ x 17⅝ in.)
Signed in pencil, lower right: *EBarlach*
Founders Society Purchase, Hal H. Smith Fund (31.1)

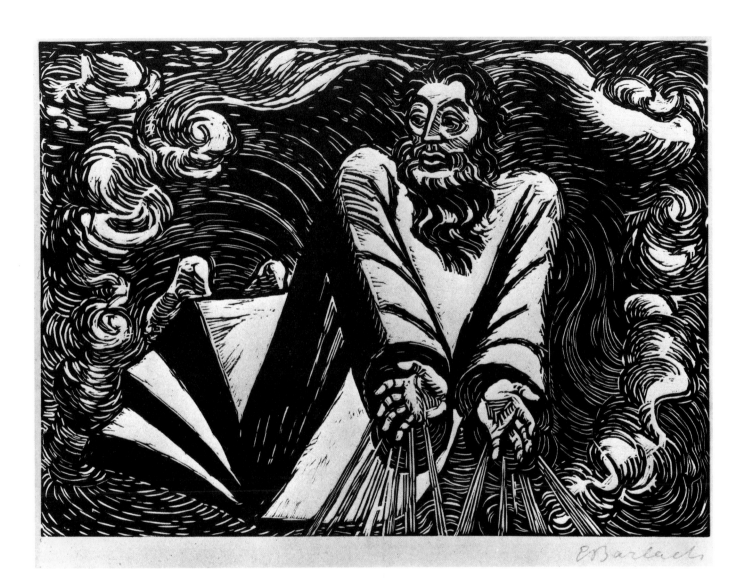

MAX BECKMANN

Max Beckmann's Expressionism was born of the carnage he witnessed firsthand while serving as a hospital orderly in World War I and of the Nazi terror which little more than a decade later began to threaten European civilization. Unlike the satirical art of Grosz, however, his works are not bound to any specific time or place, but address themselves to the human predicament in a symbolic and universal way. His pictures are parables of human cruelty and anguish, as well as strong warnings against man's irrationality and spiritual decay.

Born February 12, 1884, in Leipzig, Beckmann attended the academy in Weimar from 1900 to 1903 and in 1904 moved to Berlin, where he soon became a prominent member of the Berlin Secession. Beckmann long remained aloof from the artistic concerns of his generation and, as late as 1912,

engaged in a widely publicized feud with Marc, supporting faithful objectivity to nature in opposition to Marc's advocacy of art that seeks to penetrate appearances in search of some mysterious inner truth. He admired Renaissance masters such as Piero della Francesca and Luca Signorelli and was especially attracted to the nineteenth-century German painter Marées (see fig. 13), whose lofty idealism he combined with the earthy vigor of Corinth, painting biblical and other literary themes on a gigantic scale.

Having enlisted in the medical corps of the German army at the outbreak of war in 1914, Beckmann suffered a complete physical and mental breakdown the following year, was discharged, and settled in Frankfurt. His morbid wartime experience formed the background of a series of drawings and prints of wounded and dying soldiers, in which he abandoned the rhetoric and romanticized conception of his earlier works in favor of greater simplicity and directness. During his years in Frankfurt, he increasingly resorted to violent distortions of form and perspective, tracing the postwar collapse of civil morality in a series of devastating

portraits and in complex allegories of human suffering and vice. By the late 1920s, in a more settled Germany, Beckmann's compositions became less congested and took on a greater richness of color, though the painter's lavish use of black, usually serving as a foil for a few luminous hues, continued to endow his pictures with an unmistakably somber mood.

With the rise of the Nazi regime, Beckmann, who had accepted a professorship at the Städelsches Kunstinstitut in Frankfurt in 1925, was dismissed from his position. Seeking the anonymity of a large metropolis, he returned to Berlin in 1933. In July 1937, one week before the opening of the *Degenerate "Art"* exhibition in Munich, he left Germany for good, settling in Amsterdam where, despite many hardships, he continued to work in relative seclusion throughout World War II. In 1947 Beckmann accepted an invitation to teach at Washington University in Saint Louis. Two years later, having been offered a permanent teaching position at The Brooklyn Museum Art School, he moved to New York. On December 27, 1950, he died of a heart attack during one of his regular morning walks to Central Park.

Beckmann's mature style, a fusion of the agitated mood of works from the postwar years and the more serene monumentality of his paintings from the late 1920s, found its fullest expression in nine large triptychs painted between 1932 and the time of his death. In these, as well as in a number of closely related compositions, he became increasingly philosophical, seeking to define the ultimate values of human existence in enigmatic pictorial metaphors of guilt, suffering, and redemption.

Engraved in 1920, a time of severe social and economic turmoil, *Old Woman with a High Hat* is one of a large number of prints in which Beckmann, still suffering from the horrors of trench warfare, looked with bitter disillusionment upon the moral and spiritual disintegration of German society in the aftermath of World War I. In these works, many of them done in series bearing such evocative titles as *Hell, Carnival,* and *City Night,* he emerged as a severe moralist, recording the vulgar and commonplace faces of gangsters, pimps, prostitutes, and profiteers with the most mordant cynicism. Yet Beckmann was more than a documentary artist commenting on the civil violence and corruption of postwar society; their contemporary appearances notwithstanding, his figures are timeless personifications of human folly and vice.

In the Detroit print Beckmann attacked the social and intellectual pretensions of an entire era. His satirical manner in this work recalls such earlier critics of human behavior as Hieronymus Bosch and Pieter Brueghel the Elder, both of whom transposed man's moral frailty to a universal level by conceiving the individual not in terms of a specific likeness, but—as is the case here—as a conventionalized type. Seen within the context of the ugly realities of the postwar years, the woman's hat, perched high upon an enlarged head which is fastidiously laced with tight little curls, is no less than preposterous. At the same time, there is something exceedingly pitiful about the woman herself. Her grotesque features hardened by a lifetime of hypocrisy, she gazes self-righteously and with mock consternation at a world she can no longer comprehend.

Stylistically, the print illustrates to what extent Beckmann had by 1920 abandoned the naturalism of his earlier works in favor of exaggerated proportions and angular forms. Tonal and textural effects have been largely ignored. Instead, one can feel the forceful action that cut the copper plate, delineating the image in a decisive way. The visual clarity of the depiction and devastating fidelity with which the folly and weakness of the subject have been characterized are typical of the works that eventually gave rise to the term *Neue Sachlichkeit* (New Objectivity). This phrase was first coined in 1923 to define the incisive manner in which artists such as Beckmann, Grosz (see p. 73), and Dix described the spiritual and moral bankruptcy of the postwar world and to distinguish their trenchant observations from earlier, conventional forms of realism as well as from the more abstract and comparatively romantic Expressionism of the prewar years. The term is not altogether felicitous, however, and, in the case of Beckmann, it is even misleading. For his mature paintings and prints are not only unthinkable without the formal exaggerations of the works of the Brücke artists, but also reaffirm the basis of all Expressionist art by manipulating form freely, not objectively, in order to communicate a preconceived meaning.

Drypoint, image 30 x 19.9 cm (11¹³⁄₁₆ x 7¹³⁄₁₆ in.), sheet 45.8 x 35.2 cm (18 x 13⅞ in.)
Signed in pencil, lower right: *Beckmann*
Founders Society Purchase, Charles L. Freer Fund (66.82)

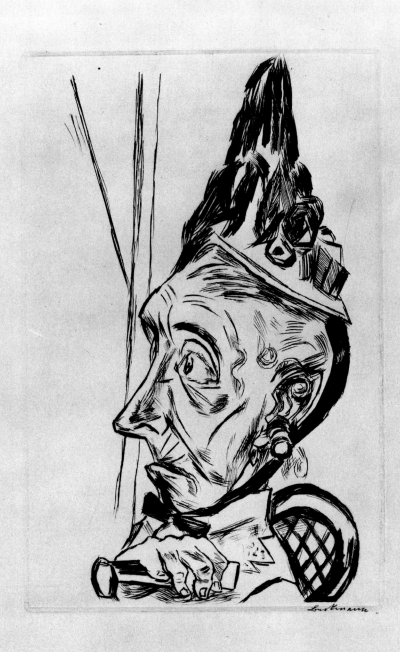

STILL LIFE WITH FALLEN CANDLES 1929

Candles were one of Beckmann's favorite motifs. Flaming upright or fallen over and extinguished, they are the most pervasive metaphor in his entire work. They are found in his portraits and with particular frequency in his large allegorical compositions, where their presence provides a poignant accompaniment to the human drama depicted, symbolizing man's desire to see or his inability to do so, prevented by either spiritual blindness or oppression. They also provide the subject matter of a number of Beckmann's still lifes, in which their meaning is less complex.

Consuming their substance in order to shed light, candles have traditionally served as a reminder of the ephemeral nature of human existence. They occur with this meaning in many Dutch *vanitas* still lifes of the seventeenth century, often grouped with rare and costly objects, books, musical instruments, timepieces, and even pipes, all of which allude to man's short-lived pleasures and the vanity of earthly pursuits. *Still Life with Fallen Candles* is indebted to this tradition and is one of many examples illustrating to what extent the art of the past remained for Beckmann a viable source of inspiration.

Like Corinth (p. 57), Beckmann endowed his still lifes with human qualities. A mild sadness seems to emanate from the Detroit painting, in which two candles, toppled over and snuffed out in their prime, their weight resting on fragile pears and grapes, have been carefully laid out as in a wake, while two mournful candles, standing farther back, seek in vain to illuminate the scene, the one on the right barely able to sustain its faint glow. The light in the picture does not emanate from them, but enters the composition in the form of harsh daylight from directly above, creating shadows of impenetrable darkness. Large parts of the painting are executed in a deep, rich black, complemented by muted shades of green, yellow, and blue. In a similar but larger composition of 1930 (Staatliche Kunsthalle, Karlsruhe), Beckmann combined the motif of the fallen and upright candles with a mirror, another well-known *vanitas* symbol, and a book, on the cover of which is written *Ewigkeit*, German for "eternity." In a macabre still life of 1945 (Museum of Fine Arts, Boston) an extinguished candle is accompanied by three human skulls.

The lucid pictorial structure of *Still Life with Fallen Candles*, emphasizing large planes of color and well-defined, simplified shapes, epitomizes the relative serenity of Beckmann's pictures of the late 1920s in contrast to his hectic and congested compositions dating from the years immediately following the end of World War I. Painted in Frankfurt in 1929, this still life, purchased by Valentiner for The Detroit Institute of Arts the same year, was the first picture by Beckmann to be acquired by an American museum.

Oil on canvas, 55.9 x 62.9 cm (22 x 24¾ in.)
Signed and dated, upper left: *Beckmann F 29*
City Appropriation (29.322)

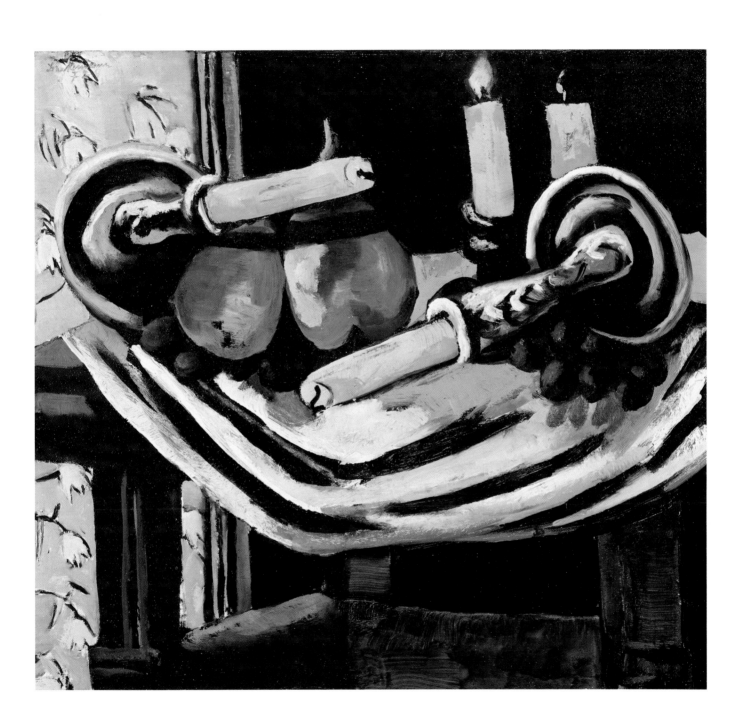

Searching for his inner self, Beckmann painted, drew, and engraved his face throughout his career, using his own features to illustrate a wide range of emotions. Like Corinth, the only modern German painter possessed by a greater need for self-contemplation and analysis, Beckmann portrayed himself in ever-changing disguises: as sailor, ringmaster, acrobat, clown, and even as a prizefighter bludgeoned in the ring. Beckmann defined himself romantically, depicting himself with large, dreamy eyes and as calculating, arrogant, and aloof. Those who knew him well often remarked on the seemingly conflicting traits of his personality, for Beckmann was at once a ruggedly built man of the world, self-reliant, imposing, even intimidating, and at the same time a withdrawn and lonely painter who, for all his pride and aggressiveness, was quite reserved and vulnerable. Evident in nearly all of Beckmann's self-portraits is the ambivalence between his need to project to the public an image of forceful independence and confidence and his desire to retreat into himself.

Beckmann's *Self-Portrait in Olive and Brown* epitomizes this contradiction. Excluding everything that might detract from a direct encounter with the viewer, the artist reduced the space around the figure to a minimum, focusing attention on his head and attentive gaze. The large and strong face, powerfully modeled by the light illuminating the figure from directly above, is rigidly frontal. The bilateral symmetry created by the bridge of the nose, chin, and shirt opening is relieved only by the reddish stripe on the wall at the left and the white edge of the picture on which the painter is working. The physical proximity of the artist, however, is countered by his psychological distance; he gazes out from the painting as if from behind an impenetrable shield.

Beckmann's *Self-Portrait in Olive and Brown* provides an interesting contrast to a self-portrait he painted eight years earlier when, having fled Nazi Germany to seek refuge in the Netherlands, he cast himself in the role of a prisoner whose iron neck-collar and handcuffs have been broken, though darkness still looms through the barred prison window behind him (Collection L. von Schnitzler, Murnau). In the Detroit self-portrait, painted soon after the withdrawal of German troops from Amsterdam in 1945, at the dawn of a new era in which his art was no longer threatened, Beckmann dropped all disguises and affirmed his profession by showing himself at work.

Oil on canvas, 60.3 x 49.9 cm (23¾ x 19⅝ in.)
Signed and dated, lower right: *Beckmann A 45*
Gift of Robert H. Tannahill (55.410)

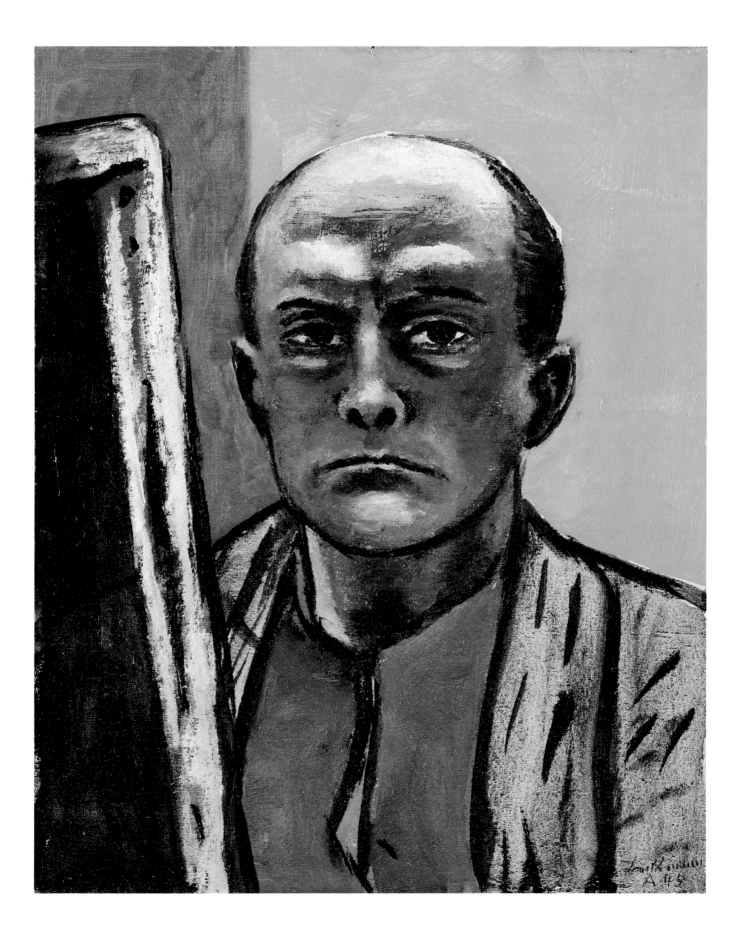

Beckmann's watercolor *Sacrificial Meal* falls thematically within the context of the nine large triptychs he painted between 1932 and his death in 1950. In these pictures Beckmann transposed his view of modern life into enigmatic parables of human existence, which he depicted metaphorically in terms of the stage, the carnival, and children's games, frequently drawing upon the epic legends of human fate in Greek and Norse mythology. Like all of Beckmann's allegories, this watercolor defies easy explanation. On the surface it seems to illustrate little more than what the title says—a sacrificial meal celebrated on a primitive cultural level. Two male figures in long robes prepare to roast large pieces of a dismembered carcass, skewered on spears, over a brightly flaming fire; a female figure, seated in the foreground on the left, voraciously claws and feeds upon a chunk of meat. Three severed animal heads, still dripping with blood, one impaled above the flames, the others lying discarded on the ground, serve as grisly reminders of the slaughter that preceded the episode shown. There is something terrifying about the deliberate calm with which the scene is enacted, while the barbaric splendor of the colors—contrasting shades of red, yellow, and blue—reinforces the violence of the subject matter.

Beckmann has long been recognized as a moral commentator on the barbarism of modern life, his horrible visions symbolizing man's folly, hypocrisy, and inhumanity to his fellowman. That this characterization holds true for *Sacrificial Meal* is borne out by a contemporary painting (Private Collection, Santa Barbara, California) in which Beckmann translated the theme into one of overt cannibalism. In the painting, for which the watercolor served as a preliminary study, the figure at the lower left has been replaced by two bound naked women, while the two male figures have driven their enormous spears through the gaping mouths of two severed human heads, which they hold suspended above the flames of the open pit.

Beckmann usually resisted all efforts to discern the meaning of his mysterious allegories. "I can only speak to people," he commented, "who, consciously or unconsciously, already carry within them a similar metaphysical code."[4] He always wished his paintings to remain private statements that communicate a feeling without having to be understood in a literal sense. Hoping that each viewer, through contemplation and creative sympathy, would arrive at an understanding not only of a given work but also of his or her own position in life, he was content to force the spectator to look. While the precise meaning of *Sacrificial Meal* may be obscure, its fundamentally tragic significance is surely readily apprehended.

Pen and watercolor, 50.2 x 31.1 cm (19¾ x 12¼ in.)

Inscribed, signed, and dated in black ink: lower right, *Chase Hotel/Beckmann/4. Okt 47/St. Louis*; verso, *"Opfermahl" Sacrificial Meal/for Mr. Newberry/2. Nov. 47. St. Louis/pour souvenir./Max Beckmann*

Bequest of John S. Newberry (65.174)

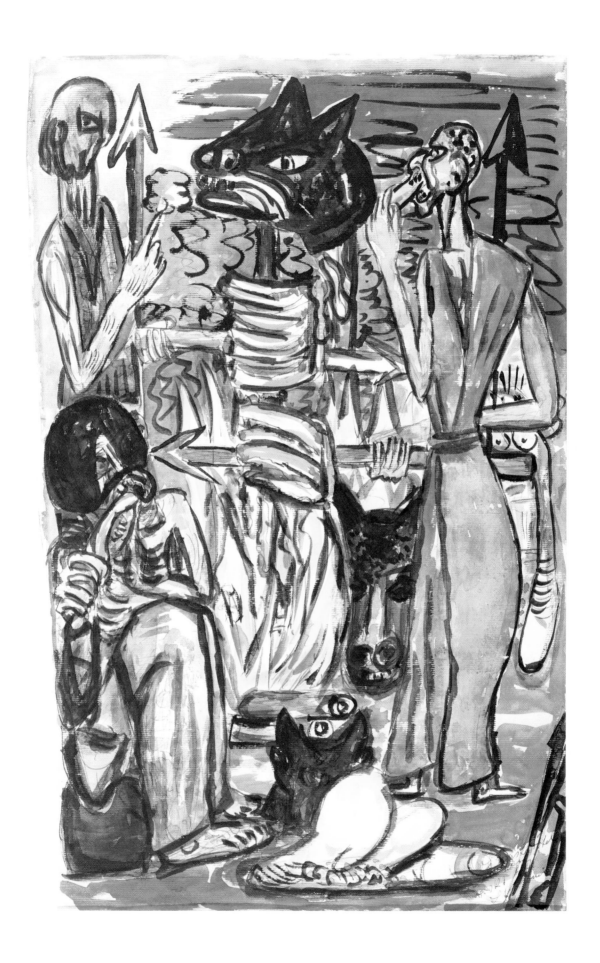

HEINRICH CAMPENDONK

The search for innocence and simplicity which led many painters of the Expressionist generation to the art of exotic tribes, folk cultures, and children is exemplified most clearly in the work of Heinrich Campendonk. For many years he chose to live in the seclusion of the Bavarian countryside, seeking to re-create in subject matter, spirit, and style the naive and forceful expression of a genuine folk art. He is often called the "primitive" among the members of Der Blaue Reiter.

The son of a textile merchant, Campendonk was born November 3, 1889, in Krefeld, a city famous for the manufacturing of silk. Intending to become a pattern designer for the textile industry, he studied at the Krefeld Textile Engineering School and from 1905 to 1909 attended the School of Arts and Crafts in Krefeld, where the Dutchman Johan Thorn-Prikker, well known for his decorative murals and stained-glass windows, first introduced him to the art of Cézanne, Van Gogh, and the great masters of early Italian fresco painting. In 1909 Campendonk assisted in the execution of a series of murals in the cathedral of Osnabrück, although it was not until the following year, while sharing a studio with Helmut Macke, a cousin of August Macke, that he began to devote himself seriously to painting. After a number of these early pictures had been seen by Kandinsky and Marc, the latter invited the young artist to visit him at his home in Sindelsdorf, a small village in Upper Bavaria, where Kandinsky was also staying at the

time. Campendonk moved to Sindelsdorf in October 1911 and in December took part in the first exhibition of Der Blaue Reiter in Munich.

The contact with the artists of Der Blaue Reiter had a profound effect on Campendonk, and for a while he emulated Marc's characteristic combination of pure colors and prismatic forms. Not until after his return from the war in 1916, when he settled in Seeshaupt on Lake Starnberg, did he develop the decorative primitivism for which he is best known. Inspired by Bavarian folk art, he also explored at this time the indigenous peasant technique of painting on glass (fig. 16).

Campendonk abandoned country life in 1920 and traveled to Italy, where the frescoes of Fra Angelico and Giotto and the mosaics in the churches of Ravenna impressed him deeply. He was made a professor at the School of Arts and Crafts in Essen in 1922, marking the beginning of a long and distinguished teaching career. In 1923 he accepted a position at the School of Arts and Crafts in his native Krefeld and, from 1926 until his dismissal by the Nazis in 1933, taught at the Academy of Fine Arts in Düsseldorf. He left Germany for Belgium in 1934 and in 1935 was offered an appointment on the faculty of the Academy of Fine Arts in Amsterdam. During these years Campendonk returned increasingly to his original interest in the applied arts: textiles, stage design, and stained glass. He died in Amsterdam on May 9, 1957.

IN THE FOREST c. 1919

The influence of Bavarian folk art on Campendonk's paintings and prints is manifest not only in his choice of subjects, most frequently scenes from farm life and landscapes in which people and animals coexist idyllically, but also in the compositions of his pictures, the disproportionate scale of the figures relative to the space they occupy, and the artist's careful attention to incidental detail. His painting *In the Forest*, generally dated 1919 on the basis of style, possesses a blend of unpretentious directness and mystery that can also be seen in the art of Rousseau. At the first exhibition of Der Blaue Reiter in Munich in 1911, two of the Frenchman's pictures were featured as prime examples of an intuitive form of expression, untainted by training and technique.

Each detail of Campendonk's canvas has a kind of conscious clarity. The landscape is neatly patterned; the fleshy trees and their foliage, painted in glowing shades of red, blue, and green alternating with white, are rigid and ornamentalized. Nothing looks real, yet everything is so sharply rendered that reality and unreality reach a state of perfect fusion. Campendonk's world is like an unfading dream in which all objects partake of some magic truth, forever suspended within the structure of the composition.

While the careful rendering of outline, the smoothing out of the paint, and the fastidious blending of one tone into another are all indicative of Campendonk's efforts to re-create the expressive simplicity of peasant art, the painting is far from primitive in conception. Unlike an actual folk artist, whose work springs from the context of a rural community and is therefore truly anonymous, or the self-taught Rousseau, who sought to master in his own naive way the realistic technique of conventional artists, Campendonk produced a highly sophisticated work. Indeed, the Detroit painting is complex in both form and content. Despite the seemingly tapestry-like flatness of the canvas, considerable depth has been achieved through the overlapping of the thick, stylized trees, and the simplified shapes are indicative of more than a passing acquaintance with Cubism. With respect to subject matter, the painting conveys a typically Expressionist identification with nature and the concomitant nostalgia for an uncomplicated and unspoiled life. In contrast to Marc, who projected his desire for a primordial state of being into the minds and bodies of animals, excluding all human subject matter from his primeval paradise (p. 157), Campendonk envisioned man and beast at peace with one another in nature, sharing in the harmony of the universe.

Oil on canvas, 83.8 x 99 cm (33 x 39 in.)
Gift of Robert H. Tannahill (44.271)

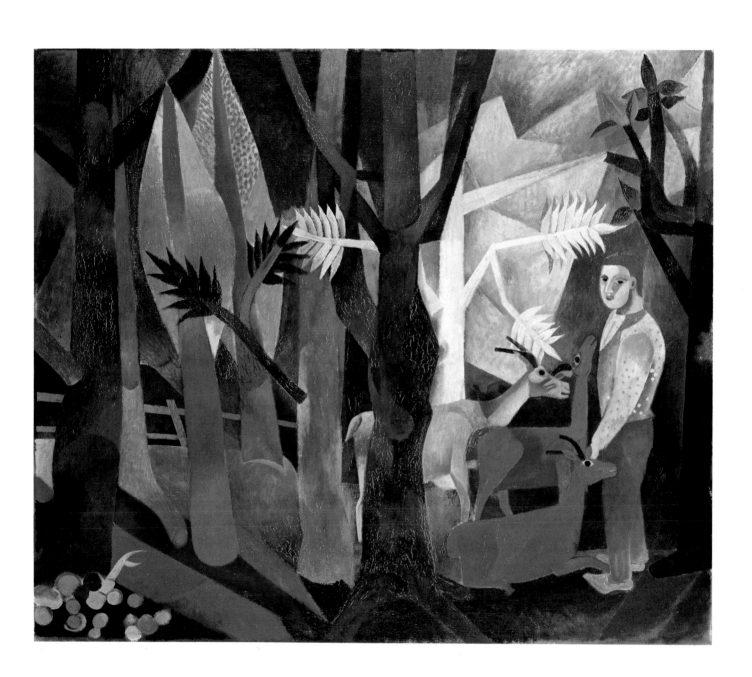

NUDE WITH FISH AND BIRDS c. 1920

Throughout his career, Campendonk exhibited in his work a strong affinity for the applied arts. His innate talent as a designer is particularly evident in woodcuts such as *Nude with Fish and Birds* of around 1920. Unlike other Expressionist printmakers (see p. 79), he did not exploit the expressive potential of the natural grain of the medium, but joined smooth contours and flat patterns in a decorative arrangement reminiscent of tapestries or stained glass. This impression is reinforced by the artist's subsequent coloring of the woodcut, using a combination of luminous flesh tones mixed with yellow and touches of indigo blue, green, and reddish brown. Although the artful distribution of the ornamentalized patches of light and shadow is of a sophistication far beyond the grasp of the ordinary folk artist, the stylized animals and rigid, puppet-like figures recall the crude simplicity of Bavarian votive paintings on glass (fig. 16). Despite the fact that some illusion of depth has been achieved through overlapping and diminution of scale, the general impression of a willful primitivism is further strengthened by the print's vertical space. The figures, animals, and plants are arranged not so much behind as above each other.

The clarity with which each detail has been rendered stands in sharp contrast to the print's ambiguous mood. As in his painting *In the Forest*, Campendonk seemingly has addressed himself to the idea of a harmonious union of man and animals in nature, a notion here reemphasized by the nudity of the larger of the two figures, a woman holding a flower bud in her left hand. Yet the birds are ready to fly off in different directions. The figures, suspended in a dream world that defies logical explanation, seem unaware of one another. Their physical proximity is not matched by psychological accord, while their enigmatic gazes, fixed upon the viewer, only reinforce their solitude and mystery.

Hand-colored woodcut, image 31.6 x 24.7 cm (12⁷⁄₁₆ x 9¾ in.), sheet 47.2 x 41.3 cm (18⁹⁄₁₆ x 16¼ in.)

Signed and inscribed in pencil, lower left: *Campendonk/vor der Auflage*

Founders Society Purchase, John S. Newberry, Jr., Bequest Fund (66.405)

Campredonk

LOVIS CORINTH

Lovis Corinth was not an Expressionist, but Expressionism is the link that binds his achievement to the modern period. His brilliant and copious work may indeed be said to join the academic tradition of the nineteenth century to the art of Nolde and the young Beckmann. The son of a prosperous tanner and farmer, Corinth was born July 21, 1858, in the small town of Tapiau in East Prussia. He began his training in 1876 at the academy in Königsberg and in 1880 became a pupil of Ludwig von Löfftz at the academy in Munich. From 1884 to 1887, while attending the Académie Julian in Paris, he studied with William Bouguereau and Tony Robert-Fleury. Except for a brief sojourn in Berlin during the winter of 1887/88, he spent the next four years in Königsberg, painting portraits and genre scenes as well as pictures with biblical motifs. His most ambitious work of this time, a life-size *Pietà* completed in 1889, was awarded an honorable mention at the Paris Salon in 1890 (this work, formerly in the Kaiser-Friedrich-Museum, Magdeburg, was destroyed in 1945). Corinth moved to

Munich in the fall of 1891. He joined the Munich Secession the following year and in 1893 became one of the founders of the Free Artists Association. In 1901 he settled permanently in Berlin, opening a private school for women painters. Together with Max Liebermann and Max Slevogt, Corinth soon dominated the Berlin Secession, becoming its president in 1915. He was made an honorary member of the academy in Munich in February 1925. On July 17, 1925, four days before his sixty-seventh birthday, Corinth died in a hotel room in Zandvoort, having fallen ill while traveling in the Netherlands to see paintings by Rembrandt and Frans Hals.

Corinth's early works conform closely to the late nineteenth-century academic tradition and are a measure of his long and rigorous training. But by the end of the 1890s he began to reveal an expressive energy that could no longer be contained within strictly academic conventions. The quick, sketchlike transcriptions of his visual perceptions in the following decade are indeed often called "impressionistic," though they have a far greater affinity with the dazzling brushwork of seventeenth-century masters such as Hals than with the intricate color orchestrations of Claude Monet, for example. It was above all through his audacious nudes and earthy portrayals of biblical and mythological subjects—expressed in his vigorous, even flamboyant manner—that Corinth came to be widely known.

On December 19, 1911, Corinth suffered a stroke that left him partially paralyzed. Although his condition eventually improved, he never fully recovered; his right hand continued to tremble for the rest of his life. Despite this handicap, the last fourteen years of Corinth's career were his most productive: he executed nearly 500 paintings and over 800 prints, as well as hundreds of drawings and watercolors—more than half of his entire oeuvre. During these years his art also changed in a fundamental way. Unable to recapture his former technical virtuosity, Corinth was forced to adopt a more generalized and expressive style that gave his art a profundity far removed from the anecdotal and descriptive character of his earlier works. Devoting himself increasingly to still life and landscape painting, he sublimated the vigor of his earlier figure compositions in magnificent evocations of nature, splendid in their amplitude, but rarely without a touch of pathos.

These pictures, as well as a series of remarkably moving late portraits, self-portraits, and prints, have secured for Corinth a place in the history of German Expressionism. He would doubtless have considered this a dubious honor, for he was strongly opposed to the Expressionists and spoke out repeatedly against what he considered their surrender to French Fauvism and faddish exploitation of the expressive character of primitive art. Indeed, despite the affinity of Corinth's late works with those by artists such as Nolde and Kokoschka, this final phase of the painter's development was not the result of a deliberate rejection of the conventional use of color and form. Corinth's "expressionism" is more accurately described as a *late* style, in which his art—like that of the aged Rembrandt, the artist he most admired—was transformed from an avowal of his sensory perceptions to an expression of deep feeling.

When the Nazis came to power, only Corinth's early works were tolerated, while all that he had done after his stroke was denounced. More than 200 of his pictures were removed from German museums, and seven were selected for special ridicule at the *Degenerate "Art"* exhibition in Munich in 1937.

STILL LIFE WITH LILACS 1917

Still Life with Lilacs demonstrates to what extent the tangible image, the felicitous rendering of which had preoccupied Corinth for so many years, had become by 1917 no more than a pretext for trying to reveal in the process of painting the inner meaning of a picture. Though seen from up close and painted life-size, neither the flowers nor the spatial setting of the still life were of interest to the artist. Dissolved in a torrent of brush strokes that follow a diagonal from the upper right to the lower left—a convention dictated by a tremor in the painter's right hand and evident in nearly all his late works—the subject can no longer be grasped in terms of its intrinsic texture and form. The entire surface of the canvas vibrates, producing an impression of restlessness and excitement that unifies the picture but does not allow the eye to focus on any specific detail. Light falls from the upper right upon the flowers, yet scarcely penetrates beyond the uppermost blossoms of the bouquet. Except for a few vivid touches of bright red, green, and white, the flowers remain shrouded in darkness, as shades of somber green and purple are enveloped by strokes of deep black. Behind the picture's blustering vigor, reminiscent of the energy that permeates the artist's earlier figure compositions and voluptuous nudes, one senses a profound disquietude and the awareness that decay embraces all living things. Prodigiously wasteful in their splendor, Corinth's lilacs seem consumed from within and —like the flowers of Nolde (p. 181)—become a metaphoric image into which the ailing painter projected the awareness of his own frail existence.

Oil on canvas, 55.2 x 45 cm (21¾ x 17¾ in.)
Signed and dated, upper center: *LOVIS CORINTH 1917*
Gift of Dr. and Mrs. Hermann Pinkus (76.159)

Lovis Corinth's watercolor *Pink Clouds, Walchensee* was done in the early morning hours of August 16, 1921, and bears a dedication to his wife, the painter Charlotte Berend, whom he called "Petermannchen," a name of endearment. Like most of his pictures of the Walchensee, Germany's largest and deepest Alpine lake, it was painted in the vicinity of the artist's vacation home high above the secluded hamlet of Urfeld at the northern end of the lake, from which Corinth enjoyed a superb view of the mountains beyond the far shore. *Pink Clouds*, dating from an especially felicitous summer, is one of several vibrant landscapes that might be called "impressionistic" were it not for the intensified colors and the vitality transfiguring each and every brush stroke—testifying to a personal involvement with the subject that elevates fact to poetry. Trees and branches frame a small mountain cottage overshadowed by a larch, behind which the fog-covered lake expands silently into the distance. Wooded hills at the southeastern shore give way to the austere slopes of the towering Wetterstein massif. Having saturated the water-soaked paper with delicate washes of yellow and pink, Corinth allowed small pools of burgundy-red to collect around the peaks of the mountains, and he defined the details of the setting only after the evocative ground had sufficiently dried. Vigorous strokes of a rich, velvety black alternate with flashes of cool green and yellow in the trees and branches, retaining the relief texture and glossy appearance of the watercolor paste wherever it was applied—like oil paint—directly from the tube. Similar blacks, modified now and then by admixtures of deep blue, slash across the hills in the distance and seep down from the sky in the upper right corner of the sheet.

Though Corinth continued to work from nature following his illness, visual observation was for him only a point of departure. He invested each motif with a subjective component, the strength of which is a direct measure of his emotional response to the image before him. His wife has described vividly the tension that Corinth experienced prior to beginning work on a given piece, the intensity with which he sought to translate his conception into pictorial form, and the physical and emotional exhaustion that followed upon its realization.[5]

Between the summer of 1918 and his death in 1925, Corinth painted the Walchensee during all seasons and at all times of the day. Ranging from sun-drenched views of the lake to lyrical nocturnes and disquieting winter scenes of near apocalyptic doom, these mountain landscapes, like his late still lifes, are metaphoric images that hold the viewer spellbound by the spectacle of a stupendous vitality in dissolution. *Pink Clouds*, expressive of a tranquil, indeed joyous, state of mind that allowed Corinth to achieve a harmonious equilibrium of feeling and fact, illustrates a happy moment in the evolution of his late style.

Watercolor, 36.2 x 51 cm (14¼ x 20¹⁄₁₆ in.)

Signed, dated, and inscribed in black ink: lower center, *LOVIS CORINTH*; lower left, *S/l Petermannchen Urfeld a/Walchensee 16 August 1921*

Bequest of Robert H. Tannahill (70.299)

OTTO DIX

Otto Dix is best known as a social critic. His work includes some of the strongest indictments of war and moral corruption in the entire history of art and is all the more terrifying for the unflinching verisimilitude with which he depicted even the most sordid manifestations of human suffering and vice. Born December 2, 1891, in the small Thuringian town of Untermhaus, near Gera, he began his career in 1905 as a painter and decorator and from 1910 to 1914 attended the School of Arts and Crafts in Dresden. His earliest works show a variety of styles, ranging from the meticulously descriptive manner with which he is most frequently associated to Impressionist and Post-Impressionist experiments with color and form. Between 1914 and 1919 he painted a series of pictures in which heightened Expressionist colors are combined with dynamic Futurist interpenetrations of form and space.

The horrors of World War I, which Dix experienced in the trenches of Flanders and France, radically affected his subsequent development. Like Beckmann and Grosz, he found war morally disgusting and from 1920 on began to channel his anger and disillusionment into shattering images of human cruelty and pain. His celebrated painting *Trench Warfare* of 1920–23 (formerly Staatliche Gemäldegalerie, Dresden; present location unknown) and the cycle of fifty etchings he published in 1924 under the title *War (Der Krieg)* are unequaled for their appallingly realistic images of death and decay. Between 1922 and 1927, while working in Düsseldorf and Berlin, Dix emerged as a mordant critic of contemporary society, painting

devastating character studies and deliberately shocking scenes of moral depravity. As in some of Grosz's satires of the late 1920s (p. 73), the beauty and brilliance of the colors in Dix's pictures, applied in thin glazes of tempera and oil to achieve a surface of impeccable smoothness reminiscent of late medieval panel painting, are strangely at variance with the ugly realities of what is represented, while the clinical precision of the artist's draftsmanship endows even the most repulsive details with a fascinating and hypnotic power.

Dix accepted a professorship at the academy in Dresden in 1927 and in 1931 was elected to membership in the Prussian Academy of Fine Arts in Berlin. Denouncing his art as unheroic and defeatist, the Nazis dismissed him from his teaching post two years later and voided his membership in the Prussian academy. From 1933 on Dix lived quietly on Lake Constance, first in Randegg, near Singen, and beginning in 1936, in Hemmenhofen. In the isolation of the Swabian countryside he made peace with society and devoted himself to the painting of romanticized landscapes. Rendered in his fastidious technique, many of these pictures show the influence of sixteenth-century German masters of the Danube School such as Albrecht Altdorfer and Lucas Cranach the Elder. After 1945 Dix abandoned his painstaking style in favor of a less controlled Expressionist manner, relying increasingly on large, bold, and decorative effects. Much honored and widely respected during the last years of his life, he died in Singen on July 25, 1969.

Dix's *Self-Portrait*, one of his earliest paintings, demonstrates fully the immaculate draftsmanship and attention to detail that lend a frightening sense of immediacy to his social commentaries and gruesome depictions of trench warfare in the 1920s and early 1930s. The astonishingly accurate differentiation of textures as varied as skin and hair, the flower, and the soft pile of the brown corduroy jacket reveals not only a striking feeling for the physical reality of things, but also a remarkable degree of discipline with respect to both observation and execution. Painted in 1912, while the twenty-one-year-old student was attending the School of Arts and Crafts in Dresden, the self-portrait testifies to the young painter's precocious and innate talent.

Dix arrived at his characteristic clarity of form and color by a technique analogous to that of late medieval painters: applying successive glazes of oil over a panel prepared with a gesso ground covered by a layer of tempera, he achieved a surface of enamel-like smoothness. Inspired by German and Netherlandish paintings of the fifteenth and sixteenth centuries, Dix's self-portrait is intentionally archaic in style and content. The staring eyes, turned to the artist's left, recall the attentive gaze in Albrecht Dürer's famous self-portraits in Paris and Madrid, while the carnation, held self-consciously close to the painter's chest, alludes to a familiar iconographic type, conveniently exemplified by Michael Wolgemut's *Portrait of a Young Man*, 1486, also in the collection of The Detroit Institute of Arts. It is possible that the carnation in Dix's hand refers to an amorous episode in the young painter's life. For although he did not marry until 1923, a carnation —or pink—held in this manner traditionally signified either the betrothal or marriage of the sitter. According to Flemish custom, a pink was worn by the bride on her wedding day, and the groom was expected to search for and find the flower.

It was from this tradition that the carnation derived its meaning as a symbol of love and faithfulness in portraits and double portraits of newlyweds or betrothed lovers.

Painted at the height of the Expressionist movement, Dix's picture may seem like a return to a traditional, naturalistic style, a reaction to the work of such champions of arbitrary color and simplified form as the artists of Der Blaue Reiter and Die Brücke. On the other hand, the portrait illustrates the same renewed interest in late medieval art that lies at the heart of the enthusiasm Expressionists such as Kirchner felt for fifteenth- and sixteenth-century German woodblocks and prints. Indeed, Dix's objectivity should be looked upon as an intensification of reality for psychological rather than illustrative purposes. The strained intensity and feeling of power barely held in check endow his features with the eloquence of a truly timeless type of Expressionism.

Incredibly, this perhaps most German of all modern portraits, formerly in the collection of the Kunstmuseum in Düsseldorf, was confiscated by the Nazis in 1937 as part of Hitler's efforts to "purify" German cultural life.

Oil and tempera on panel, 73.7 x 49.5 cm (29 x 19½ in.)
Signed and dated, upper left: *DIX 1912*
Gift of Robert H. Tannahill (51.65)

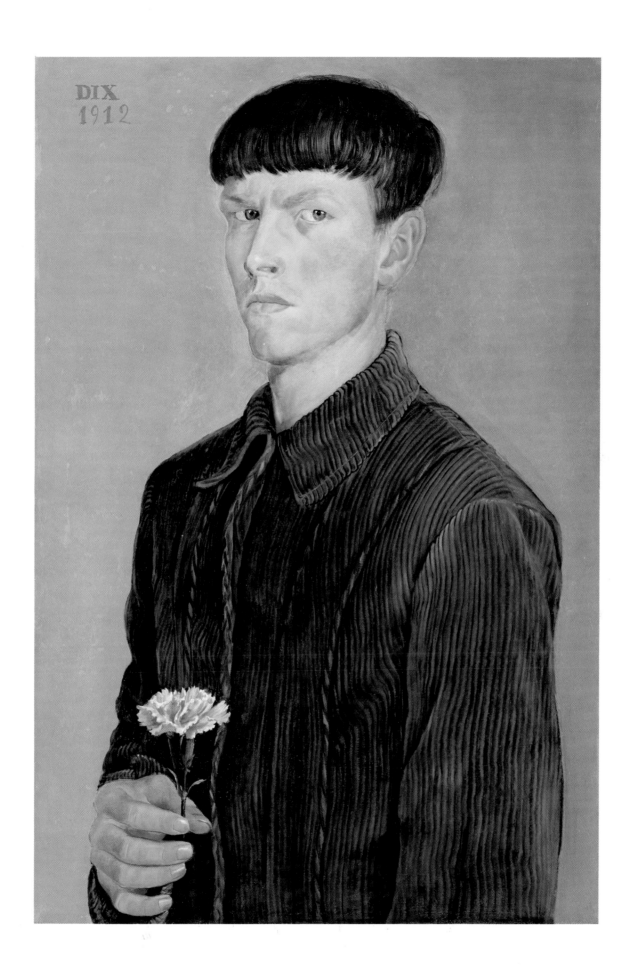

LYONEL FEININGER

Though a native New Yorker, Lyonel Feininger belongs more to the German than the American tradition of painting. He not only lived in Germany for nearly fifty years, but also specifically considered himself an Expressionist, defining painting as the formulation of the artist's innermost visions in a commensurate arrangement of color and form.

Feininger, the son of professional musicians of predominantly German descent, originally set out to become a violinist. Born July 17, 1871, he took lessons from his father at an early age and gave his first public recitals when he was twelve years old. In 1887 he was sent to Germany to complete his musical education. It seems, however, that the idea of becoming a violinist was not Feininger's but his father's, for he himself had always shown a far greater interest in drawing. While music was to remain a lifelong passion, once in Germany the sixteen-year-old gave up his plans for a musical career and obtained his parents' permission to enroll at the School of Arts and Crafts in Hamburg. He was admitted to the Prussian Academy of Fine Arts in Berlin in 1888 and in 1892 attended life classes at the Académie Colarossi in Paris. Abandoning a successful career as a social and political cartoonist for various Berlin newspapers and periodicals, Feininger began to paint in earnest in 1907.

In his earliest pictures Feininger was still a humorist. Only gradually did he adapt the bizarre distortions of the cartoonist to the fragmented forms of Cubism. Yet pictorial structure was for Feininger never an end in itself. His compositions are always pervaded by a gentle romantic spirit different from that of any other artist of his generation, with the possible exception of Marc. When Marc became

aware of Feininger's pictures, he invited him to exhibit with the members of Der Blaue Reiter at the First German Autumn Salon in Berlin in 1913.

Feininger lived in Germany throughout World War I. In 1919 he was one of several distinguished painters to be called to the Bauhaus in Weimar, where he became intimately associated with Kandinsky and Klee. He remained at the Bauhaus both in Dessau and Berlin, until the school was closed by the National Socialists in the spring of 1933.

In 1936, almost half a century after leaving New York to study abroad, Feininger returned for the first time to his native country, having accepted an invitation to teach a summer course at Mills College in Oakland, California. The following year,

finding life in Nazi Germany increasingly intolerable, he decided to settle permanently in the United States.

Virtually unknown in America, Feininger—then sixty-six years old—found the adjustment to his new environment difficult. He was not able to resume work on a regular basis until 1939. Living once again in New York, he occasionally turned to the skyscrapers of Manhattan for his subject matter, with a greater emphasis on color. But most of his late works are nostalgic recollections of his German themes: ships off the Baltic shore, old gabled houses, and the church of the small town of Gelmeroda in Thuringia, a motif that haunted him throughout his life. Feininger was elected president of the Federation of American Painters and Sculptors in 1947. He died in New York on January 13, 1956.

Ships fascinated Feininger at an early age. Growing up within walking distance of a busy harbor at a time when technological developments were rapidly changing traditional modes of transportation, he spent many a day by the Manhattan waterfront, spellbound by the spectacle of sloops, schooners, and more modern craft—using both sail and steam—making their way up and down the Hudson and the East rivers. At home he built model yachts and set them afloat on the pond in Central Park. Throughout his career, ships at sea remained a favorite motif.

Sidewheeler, 1913, is one of Feininger's seminal pictures, marking an early stage in the development of the Cubist-inspired architectonic style from which he was never to depart. As the faceted planes of subdued colors move across the canvas, they fracture and refracture, suspending the ship in fragile beams of light. It is as if the ship were growing outward, the way a crystal grows, giving definition to the surrounding space through a series of interpenetrating projections. *Sidewheeler* is less a representation of a ship at sea than of the interaction between the vessel and the forces of water and wind. Movement in space, made tangible, is the real subject of the painting.

Although the prismatic forms of *Sidewheeler* are related to Cubism, especially to the more dynamic Orphist pictures of Delaunay (fig. 4), Feininger always insisted on the difference between his Cubist paintings and those of the French. "Cubism," he wrote to a friend in 1913, "...may easily be degraded into mechanism.... My 'cubism'...is *visionary*, not physical."[6] In Feininger's hands, as in Marc's, Cubism became

a vehicle of expression rather than a means of analyzing form. This is no doubt one of the reasons why Feininger saw an affinity between the pictorial order of his compositions and the laws of music. Music, too, while based on strict rules, may be called "visionary" insofar as it appeals directly to the emotions. Feininger found his nature attuned to the dialectics of counterpoint, which to him epitomized clear laws of thinking. An ardent admirer of Dietrich Buxtehude and Johann Sebastian Bach, and a fine violinist and composer of fugues, he applied to painting such principles of fugal construction as inversion, overlapping, and repeats. But, as in music, the content of his work always transcends the rational order of the pictorial means. The pure and crystalline structure of *Sidewheeler* is a luminous metaphor for the same utopian state of harmonious being that Marc sought to make visible in the colored scaffoldings of his pictures of animals in nature (p. 157).

Oil on canvas, 81 x 100.7 cm (31¾ x 39⅝ in.)
Signed and dated, lower right: *Feininger 13*
City Appropriation (21.208)

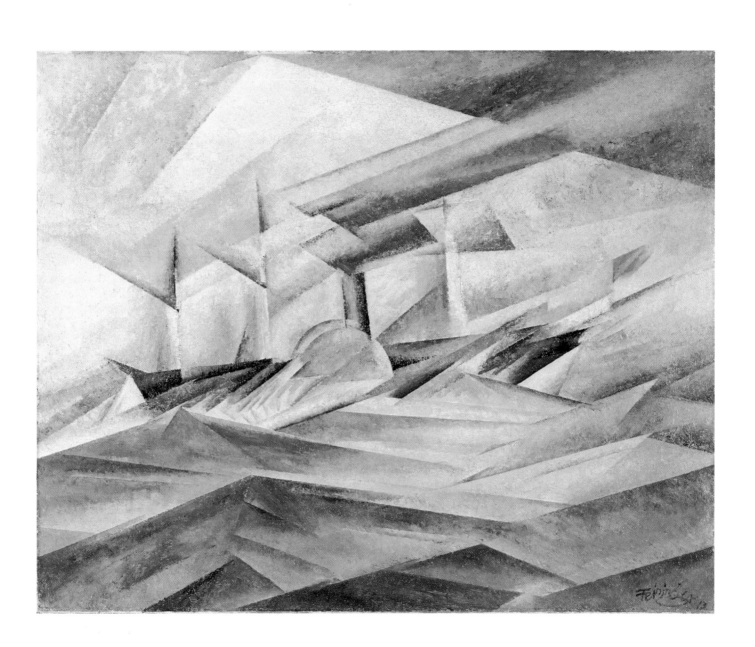

RUIN BY THE SEA I 1934

Feininger was as fascinated by the structural lines of medieval architecture as he was by the design of paddle steamers and the complex rigging of schooners and yachts. And like his luminous pictures of ships at sea—phantom vessels headed for unknown ports—his views of medieval houses and churches are pervaded by an air of mystery.

As was the case with Friedrich, the great early nineteenth-century German Romantic painter of Gothic ruins, medieval architecture became for Feininger both a metaphor for triumphant human aspiration (fig. 18) and a symbol of decay. In his watercolor *Ruin by the Sea I*, for instance, the remains of a church serve as a melancholy reminder of the ephemeral nature of human existence and man's impotence against the ravages of time. Dated July 17, 1934, this watercolor (the first of two of this subject done in that year) is based on a pen-and-ink drawing done six years earlier, when the painter, walking along a lonely beach near the Pomeranian village of Hoff, unexpectedly came upon the weathered ruin of a Gothic church, perched precariously atop a promontory overlooking the Baltic Sea. When he first discovered the desolate building, dating from the early fourteenth century, only the south wall and the choir were still standing, while the sea, pounding relentlessly against the bottom of the cliff, had long since eroded the farms which once surrounded the church. Feininger, who from 1924 to 1935 spent his summer vacations in the nearby town of Deep, returned often to the site, recording the view in numerous sketches, which subsequently served as departures for a series of austere and haunting watercolors and oils.

In contrast to the spontaneous character of his drawings of the ruin, all of which remain relatively faithful to nature, Feininger's watercolors and paintings of the subject demonstrate a metamorphosis from the real world to a premeditated pictorial order that blends fact with imagination. In the Detroit watercolor the sad remains of the building have been transposed into an ethereal delineation of form which, in its simplicity and clarity, borders on the abstract. The Gothic windows and buttresses, defined by neatly ruled lines over washes of brown and gray, surmount the precipice as if magically suspended in a single transparent plane. Spatial depth and atmosphere are not defined, and it seems as if the building itself has become an active force, imposing the very spirit of its structural laws upon the picture surface. The view is no longer conventional in the sense that the spectator can imagine entering the composition on the level of the foreground. Removed from the viewer's world, Feininger's lonely ruin, defying both gravity and palpability, rises as in a vision, accessible by spiritual, not physical, means.

Watercolor and pen and ink, image 23.7 x 37.1 cm (9$\frac{5}{16}$ x 14$\frac{5}{8}$ in.), sheet 30.2 x 47 cm (11$\frac{7}{8}$ x 18$\frac{1}{2}$ in.)

Signed, dated, and inscribed in black ink: lower left, *Feininger: Ruine am Meer I*; lower right, *17 7 34*

Julius H. Haass Fund (36.100)

Feininger · Ruine am Meer 3

GEORGE GROSZ

Best known for the drawings and watercolors he did in Berlin between 1914 and the late 1920s, George Grosz was a satirist whose pungent portrayals of vice, poverty, and moral corruption have come to be closely identified with German society in the pre-Nazi period. Born in Berlin on July 26, 1893, he attended the academy in Dresden from 1909 to 1911 and between 1912 and 1916 continued his studies at the School of Arts and Crafts in his native city. Grosz, a rebellious youth, developed a profound aversion to social conventions and even prior to 1914 expressed his disgust for society in lurid depictions of murder and rape. Military service during World War I reinforced his social hostility. As he wrote in a revealing letter of late 1915 or early 1916:

Day after day my hatred . . . is nourished afresh to hot flames by the impossibly ugly, unaesthetic, badly dressed Germans. From an aesthetic point of view, I am happy about every German who dies a hero's death on the field of honour. To be German means to be ill-mannered, stupid, ugly, fat, and to be the worst sort of reactionary —to be unwashed.[7]

Grosz was discharged from the army for medical reasons in 1917, and he began to explore the moral disintegration of German society during the last year of the war and the period immediately thereafter in searing caricatures of lecherous businessmen, arrogant officers, prostitutes, beggars, and war cripples. Emphasizing the coarseness of his characters with animal-like faces, he made no distinction between the guilty and the innocent. These works, many of them published in Communist periodicals, soon earned him an international reputation as a leading artist of the Left. Combining Futurist elements of simultaneous action with

deliberately crude draftsmanship inspired by children's art and graffiti, they betray the artist's contempt for traditional standards of drawing and may be considered a Dadaist rejection of conventional aesthetics. From 1917 to 1920 Grosz was a prominent member of the Berlin Dada movement and collaborated with John Heartfield on collages of photographs and drawings that are among the period's most mordant attacks on contemporary society.

Grosz continued his satires in the 1920s in a more naturalistic style characteristic of the clarity of form and detail that came to be known as *Neue Sachlichkeit.* In 1932 he accepted an appointment as guest lecturer at the Art Students League in New York. His life and career endangered by the rise of National Socialism, he settled in New York in 1933, teaching intermittently at the Art Students League and at his own art school.

After his arrival in the United States Grosz produced a series of works with New York as their subject. Seeking to expand his experience as an artist, he turned away from satire during these years and began to devote his creative energies increasingly to expressively neutral landscapes, still lifes, and nudes. During World War II his imagination once again took a pessimistic turn, giving rise to grotesque allegories of universal destruction and disaster. In May 1959 Grosz returned to Berlin with the intention of staying. Coming home in the early morning of July 6, and not very steady on his feet after a night out with old friends, he mistook a door and fell down a flight of cellar stairs. The bizarre circumstances of his death might have been an episode from one of his own bitter satires.

CONVERSATION c. 1928

Conversation was painted around 1928 in conjunction with a group of watercolors and drawings Grosz published two years later under the title *Love above All (Über alles die Liebe)*. Intended to illustrate, by juxtaposition, relationships among married and unmarried members of the middle class, these works are less gruesome than the artist's satires from the years immediately following World War I. While they have lost nothing of the sarcasm with which Grosz was wont to pillory the idle rich, their commentary is more cynical and detached.

In the Detroit watercolor a maid, or possibly a waitress, bends provocatively over a champagne cooler, while an elegantly dressed man and woman leer at each other, their predatory features beaming with smug self-esteem. The lecherous nature of human relationships, which Grosz usually liked to suggest by means of large buttocks, breasts, and lumpy genitalia pressing through the clothing of his figures, has here been somewhat understated, although the woman's dress, clinging tightly to her body, has been rendered virtually transparent. While the physiognomic exaggerations and the random patches of colored wash, in part independent of the figures, tend to diminish the naturalism of the whole, the meticulous contours and attention to certain details epitomize a trend toward visual clarity also found at this time in works by Beckmann (p. 41) and Dix (in marked contrast to the earlier, more abstract paintings and prints of the members of Die Brücke and Der Blaue Reiter). The soft and charming colors, shades of pink, yellow, and light blue, as well as the sensitive draftsmanship, are strangely at variance with the satirical content of the watercolor and bring to mind contemporary musicals by Kurt Weill and Bertolt Brecht such as *The Threepenny Opera* of 1928, in which cynical and obscene lyrics are sung to deceptively innocent, melodious tunes.

Oddly enough, Grosz, aiming his barb in *Conversation* at the rich bourgeoisie, had little real compassion for the downtrodden and the poor. His legless and blinded war veterans begging for alms in the streets are as repulsive as his arrogant officers, his laborers as depraved as his bloated prostitutes and pimps. Lacking the empathy that makes every print by Kollwitz an impassioned and poignant plea for social justice (p. 137), Grosz found the world irredeemably absurd and evil. A perceptive observation about his complicated character is found in a letter which his future wife wrote to a mutual friend in 1918: "George only knows extremes...and how right you are in saying that he exterminates systematically all human impulses within himself, and that he holds on to the evil in men only. What will become of him?"[8] The bitterness of Grosz's indictment of mankind was to remain his greatest emotional and artistic limitation.

Pen and ink and watercolor, 73.7 x 55.9 cm (29 x 22 in.)
Signed in black ink, lower right: *Grosz*
City Appropriation (30.380)

From the moment Grosz first arrived in New York in 1932, he loved the city. Indefatigably he explored the Bowery, Broadway, Wall Street, and the harbor, sketching buildings, billboards, gasoline stations, and all sorts of people, from wealthy dowagers on Fifth Avenue to ragpickers sleeping on benches in Union Square. He was fascinated by the city's ethnic diversity and made some of his most interesting character studies amidst the crowds in Central Park, the garment district, and Coney Island. Between 1933 and 1936 he translated his initial impressions of New York into a series of large watercolors. While in some there is still a hint of his old satirical attitude, these watercolors differ notably in both style and feeling from Grosz's German works of the late 1920s, reflecting a sympathetic curiosity about America, rather than a desire to judge.

As a boy Grosz had yearned to see America, and as early as 1916 had anglicized his first name, changing it officially from Georg to George, to express his enthusiasm for the United States. Satirizing America would have meant abandoning a cherished dream, for one can satirize only what one dislikes. Moreover, there was simply no large market in America for the kind of socially oriented art Grosz had produced in Germany, and his love for money and American-style success turned out to be much greater than his earlier lampooning of the rich and the powerful might lead one to suspect. "I have always aimed to get away from that mass," he wrote in 1933, referring contemptuously to what he called "the dungheap of small workmen and small people."[9] And in 1946 he confessed in a letter to a friend: "Only a sold picture is beautiful."[10]

Grosz's watercolor *New York* is evidence of his desire to redefine himself as an artist in America and exemplifies the emotional detachment characteristic of his work of the mid-1930s. While in the past he had cared little about the purely material qualities of his art, the rich harmony of firmly controlled washes of red, blue, and black betrays a new fascination for such traditional values as textural effects and varied rhythms of color and form. The scene depicted is not an actual view, but a composite image of many different impressions assembled from sketches made in several places and at different times. The kaleidoscopic arrangement of billboards, corniced tenements, and a church steeple, dwarfed by water towers and skyscrapers reaching fantastic heights, evokes the dynamic and ever-changing character of the modern American metropolis, but more in terms of a tourist's romanticized view of New York than a satirist's penetrating analysis.

Watercolor, 61 x 43 cm (24 x 17 in.)
Signed, dated, and annotated in black ink, lower right: *Grosz 34 N.Y.*
Gift of Mrs. Lillian Henkel Haass (34.162)

ERICH HECKEL

What distinguishes the art of Erich Heckel from that of the other members of Die Brücke is its lyricism and spiritual depth. Even in his most agitated and aggressive works, he preserved a sensitivity and reflectiveness that make it seem only natural that, as a youth, he should have contemplated becoming a poet.

Heckel, the son of a railroad construction engineer, was born July 31, 1883, in the small town of Döbeln in Saxony. In 1901, while attending the secondary school (Gymnasium) in nearby Chemnitz, he met Schmidt-Rottluff, who shared his interest in art and soon accompanied him on his painting and sketching excursions into the countryside. By 1904, when he enrolled at the Technische Hochschule in Dresden to study architecture, he had already painted landscapes of astonishing freshness and immediacy of expression. In 1905 Heckel and Schmidt-Rottluff—the latter having followed his friend to Dresden—together with two fellow students, Kirchner and Bleyl, founded Die Brücke. The thought of creating an artists' community probably stemmed from Heckel, whose idealism and faith in their association was to make him the most selfless and indefatigable champion of their cause. Even before Die Brücke formally disbanded in 1913, Heckel suffered keenly from the group's failure to overcome growing internal tensions.

Heckel, who after three semesters at the Technische Hochschule had taken a job as a draftsman in the architectural firm of Wilhelm Kreis in Dresden, did not devote himself fully to his art until 1907. His development between 1905 and 1909 was similar to that of the other members of Die Brücke. Starting from what was essentially a Post-Impressionist manner, reminiscent of late paintings

by Van Gogh, he gradually arrived at a more simplified pictorial structure characterized by large and brutal forms and solid areas of vivid colors. By 1912, in turn, Heckel's early Expressionism had indeed given way to disciplined and ascetic compositions of attenuated forms and less violent colors. A new spiritual attitude, manifest in a markedly introspective and melancholy mood, made itself felt at the same time in both his paintings and prints. Not until the early 1920s did his art become less emotive and psychologically stirring, as he turned to monumental and more naturalistic landscapes and figure compositions of great architectonic clarity and lyrical calm.

By the end of 1911 Heckel—like Schmidt-Rottluff and Kirchner—had moved to Berlin. Physically unfit for military service, he spent the war years as a volunteer medic with the Red Cross in Belgium. At the time of the "cleansing" of museums in Germany by the National Socialists in 1937, more than 700 of his works were confiscated. Thirteen were included in the *Degenerate "Art"* exhibition; many others were later destroyed. Like his friend Schmidt-Rottluff, Heckel was eventually forbidden to paint. When, in January 1944, his home and studio in Berlin were demolished by Allied bombs, he sought refuge in the small village of Hemmenhofen on Lake Constance. From 1949 to 1955 Heckel taught at the Academy of Fine Arts in Karlsruhe. He died January 27, 1970, in Hemmenhofen at the age of eighty-six.

In addition to their efforts to solicit members from the public at large (who, for a small fee, each year received a portfolio of original prints, a specially designed membership card, and an annual report which was also frequently illustrated), the most important activities of the artists of Die Brücke were their periodic exhibitions. During the early years of the association, it was usually Heckel who served as business manager in these matters. Not only was he the most practical of the group, but, through his work as a draftsman for the architectural firm of Wilhelm Kreis in Dresden from 1905 to 1907, he was able to establish useful contacts with local businessmen. He thus persuaded a suburban manufacturer of lampshades and lighting fixtures in Löbtau to turn over the showroom of his factory for the first Brücke exhibition in 1906. Although the event was advertised by a bold poster designed by Kirchner—Heckel's poster, apparently no longer extant, had been barred from public display by the Dresden police—a factory far from the center of town was hardly the place to attract many visitors. With the exception of a favorable review by Paul Fechter in the leading Dresden newspaper *Dresdner Neueste Nachrichten*, the exhibition was largely ignored. A second exhibition in Löbtau during the winter of 1906/07, devoted exclusively to graphics and including a group of woodcuts by Kandinsky, also failed to put the artists in touch with the public. Much more noteworthy—and, as it turned out, notorious—were the next three annual shows which were held at the fashionable but courageous Emil Richter Gallery on Dresden's elegant Prager Strasse where, in large and silent rooms, expensively furnished and smothered with lush carpets, the group's unconventional paintings and prints struck a foreseeably strident chord.

Unlike the nude that adorned Heckel's ill-fated poster for the first Brücke show in 1906, the one that he used to publicize the exhibition at Richter's gallery in 1908 was apparently inoffensive enough to pass the local censors. Printed in red on green paper, and a fine example of his evolving Expressionism, the aggressive poster was nonetheless certain to ruffle many a complacent Dresdener. The soft forms and flowing contours of his earlier woodcuts, which were still indebted to the decorative language of Jugendstil, have given way here to simplified and monumental shapes. Attacking the block boldly by gouging large sections out of the surface, Heckel left rough and splintered outlines and isolated slivers of wood to trap the ink in sharp-edged patches of color. The massive body of the nude, reclining beneath crude letters that form an integral part of the design, appears to have been brutally scourged.[11] Heckel, however, rarely limited his expression to the force of color and form alone, but sought to enhance his imagery with a spiritual content that was not tied to any given pictorial structure. Believing man's existence to be fundamentally tragic, he communicated his feelings in a direct and traditional manner through gesture and facial expression. The lassitude of the coarse body of the nude in this poster, as well as the woman's brooding gaze, convey a sense of physical and spiritual loneliness that adds a poignant plea for compassion to what otherwise would seem little more than a pugnacious banner of revolt.

Color woodcut, image 84.1 x 61 cm (33⅛ x 24 in.), sheet 94 x 63.5 cm (37 x 25 in.)
Signed and dated in pencil, lower right: *E Heckel 1908*
Gift of the Drawing and Print Club, Founders Society Detroit Institute of Arts (69.298)

When in the early 1900s people spoke of Berlin as an "art metropolis," what they had in mind were, above all, music and the stage. In 1910 the city had six opera houses and more than thirty theaters, ranging from the most bawdy variety hall to Max Reinhardt's innovative and prestigious Deutsches Theater. There were also the magnificent shows of the two circuses, Schumann and Busch, a plethora of cabarets, and dance acts of every conceivable kind. Isadora Duncan, Mary Wigman, and Loie Fuller had all taken the city by storm, as had the so-called Tiller Girls—the six Barrison sisters from England.

Both Kirchner and Heckel, upon moving to Berlin in 1911, developed a special fascination for the circus and the cabaret. Nothing, however, could be further removed from Kirchner's intoxicating and sensuous evocations of the nervous glitter and enticing wickedness of the city's night life than Heckel's lonely trapeze artists, dancers, and clowns who, as if in a trance and seemingly incapable of free action, move monotonously in a joyless and dispassionate world.

Heckel's delicate drypoint *Dance* was done in 1911, the beginning of a period of transition during which his early Expressionism, a forceful style of simplified lines and large colored planes, was beginning to undergo notable change in both content and form. His lines became pointed and sharp, his forms more attenuated, as contrasting areas of vivid colors gave way to subdued tonalities which set the general atmosphere of a given composition. At the same time, especially in works in which the human figure is the main subject, the empathy and compassion characteristic of Heckel's sensitive personality, feelings he had previously subordinated to his aggressive style, began to manifest themselves more strongly in an increasingly melancholy mood and in a seriousness that frequently borders on sorrow. Heckel's paintings and prints of clowns, acrobats, and dancers embody this spiritual attitude in a special way. Unlike Kirchner's *Smoker and Dancer* of 1912 (p. 99), a drawing in which the entire pictorial structure vibrates with excitement and energy, the stiff movements of Heckel's dancer in the Detroit etching are as oppressive as the cramped space of the barren cabaret stage is confining. Typically, the artist has emphasized the apathy of the audience by reducing the figures in the foreground to undifferentiated, anonymous silhouettes and concentrating all his attention on the performer, whose enlarged head and nostalgic expression carry an emotional content that reinforces the dancer's alienation and loneliness.

Drypoint, image 14 x 13.3 cm (5½ x 5¼ in.), sheet 35.3 x 25.2 cm (14 x 10⅛ in.)
Signed in pencil, lower right: *Erich Heckel*
Gift of John S. Newberry, Jr. (47.163)

Erich Heckel

Heckel's 1920 portrait of a seated woman epitomizes the mood of introspection and melancholy that pervades his paintings and prints of the preceding decade. It is the culmination of a series of works in which the artist tried to express the universality of human suffering through the evocation of physical and emotional anguish, desolation, and sorrow.

The picture was painted in Heckel's studio in Berlin, the slanting walls of which he had decorated with a panoramic landscape of stylized flowers and trees inhabited by male and female bathers whose nude bodies appear in the background of a number of his portraits, self-portraits, and still lifes. The model can be identified as the artist's wife Siddi, but, as his generic title for the picture confirms, Heckel was interested neither in the appearance nor the emotions of the specific individual, but sought to render a fundamental and universal state of human experience in a generalized and commensurately expressive form. Pressed into a small space, the tender figure embodies the very essence of loneliness. The touchingly composed hands—a traditional pose which, in such portraits as the *Mona Lisa*, conveys an air of intellectual superiority and calm—here accentuate the sitter's emotional vulnerability. The soft tonality of the painting, modulations of ocher and reddish brown accented sparingly by patches of cool blue, as well as the marked elongations and angular shapes of the composition, illustrate a further development of that spiritualization of the pictorial structure which characterizes Heckel's mature style. The individual forms are more pliable and soft than in his earlier pictures and indicate an emphasis on volume anticipating the objective quality that dominated his work beginning in the 1920s. The extended forehead of the sitter, signifying, as in medieval art,

the individual's spiritual life, reinforces the painting's expressive character. The heavy-lidded eyes, enormous in proportion to the other features, seem to gaze inward. Though physically close to the viewer, Heckel's woman is emotionally withdrawn, enveloped by an air of sadness. That her loneliness is not physical but, as in the case of many of Lehmbruck's statues (p. 145), spiritual in nature is suggested by the juxtaposition of the sitter's wakeful countenance with the face of the sleeping male nude in the wall painting behind her. This pairing of antithetical states of consciousness to underscore the spiritual isolation of the individual is a technique the painter frequently explored to augment the psychological dimension of his pictures.

Man always remained at the center of Heckel's art, and his most characteristic works are those paintings and prints which manifest his extraordinary empathy for the fundamental loneliness of human existence. To have enriched German Expressionism with so profound a conception of the human condition is his singular and most important achievement.

Oil on canvas, 80 x 70 cm (31½ x 27½ in.)
Signed, dated, and inscribed: lower left, *Erich Heckel 20*; verso, *1920 Erich Heckel*; on stretcher, *Erich Heckel Frau 1920*
City Appropriation (21.205)

CARL HOFER

Carl Hofer began his career painting an idyllic world of beauty and grace, until the bitter realities of life shattered his lofty vision, giving rise to haunting images of anxiety and mute despair. Born October 11, 1878, in Karlsruhe, he was trained at the academies of his native city and Stuttgart and spent five formative years in Rome between 1903 and 1908, evolving a monumental style epitomized by a series of male and female nudes, usually shown in a state of suspended animation alone or in pairs against a vast and indefinite landscape background. Inspired by the example of the German painter Marées who, nearly forty years earlier, had gone to Rome to recapture the timeless spirit of classical art (fig. 13), these paintings evoke a mythical world pervaded by a mood of calm and serenity.

From 1908 to 1913 Hofer lived in Paris, where he came into direct contact with various manifestations of modern art. Predisposed toward an art of formal balance, he found himself especially attracted to the structural logic of the late paintings and watercolors of Cézanne. While vacationing in France in the summer of 1914, Hofer was caught without warning by the outbreak of World War I. He was interned for three years as an enemy alien and released in an exchange of prisoners in 1917. The following year he settled permanently in Berlin.

Although he had been spared the horrid spectacle of trench warfare, an experience that radically affected the art of Beckmann, Grosz, and Dix,

among others, the war and its immediate aftermath had a profound impact on Hofer's development. Dismayed by the cultural regression of European civilization into a state of brutal barbarism, he abandoned the idealism of his earlier works in favor of a style marked by a new expressive power. From 1918 on, the compositional framework of his pictures became increasingly sparse. His colors grew somber and dry. His nudes groped through thorny, nocturnal forests or, as if to symbolize the madness of modern life, moved aimlessly through stark and spatially ambiguous interiors. Some managed to cling to each other timidly, while others sought in vain to overcome their isolation in a bleak and joyless world. Hofer tried periodically to escape from these dark visions into tranquil landscapes and still lifes, whose formal structures recall his earlier admiration for Cézanne. But his disillusionment was too deep to allow for a permanent change of expression.

In 1933 Hofer was dismissed by the Nazis from the teaching post he had held at the Berlin academy since 1920. More than 300 of his works were confiscated from German museums; some were included in the *Degenerate "Art"* exhibition in Munich in 1937. Allied air raids on Berlin in 1943 destroyed his studio and, with it, paintings, drawings, and prints from throughout his career. After World War II he was reinstated in his position at the Berlin academy. Over the last decade of his life he compulsively sought to re-create some of his lost paintings in an increasingly primitive and simplified style. He died in Berlin on April 3, 1955.

The special character of Hofer's Expressionism lies in the mood of melancholy and loneliness he communicated, often by means of figures embracing each other protectively, seeking to comfort one another through touchingly hesitant and awkward gestures. In *Wind*, awarded First Prize at the Carnegie International in Pittsburgh in 1938 and one of Hofer's most important paintings, the simplified, sculptural forms still bear traces of the artist's earlier lyrical classicism. Also classical is the ornamental treatment of the sharp-edged drapery folds enveloping the two women, whose heads, arms, and shoulders form an integral part of the compositional framework, built up in contrapuntal contrasts of slashing diagonals and sweeping curves. The harmony of the design, however, is contradicted by the anxiety mirrored on the faces of Hofer's heroines. The sensitive angularity of their limbs stresses the vulnerability of the figures, while their isolation is pictorially reinforced by the emphatic contours separating the group from the relatively uniform and simple background. The deliberately austere colors, chalky flesh tones dominated by cool shades of green and blue, enlivened in the lower part of the composition by hectic accents of reddish brown, contribute markedly to the painting's somber mood.

The theme of man exposed to the hostile elements of nature was treated by Hofer at least as early as 1911 in a picture titled *Stormy Sea* (Kunstmuseum, Winterthur). The anecdotal context of a brewing storm is quite explicit in this earlier picture, which shows four figures seated and standing by the edge of the sea, some nude, some clad in fluttering draperies. The elimination of all extraneous details, as well as the artist's emphasis on a plight far more spiritual than physical, elevate the subject in the Detroit work to a universality of meaning. Standing alone in a desolate world, Hofer's figures find consolation only within themselves and in their compassion for each other. Painted in 1937, on the eve of World War II, the picture seems prophetic of the anguish with which the painter was to watch the cataclysmic events that occurred in Germany and the rest of Europe during the next eight years.

Oil on canvas, 121.9 x 98.4 cm (48 x 38¾ in.)
Signed and dated, lower right: *CH37*
Gift of Mrs. George Kamperman in memory of her husband, Dr. George Kamperman (64.218)

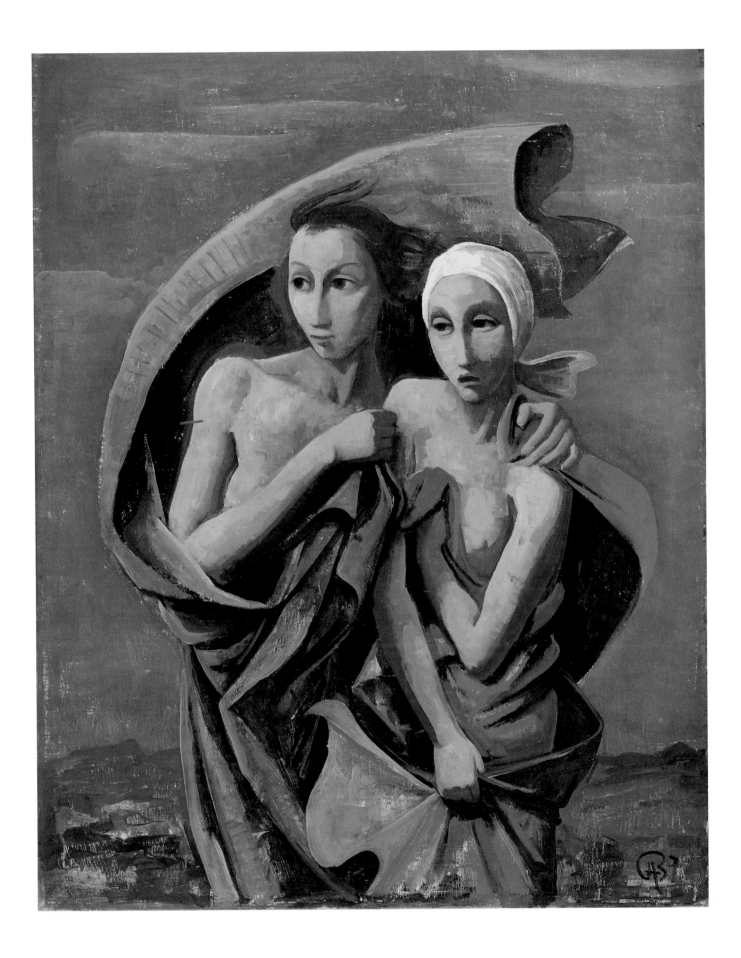

WASSILY KANDINSKY

Wassily Kandinsky's sensory perception was so acute that he believed he heard colors as if they were musical tones and saw music in terms of color impressions. He was fascinated by the idea, much discussed among psychologists at the turn of the century, that color can stimulate all the senses, that the sound of color is no less definite than its taste, touch, smell, or sight. Moreover, Kandinsky was convinced that seeing color, like listening to music, can be a profoundly moving experience and produce a spiritual resonance in the viewer. It was on the basis of this theory that he developed his concept of abstract painting, in which the artist's aim is no longer to reproduce nature but to arouse an emotional response in the beholder.

Kandinsky, who was born in Moscow on December 4, 1866, was nearly thirty by the time he decided to become a painter. As a child he had shown artistic inclinations, and his father, the well-to-do manager of a Russian tea firm, fostered his son's interests by providing private drawing lessons for him. Yet, an artistic vocation was evidently viewed as unconventional by Kandinsky's family, which may explain why in 1886 he enrolled at the University of Moscow to study law and economics. He passed his law examinations in 1892 and the following year accepted a position as instructor on the law faculty.

Several experiences between 1889 and 1895 were of crucial importance in Kandinsky's decision to become a painter. In 1889, while on an ethnographic expedition to the remote region of Vologda, he discovered Russian folk art. Stepping into the brightly colored interiors of local peasant houses, he had the impression of becoming part of a painting, an experience that taught him "not to look at a picture only from the outside, but to 'enter' it, to move around in it, and mingle with its very life."[12] The same year Kandinsky visited the Hermitage Museum in Saint Petersburg (now Leningrad), where he was especially moved by Rembrandt, before whose paintings he felt a spiritual vibration gradually taking hold of him. Both the concept of the inner life of a picture and the belief in its ability to awaken a sympathetic response in the viewer are the bases upon which Kandinsky's aesthetic rests. A large exhibition of French Impressionist paintings in Moscow in 1895 marked a turning point in the artist's career. Looking at one of Monet's famous *Haystacks*, he did not immediately recognize the subject, but noticed that the colors moved him deeply. It was this encounter which first led him to question the importance of the object as a necessary element in a painting and aroused his faith in the independent power of color. In 1896 he refused an appointment to the law faculty of the University of Dorpat and instead left for Munich to study art.

Early in 1897 Kandinsky enrolled in the private studio of Anton Azbé, where he met two fellow

Russians, Jawlensky and Werefkin. From 1900 to 1901 he attended the classes of Franz von Stuck at the Munich academy. He founded the Phalanx artists' association in 1901 and opened his own Phalanx school the following year. Among Kandinsky's first students was Münter, who remained his companion until his departure from Germany at the outbreak of World War I in 1914.

In 1909 Kandinsky helped establish the Neue Künstlervereinigung, an association of artists dedicated to bringing avant-garde exhibitions to Munich. The same year he and Münter acquired a house in Murnau, a small village in the Bavarian Alps; there Kandinsky painted some of his most engaging pictures, a series of brightly colored and rigorously simplified mountain landscapes which in their naiveté recall Russian folk art as well as Bavarian peasant paintings on glass. By 1911 color had become an increasingly independent element in Kandinsky's art. His freedom of expression, however, was not only misunderstood by the public and the critics but by some of his associates in the Neue Künstlervereinigung as well. As a result, along with Münter, the Austrian Kubin, and Marc, Kandinsky seceded from the association and made immediate preparations for the first exhibition of Der Blaue Reiter, which opened December 18, 1911, at the Thannhauser Gallery in Munich.

In 1912 Kandinsky published his two most influential writings on the psychological effects of color, his book *Concerning the Spiritual in Art* and the essay "On the Problem of Form" ("Über die Formfrage"), which appeared in the important yearbook *Der Blaue Reiter*. The years from 1910 to 1914 were Kandinsky's most productive. He divided the works from this period into "Impressions," usually Alpine landscapes which recorded images of nature; "Improvisations," pictures which were more spontaneous and casual without recourse to nature; and "Compositions," paintings which were more calculated and slowly arrived at on the basis of preliminary studies.

At the outbreak of World War I, Kandinsky returned to Russia, devoting most of his time to teaching and arts administration. But disillusioned by the increasingly hostile attitude of the Communist government to modern art, he returned to Germany in December 1921.

The following year Kandinsky went to Weimar to assume a teaching position at the Bauhaus. He joined Klee, Feininger, and Jawlensky in 1924 to form Die Blauen Vier (The Blue Four), a group which exhibited extensively in both Europe and the United States. In 1925 Kandinsky followed the Bauhaus to Dessau, and again when it moved to Berlin in 1932. When the school was finally closed by the Nazis in 1933, Kandinsky went to Paris and established a studio in nearby Neuilly, where he lived until his death on December 13, 1944.

PAINTING WITH WHITE FORM 1913

As early as 1895 Kandinsky recognized that the meaning of a painting depends not necessarily on objects copied from nature but rather on the pictorial elements of the work, its shapes, lines, colors, and planes. This does not mean that he looked upon color and form as sufficient in themselves. On the contrary, he considered them valid only insofar as they expressed the artist's feelings and elicited a commensurate emotional response from the viewer. Disillusioned by the materialism of the modern world, Kandinsky believed himself to be on the threshold of a new spiritual age, and he was convinced that only through the expression of his inner feelings could the artist convey his understanding of this new spiritual reality. But if art was to express the spirit, the artist was forced to sever his ties with the material forms of nature. Art had to be dematerialized. What aided Kandinsky in the development of such an art was his conviction that lines and shapes, no matter how geometrical and abstract, possess distinct spiritual properties which communicate themselves to the viewer. Colors, too, he believed capable not only of stimulating man's senses, but also of influencing his soul.

Despite his belief that the artist must create forms based on his feelings, Kandinsky found that the steps toward a painting that was entirely removed from nature were not easy ones. His pictures from 1910 to 1913, no matter how seemingly abstract, contain abbreviated signs of recognizable images that did not disappear from his work until after 1914. *Painting with White Form*, a study done in 1913 for a somewhat larger and more abstract picture of the same year (The Solomon R. Guggenheim Museum, New York), demonstrates how Kandinsky gradually moved away from nature in order to create a language of pure color and form. The painting in Detroit can be divided vertically down the center into what might be called a "spiritual" side on the left and a "material" one on the right. The soaring arches of variegated shades of green, yellow, brown, and red on the right can still be perceived as hills and recall Kandinsky's picturesque Murnau landscapes. The buildings, precariously perched on the "hilltop" in the upper right, echo the cupolas of the painter's native Moscow as well as the pilgrimage churches in the Bavarian countryside. A group of agitated lines at the lower right, coalescing into a hieroglyphic configuration that seemingly leaps toward the left side of the composition, represents Kandinsky's famous "Blue Rider," the mounted horseman he first painted in about 1901 (fig. 5). Kandinsky's most persistent motif, recurring in abstracted form in many of his early pictures, the rider has been interpreted as both a lyrical image of joy and the release of energy and a symbol of inspired human endeavor. Whatever autobiographical meaning the motif may have had for him, Kandinsky no doubt also looked upon the horseman as a metaphor for the spiritual in art. In the Detroit picture the rider is in the process of leaving that part of the composition which is still rooted in nature, that is to say, the "material" world, taking a mighty leap forward into a realm where the last vestiges of illusionism have been discarded for harmonies of pure color and form that call to mind music, the only art prior to Kandinsky's that did not rely on references to the outside world. It is surely no coincidence that the horseman departs from a black cliff and is greeted by a heavenly blue which, according to Kandinsky, fills man with a yearning for redemption, while high above a column of earthly yellow floats the shape in white, symbolizing a world void of all material things.

Whereas Expressionist painters such as Kirchner (p. 103) continued to use images of nature to communicate their heightened awareness of the world around them, Kandinsky sought to make visible the vibrations of his inner self through pure color and form. He was convinced that communication can take place on a subliminal level, and that a work of art has an autonomous life capable of creating its own spiritual atmosphere. The true content of Kandinsky's picture, therefore, is what the viewer ultimately experiences under the impact of the interaction of its colors and forms.

Oil on canvas, 99.7 × 88.3 cm (39¼ × 34¾ in.)
Signed and dated, lower left: *KANDINSKY 1913*
Gift of Mrs. Ferdinand Moeller (57.234)

MAX KAUS

Max Kaus was one of many German painters who in the years immediately before and just after World War I came under the influence of Die Brücke. He was born in Berlin on March 11, 1891, and from 1908 to 1913 attended the School of Arts and Crafts in Berlin-Charlottenburg, where he was trained as a painter-decorator. It was not until 1914, during a visit to Paris interrupted by the outbreak of the war, that he decided to become an artist. During his wartime service as a hospital orderly in Belgium from 1915 to 1918, he met Heckel, as well as Anton Kerschbaumer and Otto Herbig, both of whom had studied briefly with Corinth. Though Kaus's earliest prints date from 1916, his first and most characteristic paintings—portraits, self-portraits, and figures in interiors permeated by a melancholy mood reminiscent of works by Heckel—were done after the war. A series of decorative landscapes with bathers and nudes, completed between 1921 and 1924, recalls, in the measured movements of the elongated figures, the elegiac pastorals of Mueller.

Between 1926 and 1938 Kaus taught at two of Berlin's leading art schools, first at the Meisterschule für das Kunsthandwerk and, from 1935

on, at the Vereinigte Staatsschulen. His sensitive pictures of alienated and lonely figures found no favor among Hitler's taste-makers, who used art as a means of propaganda to promote the image of a conformist, productive, and harmonious society. Kaus's paintings were removed from public view in 1937, a prelude to his dismissal from the Vereinigte Staatsschulen the following year. The artist's home and studio, as well as more than 200 of his paintings and many drawings and prints, were destroyed by Allied bombs in 1943. In 1945, two days before the end of World War II, Russian artillery fire demolished what was left of his graphic work. In July of that year the painter accepted an appointment at the academy in Berlin, where he taught until his retirement in 1968.

After 1945 Kaus's art lost much of its expressive force. While still rooted in nature and occasionally recapturing the melancholy mood so characteristic of his work done between 1918 and the 1930s, form began to dominate content as his paintings became increasingly more stylized and abstract. Kaus was eighty-six years old when he died in Berlin on August 5, 1977.

MAN IN A FUR COAT c. 1918

The occupants of Kaus's sparse interiors seem to be enveloped in thoughts they cannot communicate. Some gaze fixedly into a void as if haunted by the specter of an unfathomable fate; others seek to hide their frailty beneath heavy-lidded, lowered eyes. Even when they are engaged in simple tasks—sewing or writing a letter—the poignant absorption with which each activity is performed serves to emphasize the fragility of the sitter's quiet world. Kaus shared this empathy with the loneliness of modern man with Heckel, whose melancholy figures project a similar attitude of emotional withdrawal (p. 83).

Man in a Fur Coat, possibly a self-portrait done about 1918, is an early work which illustrates the essential qualities of Kaus's art. The setting, in its deliberate and selective structure and pictorial simplicity, recalls the lucid interiors of Jan Vermeer, the seventeenth-century Dutch master from Delft, whom Kaus is known to have admired greatly. Nothing in the composition remains accidental or unrelated; the judicious relationship of rectangular and rounded forms and broad planes of dark blue, brown, and gray enlivened by patches of orange and yellow, results in an equilibrium that contributes much to the painting's introspective mood. Into this tidily ordered world, the sitter, dressed in a heavy orange-brown coat, the green collar of which casts a sallow glow over his brooding face, brings a disquieting note.

To the Expressionists the description of things and the problems of the individual were less important than the evocation of a universal experience, and the physical appearance of the individual mattered less than his humanity. Painted in the aftermath of World War I, when the meaning of human existence was foremost in the minds of many, Kaus's picture is rooted in this universalist point of view. Hemmed in by intangible forces, the sitter is like a wanderer who finds himself in a world he cannot call his own; his alienation is reinforced by the juxtaposition of his wistful features with the open space suggested beyond the parted curtains behind him. Standing close to the picture surface, he averts his gaze and shrinks into the fur of his coat as if to conceal his thoughts from prying eyes.

Oil on canvas, 75 x 65.4 cm (29½ x 25¾ in.)
Signed, lower left: *MKaus*
Gift of Julius Oppenheimer (30.291)

ERNST LUDWIG KIRCHNER

Ernst Ludwig Kirchner began his career as a realist, seeking to give pictorial expression to contemporary life. But sketching in streets and cafés quickly taught him that faithfulness to nature could not adequately express his intentions. In fact, the speed with which he worked necessarily led to calligraphic abstractions that seemed to evoke a figure or movement more eloquently than a careful and deliberate rendering. Encouraged by his discovery of similar traits in late medieval prints and carvings from Africa and the South Sea Islands (fig. 15), he gradually developed a pictorial language of highly simplified forms and bold colors. Kirchner also shared the typical Expressionist longing for a primordial state of existence, a quest that manifested itself in his pictures of nudes moving freely in intimate union with nature and, especially after his withdrawal to the lonely mountains of Switzerland, in landscape paintings of epic breadth.

Kirchner was born May 6, 1880, in the old Franconian town of Aschaffenburg. During his childhood his family moved often, settling in 1890 in Chemnitz, where the boy's father, a chemical engineer, was appointed professor for paper research at the Crafts Academy. Kirchner drew and painted early, but not until 1898, following a school trip to Nuremberg, where he saw prints by Dürer and other German old masters as well as original fifteenth-century woodblocks and copperplates, did

he determine to become an artist. It was only in obedience to his father's wishes that he enrolled in 1901 at the Technische Hochschule in Dresden to prepare for a career in architecture. After passing the preliminary examinations for his diploma in April 1903, he spent the winter and summer semesters of 1903–04 in Munich, taking drawing lessons at the academy and attending classes at the Teaching and Experimental Studio for Applied and Fine Art, the school operated by the leading pioneers of Jugendstil, Debschitz and Obrist. Although Kirchner resumed his architectural studies in Dresden in July 1905, satisfying his parents' aspirations was no longer his concern. In the second half of 1905, together with Bleyl, Heckel, and Schmidt-Rottluff, three architecture students who shared his interests, Kirchner founded Die Brücke, the first and best-organized group of artists of the twentieth century. Kirchner's ardent personality and professional fine arts training made him the natural leader of the group for several years.

Kirchner's early works betray such diverse sources as neo-Impressionism, Post-Impressionism, and Jugendstil (fig. 1). Not until 1912, following his move to Berlin, did he develop the personal language of nervous and agitated forms that has come to be recognized as his most typically Expressionist style (pp. 99, 101; fig. 12). Shortly after his arrival in Berlin, he also met Erna Schilling, who became his lifelong friend and common-law wife. With the outbreak of World War I, the painter reported reluctantly for service. Intelligent, sensitive, and highly self-centered, no greater misfit had ever joined the military ranks. A complete physical and mental breakdown, partly premeditated and self-induced, so it seems, terminated his training as an

artillery driver in Halle in 1915. After a stay at a sanatorium in Königstein near Frankfurt and subsequent treatment in Berlin, Kirchner left for Switzerland, seeking further medical care in Davos. In February 1917, back in Berlin, he was struck by an automobile, and from September on, suffering from partial paralysis and a morbid state of mind, Kirchner was a patient in a hospital at Kreuzlingen on Lake Constance. In July 1918, well enough to leave, he returned to Switzerland where he later rented a farmhouse on the Längematte near Frauenkirch, just south of Davos.

It was here, "In den Lärchen" ("Among the Larch Trees"), as the little house was called, that his convulsive style gave way to a more calm and lyrical form of Expressionism (p. 103). In the autumn of 1923 Kirchner and Schilling moved to nearby Wildboden where, under the influence of postwar formalist trends, he began to subject his art to the pictorial laws of Synthetic Cubism (p. 105). His health fully restored, he made a renewed commitment to the mainstream of modern European painting and participated actively in the cultural life of both Germany and Switzerland. In 1924 he expressed interest in the linear abstractions of Klee; and following a visit to an exhibition of modern art in Zurich in 1925, he reserved his highest praise

not for his old Expressionist friends Nolde and Schmidt-Rottluff, whose works were also represented, but for Picasso and Braque. From the time of his own first exhibition at the Kunsthalle in Basel in 1923, many Swiss artists began to turn to Kirchner for inspiration and leadership, resulting in the formation of Die Rot-Blau Gruppe (The Red-Blue Group) in 1926. Kirchner now became an important influence on the evolution of modern Swiss painting. Following the tensions of the preceding decade, these years were a period of maturity and reflection, allowing the painter, now in his forties, to create lyrical abstractions of remarkable calm (p. 107). In 1936 Kirchner's style changed once again, as the painter returned to the more representational idiom of his "Lärchen" years in a series of majestic mountain landscapes.

Except for frequent visits to Germany, Kirchner remained in Switzerland until his death. He was elected to membership in the Prussian academy in Berlin in 1931. By 1933 his paintings could be found in every major German museum. His first American retrospective exhibition was held at The Detroit Institute of Arts in January 1937. Only weeks later, the Nazis confiscated from German public collections 639 of his works, thirty-two of which were included in the *Degenerate "Art"* exhibition in Munich that summer. Kirchner suffered immensely from the systematic destruction of his reputation in his native country. Ill and increasingly fearful of yet another war, he took his own life on June 15, 1938, in Frauenkirch.

Kirchner considered his drawings the purest and finest part of his work, since they reflected to a far greater extent than his paintings and prints his initial, spontaneous response to the world. Through drawing, especially rapid sketches from life, he first developed linear abstractions that embody rather than describe the meaning of a given image. Writing about his drawings in 1920 under the pseudonym "L. de Marsalle," Kirchner called these abstractions "hieroglyphs."[13] All his ideas as a painter, graphic artist, and sculptor originated from this symbolic language of form.

Smoker and Dancer is an outstanding example of Kirchner's ability to report a sensation swiftly and to translate his impressions into a pictorial equivalent. Slashing diagonals, their rhythm accelerating to a nervous flutter in the dancer's hands, combine with sweeping curves to convey the very idea of vigorous motion. The rapidly diminished scale of the smoker reclining on the couch in the background energizes the limited space, as does the dancer's forceful stride, barely to be contained within the disproportionately small dimensions of the setting. By adjusting the height of the dancer to the size of the paper, Kirchner achieved an equilibrium of image and ground that transforms the pictorial elements of the composition into one unified hieroglyph of considerable vitality. As he himself put it: "The images are not in themselves representations of definite objects; their significance lies in their placement, their size, and their relationship to each other on the page."[14]

Throughout his career Kirchner was fascinated by the image of the naked figure in movement. He drew and painted female nudes in various positions, physically and symbolically united, in interiors and out-of-doors. *Smoker and Dancer*, in particular, is one of the many frank depictions of bohemian life that are characteristic of the artist's Brücke years. The drawing also illustrates the emergence of Kirchner's mature and most typically Expressionist style. For it was not until 1912, after he had moved to Berlin, that, spellbound by the excitement of big-city life, he developed a pictorial language of pointed, angular forms and slashing, repetitive lines with which to render the glitter, speed, and tension of the modern metropolis. Kirchner's pictures of Berlin brothels, nightclubs, and street scenes (fig. 12), compositions that pulsate—like the Detroit drawing—with nervously animated rhythms, have long been recognized as a highpoint of German Expressionism.

Graphite and black crayon on wove paper, 56.1 x 36.8 cm (22¹⁄₁₆ x 14½ in.)

Signed, dated, and inscribed in pencil: lower right, *E L Kirchner*; verso, *Raucher und Tänzerin 1912*

Founders Society Purchase, John S. Newberry, Jr., Bequest Fund (67.270)

Nearly half of Kirchner's paintings of 1912 and 1913 were devoted to subjects on Fehmarn, a large island in the Baltic Sea, just off the coast of Schleswig. It was here, in a remote and primitive environment, that he experienced for the first time a sense of artistic fulfillment, painting pictures which in his own view demonstrated his "absolute maturity."[15] Most of the paintings of Fehmarn were done during the summer months Kirchner and Schilling spent on the island. Others were completed, perhaps even begun, after the painter's return to his studio in Berlin. Besides landscapes, they include such typical nineteenth-century Romantic subjects as interiors with a view through an open window and seascapes with storm-tossed boats. Many paintings of male and female nudes, under trees, on the beach, and in the sea, express the typically Expressionist yearning for a primitive state of being through man's intimate union with nature.

The subjective distortion of color and form in *Coastal Landscape on Fehmarn* is based on a formula which Kirchner developed during the summer of 1912. At that time he had begun to mute with white his formerly brilliant colors. In the Detroit picture the triad of secondary hues—pale blue, pink, and green—has been grayed in this manner. The vibrant brush strokes of reddish brown animating the shrubs in the foreground are related to the dynamic calligraphy which

Kirchner had first used in an effort to create a formal vocabulary appropriate to his Berlin subjects (fig. 12). Most remarkable is the way in which the artist employed distortions in order to intensify the viewer's awareness of pictorial space. Assuming a vantage point in the lower center of the composition, he counteracted the concave rhythm of the shoreline by the altogether arbitrary arc that spans the weeds and grasses in the foreground, launching a spatial thrust that reverberates in the equally emphatic curvature of the horizon.

Like the German Romantic landscapist Friedrich (fig. 14), and through comparably simple means, Kirchner succeeded in transporting the viewer's consciousness into a space so vast that it has become nearly impossible to relate to it logically. Moreover, his conception of space in this as well as in several other landscapes of Fehmarn parallels that of Friedrich's friend Karl Gustav Carus, who, in his *Neun Briefe über Landschaftsmalerei (Nine Letters on Landscape Painting)*, written between 1815 and 1824, rejected the faithful rendering of a given place as incomplete. Instead, he favored a picture in which the artist intensified nature, so as to bring out the fact that landscape is a microcosm in its own right. Carus, who proposed the word *Erdlebenbild*—the image of the life forces of the earth—for this sort of landscape, felt that such a painting had a transcendental effect on the viewer.

Oil on canvas, 90.2 x 120.7 cm (35½ x 47½ in.)
City Appropriation (21.204)

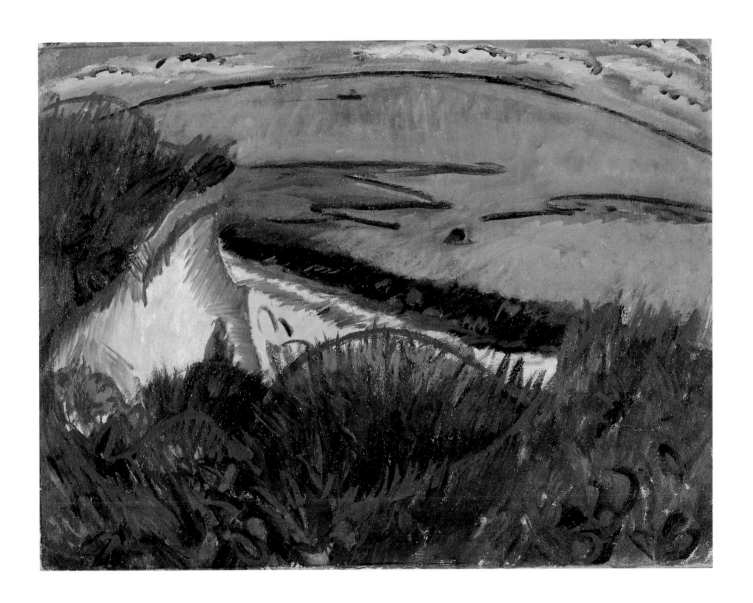

Kirchner's *Winter Landscape in Moonlight* is actually an image of dawn, in which the moon—growing pale in the bright orange-red sky—is still visible. That the idea for the painting in fact originated in the early morning hours of January 20, 1919, is documented by letters that Kirchner wrote later that day. Secure in the peaceful world of his mountain retreat, he expressed his gratitude for being spared the necessity of having to witness the political upheaval and mad whirl of postwar Berlin:

People are half mad there. Amidst machine-gun fire and invasions they are partying and dancing. . . . while here there was such a wonderful moonset early this morning: the yellow moon on small pink clouds and the mountains a pure deep blue, completely magnificent. I would have so gladly painted it. But cold it was, even my windows were frozen though I had a fire all night. Yet how eternally happy I am to be here, and to receive only the last splashes of the waves of outside life through the mail.[16]

Painted at his Alpine farmhouse "In den Lärchen," Kirchner's winter landscape is indeed no less than a joyous surrender to the restorative powers of nature. Man and his creations lie hushed and insignificant beneath the blue, snow-covered mountains rising toward the brilliantly illuminated sky, where bright ocher clouds crystallize in the frosty air. Only the larch trees, their branches bent beneath layers of snow that have turned pink in the cold morning light, appear to rouse themselves to greet yet another day.

The picture is one of several large mountain landscapes that Kirchner began during the winter of 1918/19 when, after months of illness and depression, he had finally achieved a new sense of calm and serenity. Though dependent on a style first developed in 1912, the individual forms in the Detroit painting have greater amplitude and are unified in large rhythms that surge with a feeling of renewed strength. The juxtaposition of the three primary hues, red, yellow, and blue, is invigorating and bold. During this period of relative isolation, Kirchner turned away from agitated renderings of contemporary life (fig. 12) toward a form of representation characterized by an intensified concern for the poetic and epic.

Kirchner's Expressionism, as manifest in his "Lärchen" landscapes, is the result of a new relationship between the artist and his environment. Late in 1917 he had already expressed the desire to render the intangible reality that lies beneath all phenomena in nature. The artist's changing attitude toward subject matter, as something distilled and dematerialized, is epitomized in a letter he wrote at that time to Eberhard Grisebach:

The great mystery which lies behind all events and objects of the environment sometimes becomes schematically visible or sensible when we talk with a person, stand in a landscape, or when flowers or objects suddenly speak to us. We can never give it concrete verbal expression, we can only express it symbolically in forms or words.[17]

Kirchner's *Winter Landscape in Moonlight* once belonged to the Kaiser-Friedrich-Museum in Magdeburg. It was confiscated by the Nazis in 1937 as "degenerate."

Oil on canvas, 120.7 x 120.7 cm (47½ x 47½ in.)
Signed, lower right: *E. L. Kirchner*
Gift of Curt Valentin in memory of the artist on the occasion of Dr. William R. Valentiner's 60th birthday (40.58)

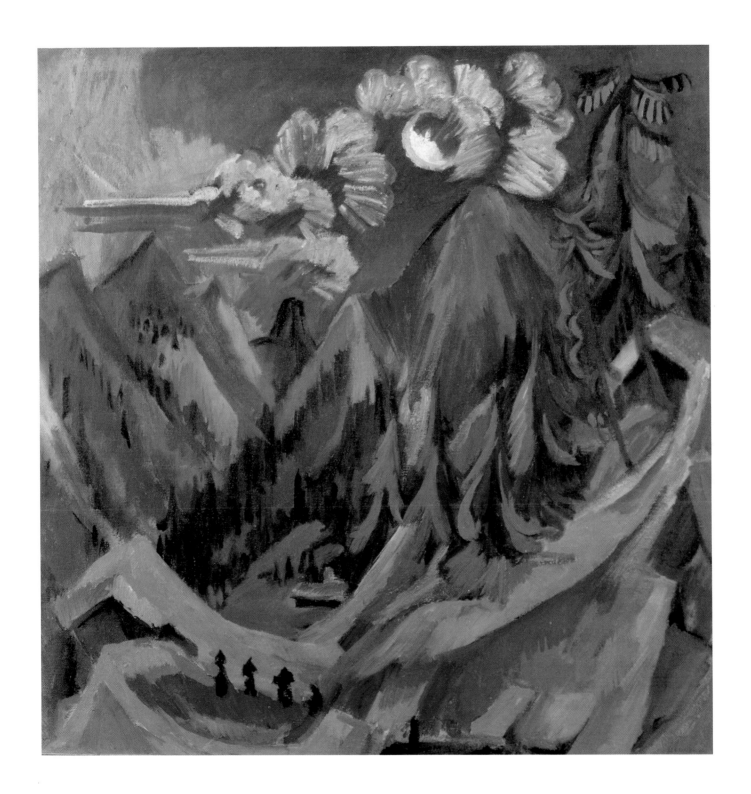

Kirchner's *Café* is one of several urban subjects inspired by a visit to Germany during the winter of 1925/26. The painting was done from memory at Wildboden and illustrates to what extent the painter, by the late 1920s, was seeking to accommodate his art to postwar formalist trends. *Café* is not an example of German Expressionism but belongs to the broad international stream of Synthetic Cubism. The picture's architectonic structure is emphatically underscored by the reinforced vertical axis of the canvas. The unmodulated color planes are uncompromisingly flat, and broad bands of color around the profile heads of the four walking figures further strengthen the two-dimensional effect of the design. Certain forms and colors, moreover—such as the triangular shape of bright pink in the upper right and the repetitive stripes of blue and green in the lower left and pink and orange above the two seated figures, respectively—seem to have no representational function at all. Several other color planes, especially noticeable in the two women in the upper left and the seated one facing the viewer across the café table, have been divested of their shape-enclosing outlines, permitting areas used to define the dress of one woman to infiltrate the costume of the adjacent figure.

What distinguishes Kirchner's work at Wildboden in the 1920s is precisely this emphasis on the aesthetic rather than the expressive features of his art. During the winter of 1923/24, the late Expressionism of his "Lärchen" paintings had already begun to give way to a noticeably decorative phase, culminating in a series of sumptuously painted compositions reminiscent of contemporary works by Matisse. At about the same time Kirchner also began to work closely with the Swiss weaver Lise Gujer, who transposed a number of his compositions into tapestries and whose collaboration was doubtless an important factor in the evolution of the painter's post-Expressionist style.

Oil on canvas, 80 x 70 cm (31½ x 27½ in.)

Signed, dated, and inscribed: lower left, *E L Kirchner*; verso, *E L Kirchner 28/Café 28*

Gift of Mr. and Mrs. A. D. Wilkinson (59.450)

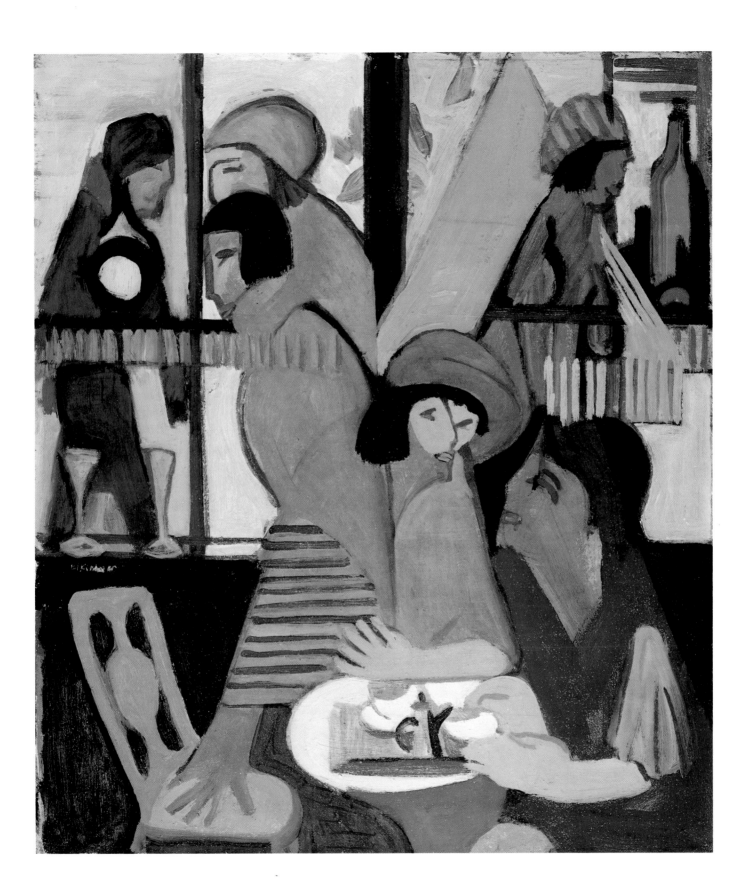

Kirchner's abstract style culminated in works executed between 1930 and 1935. In figure compositions, interiors, and landscapes, as well as in many paintings and drawings done in connection with a series of wall and ceiling decorations intended for the festival hall of the Museum Folkwang in Essen, a project which had to be abandoned in 1933 under Nazi pressure, he continued to strive for architectonic clarity and carefully balanced patterns of color planes that stress the two-dimensional integrity of the design. A completely nonobjective art, however, was impossible for him, as is documented by a letter to the critic Will Grohmann on July 8, 1925, in which Kirchner spoke of the nonobjective artist as one who

without ever touching on natural forms, has to invent forms; they can only arise from his mind. . . . To be deciphered, these pictures . . . require a key which the artist or the art scholar must supply. . . . But is this a development worth striving for? Could not art in this way cease to be art, and become simply a school discipline like geometry and algebra?[18]

Kirchner's *Mountain Lake* is a blend of abstraction and representation that allows the viewer ample opportunity for empathy. The repetition of broad bands of watercolor wash reinforces the flatness of the composition and arrests whatever spatial thrust is implied by the diminishing scale of the mountains. Their flat silhouettes, in turn, have been carefully woven into the pictorial fabric by means of methodically applied horizontal striations in dark green and the near-identical cloud formations that shroud their tops. Although a wavy pattern of pink and light green animates the cloudy sky and introduces a modicum of atmospheric depth into the landscape, the austerity of the design remains unmitigated by the delicacy of the colors, ranging from light blue in the foreground to light green and pink in the middle and far distance, respectively. On the contrary, the diaphanous washes accentuate the remote and imaginary character of the setting insofar as they dematerialize even further the ethereal references to the real world that remain.

Kirchner's watercolor illustrates that although the artist had left behind the excitement of his Fehmarn and "Lärchen" landscapes to express himself in a more calm and epic form, he nonetheless remained true to the conception of his art he had formed nearly thirty years before. For *Mountain Lake*, with its abbreviated natural forms, conveys its meaning through a symbolic language that Kirchner hoped would forge a link between external nature and personal feeling. A great stillness descends over the lake, and the austere and simple forms give rise to a hushed and meditative mood. Through the presence of the isolated figure of the oarsman, seen from behind and held firmly in place by the architectonic composition, as in many a picture by the Romantic landscape painter Friedrich (fig. 14), the viewer can project his consciousness into the overpowering vastness of nature and empathize with man's essential loneliness.

Watercolor over graphite, 36.8 x 50.5 cm (14¹⁄₁₆ x 19⅞ in.)
Signed in pencil, lower left: *E L Kirchner*
Gift of John S. Newberry, Jr. (45.458)

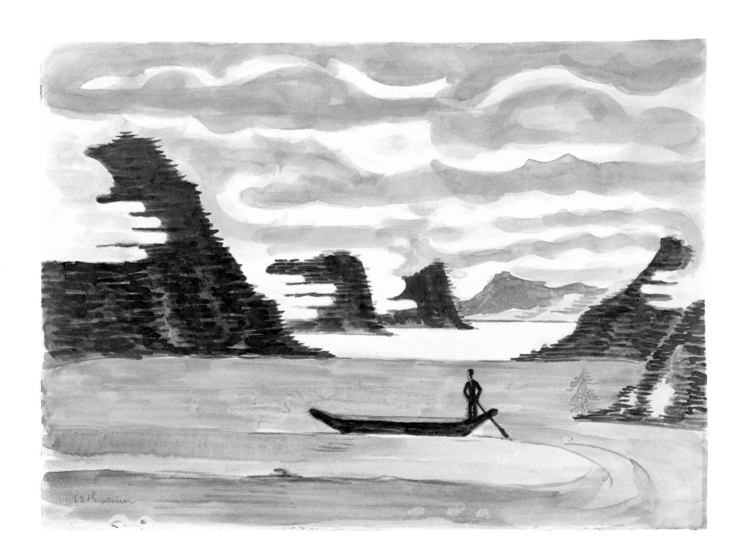

Kirchner's quest for a synthesis of natural forms and a rigorously simplified, decorative design climaxed in several color woodcuts he executed in 1933. In *Cemetery in the Forest*, the two-dimensional character of the picture surface is carefully preserved, as trees and mountains, divested of any space-defining function, provide a calligraphic framework for uniformly flat color planes. Kirchner had first become interested in the woodcut as a youth, and his extensive work in this medium constitutes a major chapter in the history of the graphic arts. He printed his own blocks and, as a result, his editions were usually small. *Cemetery in the Forest*, for instance, is one of an edition of six. Moreover, the Detroit version is unique, since the colors differ noticeably from print to print in the series. Kirchner used several blocks for this woodcut. The graphic framework of trees, mountains, and gravestones was printed from one, the colors were added from several others. Since each block was colored separately in such closely related hues as blue, yellow, and green, the artist achieved not only the most subtle color harmonies, but, through overprinting, managed to obtain astonishing intermediary nuances, as in the sunny spot near the center of the composition, where a thin veil of yellow brightens the underlying blue to a delicate pale green. This spotlight effect, while entirely arbitrary in its ornamental appearance, and several isolated flashes of light in the trees and on the gravestones, signal the end of Kirchner's abstract style, insofar as they seem to indicate the greater commitment to nature that was to make itself felt in the artist's work beginning in 1936.

The remarkable blend of skill and imagination that distinguishes Kirchner's use of the woodblock epitomizes his view of the dual nature of art as he first tried to summarize it in 1927 while outlining a series of lectures in anticipation of a professorial appointment in Dresden which never materialized:

Without emotion, or feeling, there is no living art, only craft. Then what is conscious, what is feeling, in art? To be conscious is to know your means, to have knowledge of how color works, to have experience in composition.... Feeling is imagination, the invention of ways of forming, the invention of objectives, the application of known laws in a certain direction—everything, all else remaining in the work of art, which is not explainable by intellect.[19]

The serenity of *Cemetery in the Forest* stands in the sharpest possible contrast to the events that troubled Kirchner's life during his last years. From 1930 to 1932 he and his companion were frequently ill. Moreover, the world economic situation grew continuously worse. When the German government in 1931 severed its ties to foreign exchange, the artist's opportunities to sell his works in Germany, his only important market, were sharply reduced. Two major retrospective exhibitions in the spring of 1933 in Bern and the resulting strengthening of his reputation in Switzerland could only have been a small comfort at a time when his art was beginning to be denounced in his native country. As early as May 1933 Kirchner sensed that a new war was imminent. Yet, like *Cemetery in the Forest*, his paintings of these years, especially his large epic mountain landscapes, suggest that at least in his art, Kirchner was permitted to withdraw from these conflicts into an ideal world where order and harmony were still possible.

Color woodcut, image 35.7 x 50 cm (14¹⁄₁₆ x 19⅛ in.), sheet 42.5 x 59.5 cm (16¾ x 23¾ in.)
Signed and inscribed in pencil: lower left, *Handdruck*; lower right, *E L Kirchner*
Gift of Mr. and Mrs. Henry Reichhold (37.6)

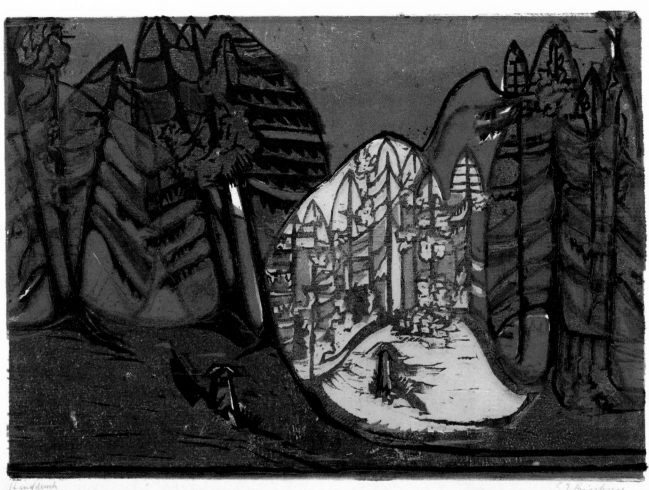

PAUL KLEE

Paul Klee looked upon art not as a representation of things that can be seen, but as a means to reveal realities that can be grasped only by intuition. Unlike most Expressionists, however, he was less preoccupied with his own feelings than with human experience itself, seeking to convey its multiple levels in a symbolic language of pictorial signs.

Born December 18, 1879, in the Swiss town of Münchenbuchsee, near Bern, Klee began his artistic training in 1898 in Munich, studying first in the private atelier of Heinrich Knirr and later with Stuck at the Munich academy. Between 1902 and 1906, while living with his parents in Bern, he produced his first original works, a series of etchings which in their grotesque humor recall contemporary prints by Kubin. In the fall of 1906 Klee returned to Munich. He took part in the second exhibition of Der Blaue Reiter in 1912 and showed his work at the First German Autumn Salon in Berlin the following year.

As an artist Klee matured slowly. Though he admired the Orphism of Delaunay, he made little use of color prior to 1914, concentrating mostly on drawings and prints. It was only when he went to Tunisia in the spring of that year, accompanied by August Macke and the Swiss painter Louis Moilliet, that, in the translucent light of the North African sun, his eyes were first fully opened to color.

Klee, who had German citizenship, served in the German army from 1916 to 1918. The year 1920 saw the publication of his essay "Creative Credo"

("Schöpferische Konfession"), a lucid explanation of the basis of his art. In 1921 he joined the teaching staff of the Bauhaus in Weimar.

The Bauhaus years were the happiest and most productive period of Klee's career, giving rise to works that possess a singular poetic charm (p. 115). His teaching obligations also helped him to further clarify and express his ideas. In addition to his diary entries and "Creative Credo," theoretical writings from this time such as "Concerning Modern Art" ("Über die Moderne Kunst"), the text of a lecture given at the museum in Jena in 1924, and *Pedagogical Sketchbook (Pädagogisches Skizzenbuch)*, 1925, a summary of his creative aims conceived as a textbook for his students, provide the most important guide to Klee's art.

Klee resigned from the Bauhaus in 1931 to accept a professorship at the academy in Düsseldorf. One of the first modern artists forbidden to teach by the National Socialists, he left Germany in December 1933 and returned to his native Switzerland, living once again in Bern. In the summer of 1935 he experienced the first symptoms of scleroderma, a progressive calcification of the skin and other body tissues, from which he was to die five years later on June 29, 1940, in a clinic at Muralto, near Locarno. Though he never gave up hope of being cured, Klee's late works were born of his illness. The delicate character of his earlier small-scale compositions gave way to linear abstractions that are not only relatively large in size, but somber in both form and expression. Many of these late pictures are filled with poignant premonitions of the artist's imminent death.

Like Marc, Klee shared with the nineteenth-century German Romantics the wish to penetrate into the secret life of nature, into the very processes of organic growth. "I seek a distant point at the origins of creation," he wrote in his diary in 1916, "and there I sense a kind of formula for man, animal, plant, earth, fire, water, air, and all circling forces at once."[20] In "Creative Credo" he further elaborated this idea:

Formerly we used to represent things visible on earth, things we either liked to look at or would have liked to see. Today we reveal the reality that is behind visible things, thus expressing the belief that the visible is merely an isolated case in relation to the universe and that there are many more other, latent realities.[21]

It was Cubism, probably the most important influence on Klee's development, that first showed him how to reveal through pictorial means the universal formula he perceived in nature. For in Cubism, too, the world of visible realities had been left far behind. The form of an object was no longer fixed, but rather represented from various different points of view.

The overlapping, interpenetrating planes of *Garden*, a black-and-white watercolor of 1915, recall the disciplined structure of early Cubist paintings by Picasso and Georges Braque. But closer examination reveals that Klee's pictorial method differed fundamentally from those employed by the orthodox Cubists. For Klee did not shatter nature into individual fragments but, rather, invented plantlike forms out of simple elements that suggested themselves to him as he was working. As a result, in *Garden* the rhythmically arranged composition of delicate shades of gray is not a simplified rendering of plants and trees; it is a pictorial metaphor for creation itself. Convinced of a secret correspondence between pictorial forms and forms in nature, Klee looked upon a work of art not as a product, but as a process of formation and genesis. Treating formal elements with unprecedented freedom, he gradually developed a language of signs which, while evolving steadily away from visible reality, ultimately provided him with a key to nature.

Watercolor, 13 x 24.1 cm (5⅛ x 9½ in.)
Signed, dated, and numbered: lower right, *Klee*; lower left, *1915 162*
Bequest of Robert H. Tannahill (70.342)

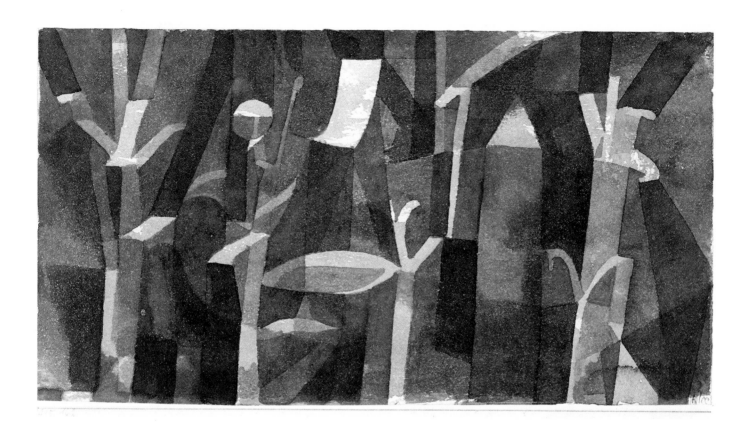

TIGHTROPE WALKER 1923

Klee developed his well-ordered compositions from the smallest elements of form, placing great importance on the balance of pictorial forces. In his lessons at the Bauhaus he frequently used the image of the tightrope walker as a metaphor for the dialectical process which he saw as the basis of creation in both nature and art. In *Tightrope Walker* this concern is vividly illustrated anecdotally as well as by formal means.

Klee's competent equilibrist, seen in the upper third of the composition just to the right of the vertical axis, seeks to maintain a precarious balance atop a whimsical structure of wires and ropes that not only defies all logic of engineering but, instead of being securely fastened, floats freely in space. The tightrope walker's feat is embodied in the prominent white cross, placed slightly askew in a field of transparent pink which is left undifferentiated except for a few black smudges and black grain at the upper and lower borders. This shape, normally stable and firmly rooted to the ground, provides the foil against which the tightrope walker must perform. His success rests upon his ability to counteract the gravitational pull exerted by the slanting position of the cross. And he succeeds splendidly, adjusting his balance bar in such a way that it forms the upper side of a parallelogram, the angles of which approximate those of the asymmetrical cross. Tilting in the opposite direction, they restore an equilibrium that is dynamic rather than static and fixed.

The figure of Klee's tightrope walker, conjured up by a few diagrammatic lines, is shown with the disregard for correct optical appearance characteristic of children's art. Indeed,

Klee's involvement with basic elements of design led him to a deep appreciation of the direct and spontaneous expression of children, in whose paintings and drawings he saw formal structures at the most elementary cultural level, uncompromised by training and convention. Yet, despite the fact that many of his linear abstractions show a kinship to children's art, Klee was clearly not intuitively spontaneous. There is a world of difference between a child's inability to draw "correctly" and Klee's deliberately simplified compositions and hieroglyphic signs. The subtle gradations of the colored ground in *Tightrope Walker* are the result of a highly sophisticated technique, while the carefully thought-out skeletal structure of the acrobatic mechanism testifies to the artist's compositional skill. Klee welcomed the promptings of his intuition, but he prized even more the interaction of imagination and reason. Deceptively childlike and simple, his art reflects his complete mastery of form.

Color lithograph, image 44.2 x 26.9 cm (17⅜ x 10⁹⁄₁₆ in.), sheet 52.3 x 38.3 cm (20⁹⁄₁₆ x 15 in.)

Signed, dated, and numbered in pencil: lower right, *Klee*; lower left, *23 138*

Founders Society Purchase, Dr. and Mrs. George Kamperman Fund (71.103)

RECLINING c. 1937

Klee rarely began his compositions with forms derived from nature. Rather, he started with purely formal motives, basic pictorial signs which he developed into a theme the way a composer develops a musical motif. The most simple element, such as a dot, became for him an active force. Set in motion, it might engender a line, a square, a triangle, or a circle, or unite with other lines to form more complex two- and three-dimensional structures, each invested with its own pictorial energies. Placing dot upon dot, line next to line, and form upon colored form, Klee sought to emulate the formative processes of nature. Thus, his polyphonic compositions become, by means of their creation, metaphors for organized states of growth.

While Klee began his compositions without any preconceived object or content in mind, he nonetheless accepted the suggestive power of pictorial signs as a bridge between abstract form and the objective world. For example, in *Reclining*—one of several unusually lyrical paintings from the late 1930s that freely combine barlike signs and curved configurations with hues of pale yellow, pink, and blue—the individual forms, not resembling anything already present in nature, cannot be specifically identified. Having emerged into the realm of visibility, however, they evidently demanded at one point in their development some associative recognition. It took in fact the mere addition of eye and mouth symbols to transform the enigmatic hieroglyphs into an allusion to three living creatures which seem to be lying down. It was only after Klee had finished a picture that he tried to find a verbal simile for what he had produced, often waiting weeks before adopting a title that would translate—as in the Detroit painting—the essence of his associations into words. Yet the titles of Klee's pictures were not intended necessarily to limit the viewer's imagination. For Klee always welcomed interpretation of his works by others, believing that his paintings, like a pictorial script in which the viewer might discover his own experience of himself and the world, served merely as points of departure for further insights. To have shown that aside from the visible world there were other latent realities accessible to intuition and communicable through art was Klee's particular contribution to the Expressionist movement.

Oil on canvas, 34.3 x 61 cm (13½ x 24 in.)
Signed, upper right: *Klee*
Gift of Miss Edith Ferry (44.90)

OSKAR KOKOSCHKA

Although Oskar Kokoschka spent some of the most decisive years of his career in Germany, his art originated in the cultural milieu of turn-of-the-century Vienna. Born March 1, 1886, in Pöchlarn, a small Austrian town on the Danube, he grew up in Vienna and, from 1905 to 1909, attended that city's School of Arts and Crafts. Caught up in his own imaginative world, he began to express himself during these early years not only pictorially, but through poetry and drama as well. His earliest works include an important group of color lithographs illustrating his prose poem *The Dreaming Youths (Die träumenden Knaben)*, published in 1908. Combining flat, colored grounds with sensitive, angular figures, they show the influence of Gustav Klimt, the leading exponent of Vienna Jugendstil, and are pervaded by an air of wistful melancholy—a mood at variance with the metaphorically disguised, but nonetheless urgent, drives of adolescent sexuality that form the subject of the text. In contrast to his graphics, Kokoschka's early oil portraits were unmistakably personal. Painted in muted colors, they capture the sitter's inner face and in the process characterize the spiritual morbidity of an era—an exposure the Viennese found impossible to tolerate. In 1909 an open-air performance of Kokoschka's play *Murderer, Hope of Women (Mörder, Hoffnung der Frauen)*, an allegorical drama of violence and lust dealing with the eternal conflict between man and woman, elicited such a hostile reaction that the young artist was forced to leave Vienna. Following a brief sojourn in Switzerland and Germany, he was called by the publisher and propagandist Walden to Berlin to become the first illustrator of the literary weekly *Der Sturm*.

Kokoschka volunteered for military service at the outbreak of World War I, was critically wounded during the Russian campaign, and in 1917 settled near Dresden to recuperate. The aftereffects of his injuries and his acute sensitivity to the general instability of the period brought about a

severe emotional crisis. The early Dresden pictures are full of tension and at times verge on formlessness, as thick, writhing brush strokes create frantically twisted shapes out of feverish wriggles of paint. Only occasionally, as in some of his portrait lithographs of that period, did Kokoschka manage to achieve control of both technique and imagination.

In 1919 Kokoschka was appointed to a professorship at the Dresden academy, and from 1920 on, no doubt as a direct result of his teaching position, he abandoned the scrambled brush strokes of the preceding years in favor of a more deliberate execution. His colors became strong and luminous, while the psychological elements receded, making way for a newfound joy in the beauty of nature (pp. 123, 125).

In 1924 Kokoschka resigned from his position at the academy and during the next seven years traveled extensively. Devoting himself almost exclusively to landscape painting, he visited three continents, setting down his visual impressions with dashing brush strokes and increasingly brighter colors (p. 127).

Kokoschka returned to Vienna in 1931. Three years later, horrified by the rise of Nazism in Germany as well as in his native Austria, he moved to Prague. Toward the end of 1938, with the approach of German troops, he fled once again, this time to London, where he remained for the next ten years. He resumed his travels after World War II and in 1953 settled at Villeneuve, on Lake Geneva. His last pictures include landscapes and portraits, the best of which combine his early intuitive approach with his later striving to capture the light and color of the visible world. Kokoschka died at Montreux, Switzerland, on February 22, 1980, one week before his ninety-fourth birthday.

Having been declared unfit for further military service on account of a serious head injury, Kokoschka in 1917 took up residence at the Weisser Hirsch, a colony of artists adjacent to a military sanatorium in the idyllic countryside near Dresden. There he soon became the center of a bohemian group of writers, actors, and intellectuals, whose faces are familiar from several drawings, paintings, and prints he made of them during the next few years. His portrait of Hasenclever, a pioneer and leading exponent of the German Expressionist theater, dates from this time. Like Kokoschka, the playwright had been severely wounded in the war and was convalescing at the Weisser Hirsch. Four years younger than the painter and only twenty-seven when the two first met, he had already established a considerable reputation for himself, largely on the basis of his play *The Son*, a symbolic drama of conflict between two generations, specifically, the tensions between a dominating father and his son, a theme that was to become central to the German Expressionist stage. Long considered the beginning of Expressionist drama, the play caused much excitement at its opening in Prague in 1916; the same year Hasenclever, a confirmed pacifist after his wartime experience, began writing *Antigone*, a protest in a classical setting against war and absolute government. Many of his later plays were comedies. Born in Aachen in 1890, Hasenclever lived in exile from 1933 on and in 1940 committed suicide while imprisoned in a French internment camp.

In contrast to Kokoschka's contemporary paintings, done in a violent style of thick, undisciplined brush strokes, the portrait of Hasenclever shows considerable control, combining penetrating characterization with a fairly objective likeness. The essential features of the finely shaped head, the dark, pensive eyes, protruding upper lip, and short, dishevelled hair have been indicated swiftly and in a manner utilizing all variations of lithographic technique. Rapidly working in the tonal areas with the side of the soft crayon, using the sharp ends for more emphatic and thinner lines, Kokoschka blocked out the head in short strokes. The resulting patches of light and dark lend the skin texture a measure of nervous mobility well suited to the young writer's intense face. His inward gaze conveys an impression of complete self-absorption. Withdrawn and infinitely lonely, the writer seems resigned to an unknown fate.

Confiscated by the Nazis, Kokoschka's portrait of Hasenclever was singled out for special ridicule at the *Degenerate "Art"* exhibition in Munich in 1937 and illustrated in the exhibition guide with an accompanying caption comparing the print to drawings by the insane (fig. 20).

Lithograph, 44.5 x 36.5 cm (17½ x 14⅜ in.)
Signed, titled, and numbered: on the stone, *OK*; in pencil, lower right, *OKokoschka*; in pencil, lower left, *102/110 Hasenclever II*
City Appropriation (30.77)

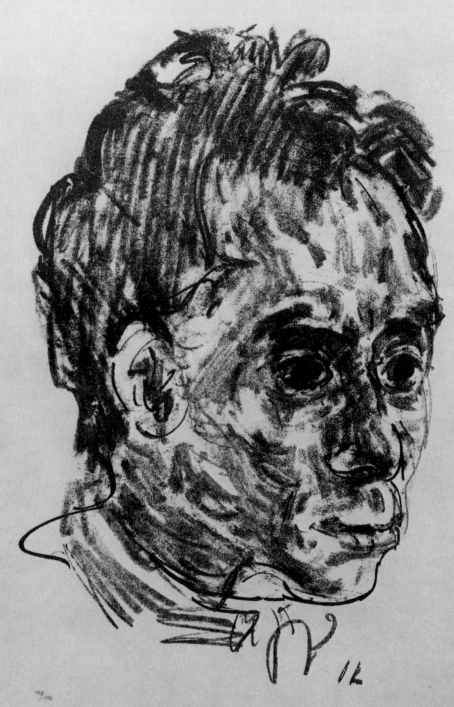

Chameleon I

DRESDEN NEUSTADT II c. 1921

Dresden Neustadt II is probably the most famous of several magnificent river landscapes Kokoschka painted in the early 1920s and one of the earliest works by the artist to have been acquired by an American museum. The glowing patches of color, dominated by bright tones of red, green, and blue, look like pieces in a sparkling mosaic. Applied heavily and with considerable care, they serve as constructive elements in the composition and reveal a concern for pictorial order and harmony characteristic of Kokoschka's painting style during these years. The three major components of the view, the horizontal planes of water, embankment, and sky, are in perfect balance, enlivened by the asymmetrical church tower breaking the line of clustered buildings on the far shore and by the scintillating patchwork of the colors themselves, applied to the canvas with assurance. A great deal of the picture's appeal derives from the artist's direct approach to the relatively straightforward subject. Indeed, the painting's simplicity and mood of serene detachment make it a worthy descendant of similarly uninhabited city views by Camille Corot and Cézanne.

Kokoschka painted the picture from the window of his studio at the Dresden academy, from which he enjoyed a splendid view of the Elbe River, its bridges, and the houses rising on the far shore. The vistas of the eighteenth-century city with its Baroque architecture undoubtedly appealed to his eye, accustomed as he was to Viennese palaces and church façades. Yet he might never have evolved the structural logic of his Elbe River pictures without his daily studies of works by the old masters in the Staatliche Gemäldegalerie in Dresden, especially those of Vermeer and Jan van Eyck, artists he deeply admired for their lucid and yet mysterious spatial constructions. On the other hand, the effect that Kokoschka's appointment to a professorship at the Dresden academy in 1919 had on his development can scarcely be overestimated. For the recognition, material security, and sense of tranquility the position provided for him did much to restore stability to his troubled nature during the postwar years. Beauty of nature now took the place of psychological anguish, as visual impressions kept him too busy to dwell on the torments of the soul. For the first time Kokoschka's art became objective, and landscape painting began to hold a special interest for him. His landscapes prior to 1920 are rare, inspired by an occasional and particularly impressive view. Despite their individual importance and indisputable brilliance, they fall outside the mainstream of his artistic development. Kokoschka's Elbe River views, by comparison, were serious ventures that paved the way for many fine landscapes which followed.

Oil on canvas, 59.7 x 80 cm (23½ x 31½ in.)
Signed, lower left: *OK*
City Appropriation (21.203)

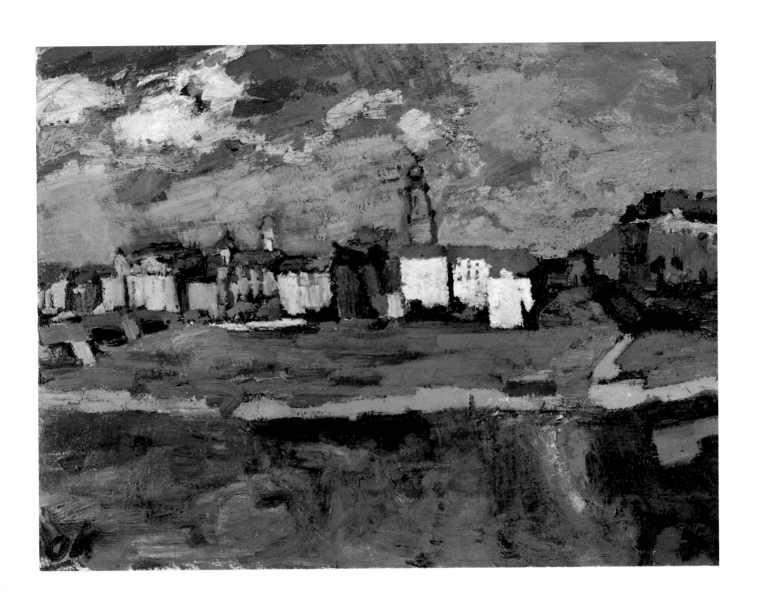

GIRL WITH A DOLL c. 1921–22

In both form and conception *Girl with a Doll* illustrates the marked change Kokoschka's painting underwent about 1920. No longer is there any trace of the restless brush strokes which, during the preceding period, meandered across his compositions in seemingly random streaks, charging his pictures with a sense of nervousness and high-pitched tension. Instead, the artist applied the paint much more methodically and with greater deliberation, covering the canvas with rough-edged patches that recall the rich texture of a tapestry. Even the figure of the girl is not delineated graphically but rather mapped out in broad areas of paint and integrated into the flat surface pattern. Most striking are the unexpectedly vivid colors, arranged in glaring and challenging contrasts of blue, yellow, and red, and shot through with brilliant green as well as shades of ocher and brown. While Kokoschka's previous works were thoroughly expressive in their revelation of character, their predominantly dark and murky tones were apparently a subconscious reflection of the artist's troubled state of mind. Now that he was settled in Germany, the saturated hues utilized by the artists of Die Brücke suddenly became of interest to him. There is little doubt that the radiant colors of the Detroit picture are a direct consequence of his familiarity with works by Expressionists such as Nolde.

While his colors intensified, however, Kokoschka's earlier introspection diminished. His interests, directed inward for so long, now turned to the material beauty of color and the treatment of the pictorial elements for their own sakes. Interpretation and the desire to characterize the subject from a psychological point of view play no part in *Girl with a Doll*. All sentimental and introspective qualities have been avoided, as the bold colors and rigorous design lend the little girl a refreshing robustness.

Oil on canvas, 91 x 81 cm (36 x 32 in.)
Signed, upper right: *OK*
Bequest of Dr. William R. Valentiner (63.133)

124

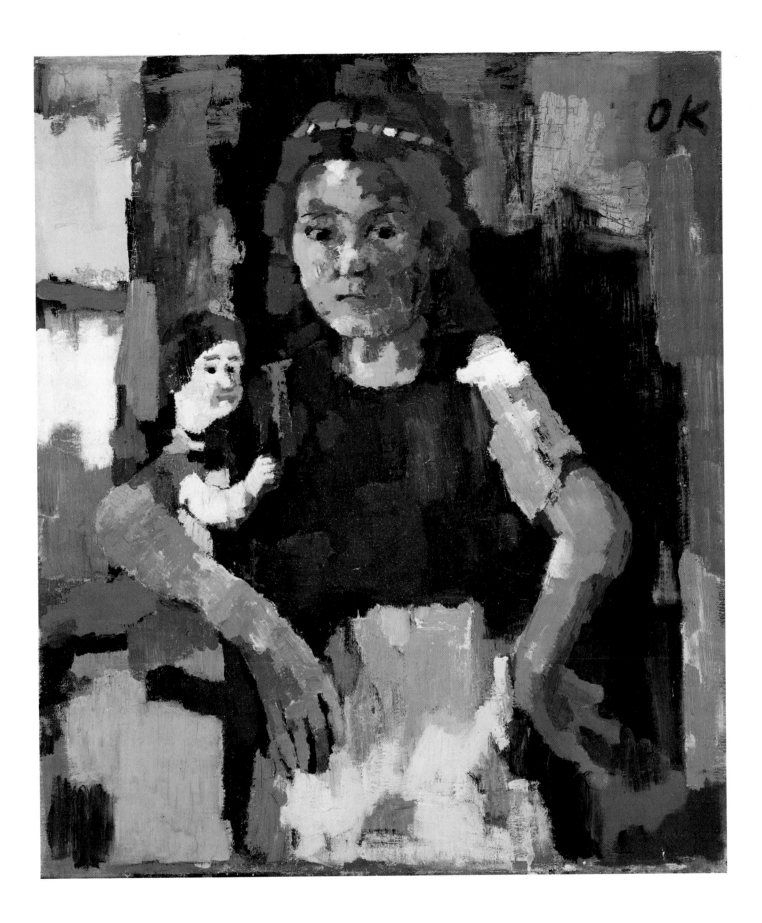

VIEW OF JERUSALEM 1929–30

In 1924 Kokoschka left Dresden and during the next seven years traveled through three continents. For years preoccupied with man's soul, he now turned his attention to the face of the earth, painting many of the sites and cities he visited. As if he had long yearned to take in the whole breadth of the world, he was driven to seek out high elevations, be it a top-floor room at the Savoy in London or a slope of the Atlas Mountains, always composing his landscapes so as to encompass the widest possible view. Kokoschka's painting method changed considerably during this period. Discarding the tightly knit structure of his first major series of landscapes, the Elbe River views from the early 1920s, he developed a more fluid style, setting colors down in dashing brush strokes reminiscent of those of the Impressionists. Yet by no means can these pictures be considered objective in the Impressionist sense. Very different places such as Venice, London, Paris, or Istanbul take on a strikingly similar look, unified by the artist's personality rather than by their visual data. Like Corinth, whose Walchensee landscapes (p. 59) seem to have influenced him at this time, Kokoschka accommodated the French message of plein air painting to his temperament. His new landscapes are alive with dramatic feeling.

View of Jerusalem, begun in the latter part of 1929 on a journey to Asia Minor and Palestine and finished in the spring of 1930 in Vienna, illustrates the high vantage point and spatial breadth typical of Kokoschka's landscapes and city paintings from these years. Seen from the Jewish cemetery on the Mount of Olives, the city has been observed as part of the landscape that surrounds it, appearing to have grown from the hillside it occupies. Even the buildings, surmounted by the cupola of the Mosque of Omar and enclosed by the ancient walls, look as if they had been formed by nature, like the rocks and boulders that lie strewn across the foreground and the Valley of the Kidron below. Cows climb or rest among the stones in the foreground, while a figure sits idly at the lower left. These elements, however, which in the work of a more traditional painter might have been a picturesque focus of interest, play a subordinate role here, having been assimilated by means of vibrant brush strokes into the irregular features of the terrain. The theme of the picture is the city itself, floating like a mirage in the far distance, isolated and remote. Kokoschka's inspired and lively execution lends even static objects an appearance of motion and endows the picture with a spiritualized quality that invites comparison with El Greco's ecstatic evocations of the Spanish town of Toledo. With paintings such as *View of Jerusalem*, considered by many the greatest of his city views, Kokoschka took his place in the grand northern tradition of aerial landscapes first introduced by sixteenth-century masters such as Joachim Patinir and Brueghel.

Oil on canvas, 80 x 128.3 cm (31½ x 50½ in.)
Founders Society Purchase, Membership and Donations Fund (35.110)

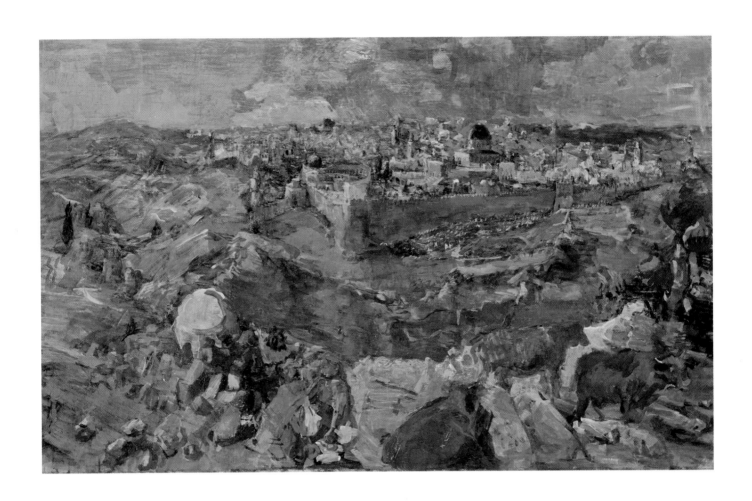

GEORG KOLBE

Georg Kolbe's short-lived venture into Expressionism was limited to the period from about 1919 to 1923 when—seemingly as a result of his association with the Novembergruppe and his friendship with Schmidt-Rottluff—he briefly espoused Expressionist ideals of content and form; thereafter, he retreated into a more naturalistic approach to art.

Kolbe was born April 15, 1877, in the small town of Waldheim in Saxony. Between 1891 and 1897 he studied at the academies in Dresden and Munich, as well as at the Académie Julian in Paris, with the intention of becoming a painter. Not until 1898, while pursuing independent studies in Rome, did he decide to devote himself instead to sculpture. Following a period of extensive travel in Europe, North Africa, and Russia he settled permanently in Berlin in 1903. The rhythmic inventions of his statues prior to 1919, usually young nudes in poses that recall the expressive gestures of modern dance, reflect the influence of Rodin, whose studio he visited in 1909, although the mood of Kolbe's early works is far more lyrical and his modeling smoother and more controlled than the Frenchman's.

The years immediately after the end of World War I marked a turning point in Kolbe's development, as the naturalism of his earlier sculptures gave way to severely simplified forms, elongated proportions, and a more monumental approach—

tendencies that found their most succinct expression in his works of 1921. In the course of the 1920s, however, Kolbe returned to more realistic portrayals and by the end of the decade substituted vigorous modeling and a more aggressively forceful body language for the smooth planes and graceful lyricism of his earlier statues. Although he occasionally succeeded in recapturing the dramatic character of his works from this period, in the 1930s Kolbe fell increasingly prone to a grandiose, idealized naturalism, epitomized in a long series of monumental and stereotyped nudes, shown singly or in pairs, that conjured up the vision of a genetically superior Nordic race, prevalent in Nazi ideology. Needless to say, these statues of athletic men and women, extolling the virtues of health and physical strength, were in perfect accord with Nazi taste, and Kolbe possesses the dubious distinction of having been respected and honored by the National Socialists. Although several of his earlier, more expressive sculptures were ordered removed from public display, Kolbe actively participated in the cultural life of the Third Reich by showing his later works in numerous official exhibitions. He died in Berlin on November 20, 1947. In 1950, in accordance with his wishes, his house and studio in Berlin-Charlottenburg were opened to the public as a museum.

Kolbe's popularity prior to 1919 was based largely on his graceful statues of nudes, whose young and slender bodies he portrayed in rhythmic arrangements. Rarely did he invest these statues with strong emotions. The feelings they project are gentle, and their gestures, even when most animated, seem measured and posed rather than determined by a powerful impulse toward self-revelation.

Dancer, a bronze of 1914, epitomizes the gracious spirit of Kolbe's early works and illustrates, by virtue of its delicate fusion of realism and simplification, the sculptor's innate conservatism as well as his modernity. Said to have been inspired by Nijinsky, the great Russian dancer and choreographer whose legendary performances held European audiences spellbound on the eve of World War I, the statue testifies to Kolbe's thorough knowledge of the internal structure and outer appearance of the human body and to his skill in rendering the human form accurately. At the same time, the statue is far from being a mere illustration of a male nude. For subtle license has been taken with the anatomy to reinforce the body's intrinsically sculptural features and thus to enhance the work's effectiveness as a three-dimensional object in space. While the modeling is incisive, the surfaces remain sufficiently generalized to prevent muscles and bones from asserting themselves too forcefully. As a result, the dark, rich patina offers no strong contrasts of light and dark, but allows the eye to glide swiftly along the contours and major gestural lines, all of which transmit the impression of spirited movement. The statue may be seen satisfactorily from any direction; the design encourages the spectator to move around the figure in search of a summary of all possible views.

Light-footed as a panther and as if entranced by his own agility, the dancer scarcely skims the ground, seemingly oblivious to the limits of the narrow base. As the body turns upon its own axis, the movement that springs from the legs gradually pervades the revolving torso, while the slightly raised arms not only enliven the otherwise smooth and closed silhouette but also impart the statue's rhythm to the surrounding space. The focus of the work thus lies somewhere outside the sculpture itself, and the boundary between it and the space the viewer inhabits has been abolished. Spatial extension, which had had a long tradition in sculpture from Gianlorenzo Bernini to Rodin, is one of the chief characteristics of Kolbe's early works. It allowed him to communicate the gentle spirit of his subjects by including the observer vicariously in the action.

Bronze, 64.8 cm (25½ in.) h.

Signed on top of base beside left foot: *GK*

Gift of Mrs. George Kamperman in memory of her husband, Dr. George Kamperman (64.261)

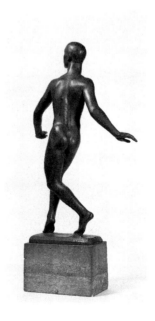

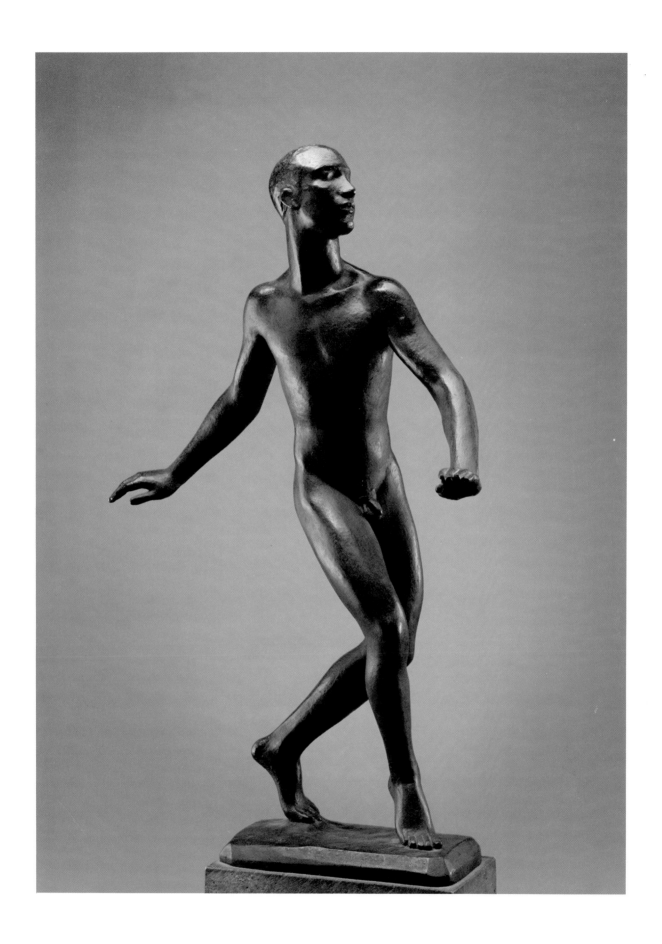

Assunta marks a high point in Kolbe's development and demonstrates to what extent his encounter with Expressionism during the years immediately following World War I allowed him to invest his earlier naturalistic works with a new language of feeling. Done in 1921, the sculpture displays neither the complex rhythmic design nor the gracious mood of *Dancer*. Stillness and serenity emanate from the attenuated body, the lines of which ascend quietly from the feet to the shoulders in a slow and measured flow. Only the hands, raised chastely before the breasts as if in prayer, and the simplified planes of the face which create multiple reflections of light interrupt the otherwise smooth transitions from one part of the body to the next. The austerity of the statue is markedly softened if the figure is viewed from either the right or the left. For what appears as a rigidly erect pose from the front may then be perceived as imbued with a gentle motion, while the reticent face takes on a lyrical, almost smiling expression. But here too the general impression remains one of physical and emotional withdrawal. Unlike *Dancer*, a statue that projects its movement into the surrounding space and thus allows the beholder to share vicariously in its physical vigor, *Assunta* disavows the physical by virtue of its self-contained, spiritualized form as well as its theme, the assumption of the Virgin Mary into heaven. Devoid of all anecdotal detail, the slender body, anchored to the base by a stylized piece of drapery, floats above the ground, having severed its earthly ties. A drawing by Kolbe (present location unknown) indicates that the artist intended the bronze to be displayed in a circular architectural setting, open to the sky and decorated on the inner wall with sculptures in low relief, presumably of the twelve Apostles, who witnessed the miracle.

In terms of both its ascetic severity of form and interiorization of mood, Kolbe's *Assunta* bears comparison with the works of Lehmbruck and is one of several statues, including *Resurrection*, 1920, a smaller and more lyrical conception of an upward-floating female nude, also in the collection of The Detroit Institute of Arts, in which the sculptor took refuge in a highly generalized portrayal of religious subjects. Like Schmidt-Rottluff, Rohlfs, Pechstein, and others, Kolbe was moved by the pain and sorrow brought on by World War I and joined these artists in their idealistic search for a new humanity and a new relationship between God and man. Seen within this context, *Assunta* goes beyond its conventional religious meaning and becomes a metaphoric image of the typically Expressionist longing for otherworldliness.

Bronze, 193 cm (76 in.) h.
Signed on base behind left foot: *GK*
City Appropriation (29.331)

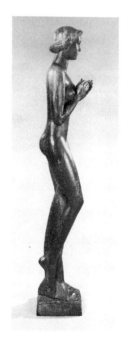

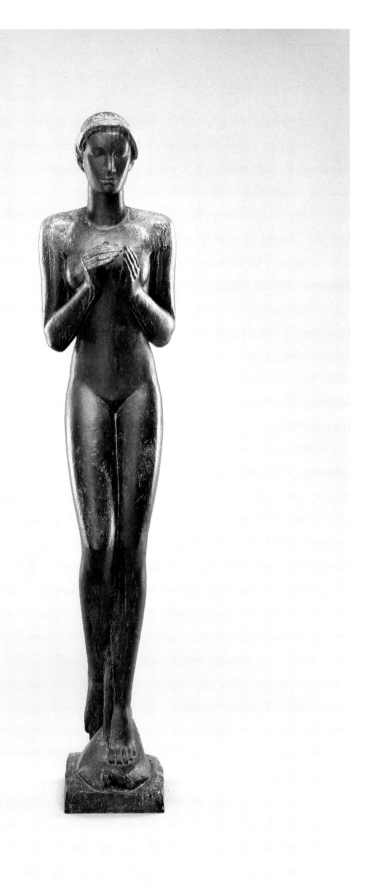

KÄTHE KOLLWITZ

The art of Käthe Kollwitz was motivated less by aesthetic than by ethical considerations. Profoundly disturbed by the plight of the poor and the oppressed, she portrayed human misery and anguish so that she might move people's hearts to eliminate the causes of want and grief.

Born July 8, 1867, in Königsberg, the provincial capital of what was then East Prussia, Kollwitz grew up in an atmosphere of social and moral idealism. Her father, Karl Schmidt, gave up the study of law when he could not reconcile his socialist convictions with the tenets of the legal profession as then practiced in the Prussian state. Instead, he became a mason and eventually a successful contractor. From him Käthe Schmidt inherited the impulse toward social responsibility that was to be the basis of her art.

Schmidt recognized his daughter's talent early and provided her with the best training available. She took her first drawing lessons at fourteen and from 1885 to 1886 studied at the School for Women Painters in Berlin with Karl Stauffer-Bern. A first-rate draftsman and etcher, Stauffer-Bern immediately perceived her ability as a graphic artist and introduced her to the prints of Max Klinger, whose cycle *A Life*, 1883, a series of naturalistic interpretations of social injustice, deeply impressed the sensitive young woman. In 1887, back in Königsberg, Käthe Schmidt painted her first pictures under the tutelage of Emil Neide. Sometime in 1888 or 1889, while continuing her studies in painting with Ludwig Herterich at the Women's Art School in Munich, she concluded that her strength lay in the black-and-white mediums of the graphic arts. Moreover, the idea of making prints appealed to her because printmaking permits the widest distribution of original works of art at the lowest cost and thus is the most democratic of the visual arts. Kollwitz's prints, some 270 etchings, lithographs, and woodcuts, have brought her international fame.

Upon her marriage in 1891 to Karl Kollwitz, a physician who participated in an early form of socialized medicine for the poor, the artist settled in a working-class district in Berlin that was to remain her home for nearly the rest of her life. From 1893 on she began to explore in her art subjects of social drama, culminating in *The Weavers' Revolt*, a set of six prints inspired by a play by Gerhart Hauptmann about the uprising of Silesian weavers in 1844. When it was first shown in a Berlin art exhibition in 1898, the cycle caused quite a sensation and was nominated for a gold medal. But the Kaiser, who called all art of social content "gutter art," vetoed the award. In 1899 *The Weavers' Revolt* was exhibited in Dresden, and Kollwitz was granted a gold medal by the king of Saxony. From 1902 to 1908, she worked on her second great cycle, *The Peasants' War*. For *Outbreak*, the fifth print in the final sequence but the

first to be completed and published, she earned in 1907 the Villa Romana Prize, permitting her to spend a year in Italy. During these years Kollwitz also began to work as a sculptor, attending sculpture classes at the Académie Julian in Paris in 1904 and 1907. Her most important sculptural project, a war monument commemorating her younger son Peter, who at eighteen was killed during World War I, was erected at Roggevelde Military Cemetery near Diksmuide in Belgium in 1932. In 1919 Kollwitz became the first woman to be elected to membership in the Prussian Academy of Fine Arts. She was named head of the academy's master studio for graphic arts in 1928. Early in 1933, following Hitler's appointment as German chancellor, Kollwitz and her husband joined a number of prominent intellectuals in a public appeal to all the workers of Germany for electoral unity against the Nazis in the upcoming elections. A few weeks later she was expelled from the academy.

The last ten years of Kollwitz's life were difficult and tragic. Although the Nazis did not officially prohibit her from working, as they did Nolde and Schmidt-Rottluff, her art was sufficiently identified with the social democrats and the communists to be marked for suppression. From 1936 on German galleries and museums were no longer allowed to exhibit her work. In 1940 her husband died. Her grandson was killed in battle in 1942. The following year, intensified air raids forced her to flee to Nordhausen in the Harz Mountains. In November the house in Berlin in which she had lived for so many years was destroyed and with it a large number of drawings and the complete collection of her prints, including many unique and unpublished proofs. In the summer of 1944 Prince Ernst Heinrich of Saxony offered the aged artist a place of refuge on his estate at Moritzburg, near Dresden. It was there, on April 22, 1945, only days before the end of World War II, that Kollwitz died.

Throughout her career Kollwitz sought to use her art as a means of communication. For that reason she never abandoned naturalism. Her development illustrates a progressive tendency toward massive and simplified forms of great emotional power. But she intentionally avoided the rigorous stylizations of the German Expressionists, whose art she felt tended toward eccentricity and affectation and thus remained incomprehensible to the average man. Yet her ability to extract the emotional content from life and the searing intensity of feeling that underlies each and every one of her works endow her art with a profound Expressionist quality.

Raised in a liberal intellectual environment, Kollwitz possessed a deep compassion for the downtrodden and the poor and throughout her career used her art to cry out against social injustice. Her earliest known figure composition, a drawing probably done in 1888, illustrates a key episode from *Germinal*, Emile Zola's vivid account of the class struggle of oppressed miners in northern France. In 1893 she began work on *The Weavers' Revolt*, 1893–97.

Kollwitz's seven etchings published in 1908 under the title *The Peasants' War* describe the plight of the poor. Based on her reading of *History of the German Peasant War (Geschichte des deutschen Bauernkrieges)* by Wilhelm Zimmermann, a chronicle of the bloody peasant revolts in southern Germany during the early years of the Reformation, the cycle was commissioned by the Society of Historical Art on the strength of *Outbreak*, an etching Kollwitz had published in 1903, and around which she subsequently developed the remaining compositions of the series. *Outbreak* became the fifth print of the finished cycle, preceded by depictions of economic and social exploitation and preparations for open revolt. The last two prints in the sequence, *Battlefield* and *The Prisoners*, record the tragic aftermath of the abortive rebellion.

Outbreak is probably the most important graphic work of the artist's early career, marking a decided high point in her development. It not only demonstrates her outstanding achievement as an etcher, but anticipates that elimination of the nonessential that came to epitomize her mature prints. Combining aquatint with soft-ground etching, a technique in which the image is drawn upon the copperplate through a sheet of rough-textured material—in the case of this print it was probably linen—Kollwitz obtained a rich texture of halftones that contrast with flashes of highlights and deep, velvety shadows.

Though the composition is descriptive and the modeling conventional in comparison to Kollwitz's preceding series of prints, *The Weavers' Revolt*, the subject has been conceived on a far grander scale and translated into simple and powerful forms that raise the specific to the level of the symbolic. *Outbreak* is the pictorial equivalent of a revolt that explodes right on the paper, as the peasants sweep across the composition in one unified, terrifying phalanx. Similarly, the woman in the foreground, representing Black Anna, an actual participant in the tragic events of 1523–25, transcends her identity within a given time and place. Seen from the back, she is no longer just a historical figure. Raising her work-worn hands in an impassioned gesture inciting the peasants to action, she personifies the generating force of rebellion.

Etching and aquatint, plate 48 x 57.1 cm (18^{15}/$_{16}$ x 22½ in.), sheet 54.2 x 70.5 cm (21⅜ x 27¾ in.)

Signed and dated in the plate, lower right: *KKollwitz 1902* (The publisher of the edition is indicated on the plate, lower right: *DRUCK VON O. FELSING, BERLIN*; *1921* in the lower right refers to the date of the edition.)

City Appropriation (30.78)

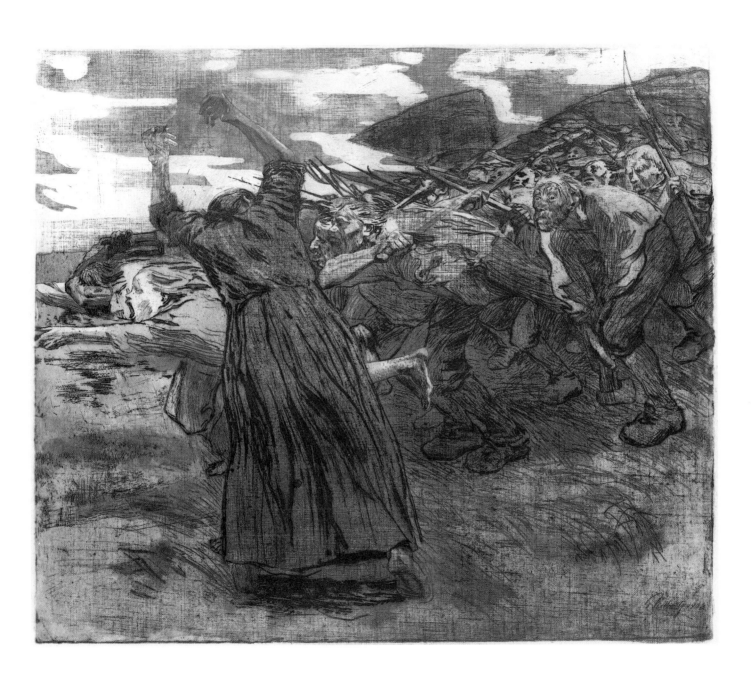

BURIAL c. 1903

One of the fundamental human experiences to which Kollwitz's imagination turned repeatedly was death. She considered the subject inexhaustible and depicted it in many variations, directly—in the traditional allegory of the skeleton or in the act of dying—as well as indirectly, by portraying the sorrow of those left behind. Having suffered the loss of both her son Peter and subsequently his nephew and namesake, her beloved grandson, she herself experienced death as a cruel force that separates those who are united in friendship and love. But as the wife of a doctor in a poor working-class district in Berlin, she was witness to enough human misery to know that death is also benevolent, delivering man from a grievous existence. In her later years Kollwitz yearned for death, sustained by a faint hope of reunion with those who had preceded her. Yet she was also intensely afraid of dying. Both her longing and fear are eloquently expressed in *Death*, her final and most poignant print cycle, of 1934–35. In this sequence of eight lithographs, death, appearing in various disguises, confronts man in two fundamentally different ways, as friend and foe, serene and violent.

In 1903, almost as if she had a premonition of his untimely death, Kollwitz posed with her young son before a mirror to do a preparatory drawing (Private Collection, Basel) for an extraordinary etching in which a naked woman, a shattering evocation of grief in its most primordial and savage state, crouches on the ground, clutching her dead child to her body. Less intense, but no less prophetic, is the moving charcoal drawing in Detroit, in which the artist based the image of the dead child in the lower left on yet another sketch of her sleeping son Peter, also dated 1903 (Staatliche Museen, Berlin). In the Detroit drawing, a mother pushes a shovel into the earth in order to prepare a grave for her dead child.

Originally intended to be included in *The Peasants' War*, the composition was omitted from the series in favor of a moving scene of muted grief, showing a mother wandering across a nocturnal battlefield in search of the body of her fallen son. The Detroit drawing demonstrates even more succinctly than the etching *Outbreak* the direction Kollwitz's art eventually was to take. Only in the faces of the figures and the hand of the child is there still evidence of the artist's original fascination with the particular. In the rest of the composition the specific has been subordinated to a more generalized and abstract conception that permits the drama to unfold in a simplified form. All action has been internalized, as the woman, enveloped by impenetrable darkness and cut off from all contact with the world outside, is utterly alone with her dead child. Yet her lament is not mute. Kollwitz, an intensely dramatic artist at heart, has turned the woman's entire body into a towering gesture of grief, exemplifying that stoic attitude with which the artist herself in later years endured the pain inflicted upon her by the loss of her son, husband, and grandson, and with which she subsequently approached her own death.

Charcoal and yellow chalk on cardboard, 54.2 x 47.8 cm (21½ x 18⅞ in.)
Bequest of Robert H. Tannahill (70.308)

Although the subject of Kollwitz's art was mankind, she made only a few portraits. This may be explained by the fact that her concern with human fate was always greater than her interest in observing the individual. She dealt with universal themes symbolizing the tragedy of life, not with the specific. Perhaps natural for one whose work was so strongly determined by her personal feelings, Kollwitz's self-portraits are numerous. She made at least fifty, including prints, drawings, and sculptures. Recording the traces of time and experience, they range from the fresh face of the young student and bride to the seared and lined features of the old mother and widow. But here, too, only the earliest examples, done in a meticulous, naturalistic style, are indicative of her efforts to explore her countenance. Those which she executed from about 1903 on, while still close to nature, are far less individualized. Simplified in form, they transcend the particular and acquire a timelessness of expression.

Kollwitz's ability to reconcile the specific with the universal is demonstrated in her superb *Self-Portrait* of 1920. In this lithograph the fifty-three-year-old artist was concerned solely with those features that were destined to carry the expression: her sad, introspective eyes and the mouth, bitter, but firm in its resignation. Only they have been worked out in some detail, while the shape of the head is generalized and comparatively indistinct. The print is a tour de force of modeling, combining in a few bold strokes with the lithographic crayon the most transparent shades of gray with areas of deep darkness. Kollwitz's face lent itself readily to this sort of simplification. Made up of large and clearly defined forms, it was not only unusually impressive, but had something

timeless and supra-individual about it. This is doubtless the reason why Kollwitz was able to impart her features to so many of her figures without detracting from their universality.

Kollwitz's *Self-Portrait* also confirms descriptions of her personality by friends and acquaintances. While in the intimate circle of her family she was outgoing, a human being who could laugh, sing, and dance, her basic outlook on life was grave. In public she was shy and retiring, always listening intently, but rarely speaking herself. Detesting personal aggrandizement of any kind, she dressed simply and masked her reticence by a quiet, dignified bearing, and even with a degree of assumed formality. While Kollwitz's *Self-Portrait* confirms her somber temperament and reserve, the forcefulness of the conception transcends the limitations of her individual personality. A poignant document of the physical and psychological effects of aging and sorrow, hers is a face whose tired and serious expression bears witness to the tragedy of life.

Lithograph, 27.2 x 24.2 cm (10⅝ x 9½ in.)
Signed in pencil, lower right: *Kathe Kollwitz*
City Appropriation (30.79)

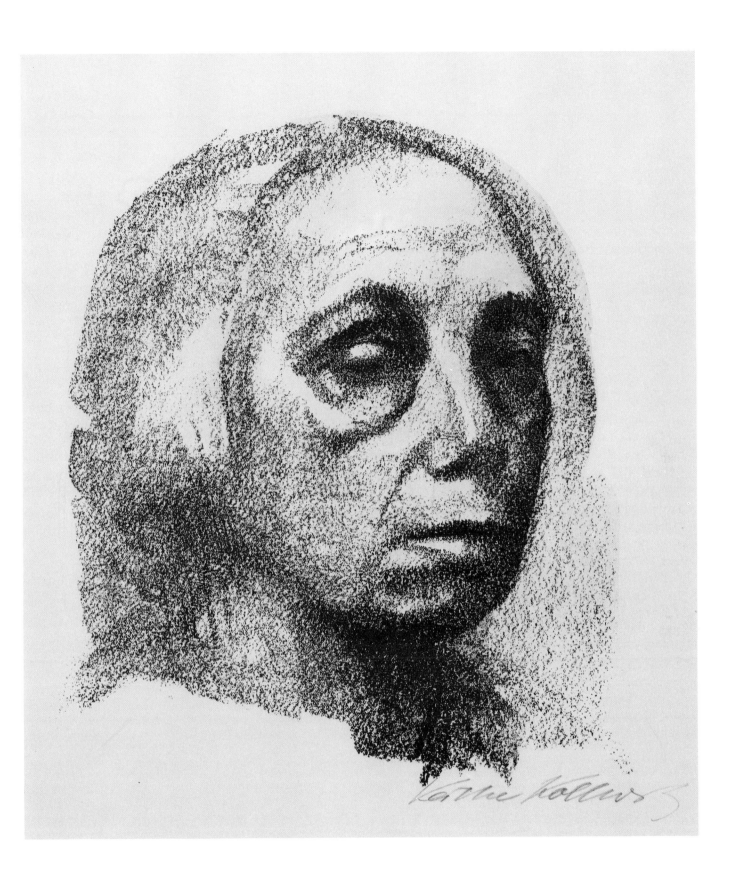

WILHELM LEHMBRUCK

Seeking to reveal man's soul beneath the physical appearance of the body, Wilhelm Lehmbruck looked upon sculptural form not in terms of its anecdotal function, but as a key to man's inner life. Unlike Barlach, however, he was not satisfied with the exploration of mass and weight, but stripped his statues of their material substance, developing a language of attenuated proportions that lends his figures an air of physical and emotional vulnerability. Noble and serene, his slender nudes pose in brooding reverie, animated by slow and measured gestures, as if engaged in a solemn dialogue with their innermost thoughts.

The son of a mine worker, Lehmbruck was born January 4, 1881, in Meiderich, a suburb of the industrial city of Duisburg. Quiet and introspective by nature, he began to carve small statuettes from plaster and chalk at an early age and from 1895 to 1899 attended the School of Arts and Crafts in nearby Düsseldorf. Between 1901 and 1907 he continued his studies at the academy in the same city. His early works range from naturalistic bathers and nudes done in the polished academic manner to didactic subjects of social content, foundry workers and miners, inspired by the idealized realism of the Belgian sculptor Constantin Meunier. Not until after he had completed his formal studies did Lehmbruck seek to overcome his academic predilections by emulating the vigorous modeling and expressive forms of Rodin.

In 1910 Lehmbruck settled in Paris, where he not only acquired a more profound understanding of Rodin's work, but also came into contact with the calm and ponderous statues of Aristide Maillol. Lehmbruck's personal style first manifested itself the following year in *Kneeling Woman*, a monumental statue in plaster, subsequently cast in both stone and bronze. Here the expressive possibilities inherent in Rodin's use of the entire human body

as a gestural symbol of an emotional state culminate in a stylistic vocabulary of elongated limbs and enigmatic movements, resulting in a spiritualization of form and intensification of feeling that henceforth became the hallmarks of Lehmbruck's sculptural expression.

With war imminent, Lehmbruck left Paris in the summer of 1914 and returned to Germany. Having registered with the military reserve in his home town, he set up a studio in Berlin. As a reservist he was spared the gruesome spectacle of trench warfare, and yet he was unable to escape psychologically from the misery brought on by the war. During these years he turned frequently in his drawings and prints to prototypical themes of human suffering (p. 149), while in his sculptures his once elegiac concept of the nude took on a truly tragic spirit. In these works, in which simplified tubular limbs encircle evocative spatial voids, Lehmbruck's transformation of the human body into an independent formal structure reached its extreme (p. 147).

Afraid of being called up for military duty, Lehmbruck moved to Zurich in December 1916. But the Swiss city, still reeling from the staging of the first major Dada demonstrations, proved to be an uncongenial place for the sensitive sculptor. Deprived of a circle of sympathetic artists who shared his belief in the rebirth of a monumental sculpture capable of expressing the spirit of the modern age, he increasingly withdrew into himself. In the middle of March 1919 Lehmbruck returned to Berlin. On March 19 he received official notification of his election to membership in the Prussian academy. Six days later, in a desperate gesture of self-doubt, Lehmbruck took his own life; he was only thirty-eight.

The meaning of a statue by Lehmbruck is revealed not only in the full figure, but in each of its individual parts. Details such as an upraised hand, the tension of a leg, or a head may pulsate with the same expressive energy that pervades the sculpture as a whole and communicate, even if seen in isolation, the very essence of the sculptor's conception. Moreover, Lehmbruck continued to be preoccupied with certain of his statues long after they had been completed and, like Rodin, was in the habit of casting separately those parts of a piece—usually the head or bust, or the torso stripped of its arms and legs—which seemed to him especially successful. Substituting the part for the whole, he endowed each fragment with its own expressive force.

Head of a Woman is a concentrated evocation of the melancholy mood of *Pensive Woman*, one of several monumental statues Lehmbruck made in Paris between 1910 and 1914, and the one in which the quiet and contemplative character of his work manifests itself most fully. The stillness and innate nobility emanating from the original standing figure are here conveyed by the graceful head alone. Slightly inclined on the slender, elongated neck, the head, with its inward-gazing, heavy-lidded eyes and large, sad mouth, is an expressive entity in itself, the formal embodiment of complete silence. Physical beauty, in the traditional sense, is not allowed to disturb the inner content of the work. On the contrary, description of matter has been subordinated to a pronounced spiritualization of form.

Enveloped by a poignant air of loneliness and melancholy reverie, *Head of a Woman* testifies to Lehmbruck's meditative spirit. Indeed, nearly all his mature works, except a few portrait busts he made of his wife and close friends, may be looked upon as disguised self-portraits or extensions of his own nature. Contemplative and subject to periods of severe depression, he projected his unfulfilled yearning for a life of harmony and perfection into his works. It is this subjective approach to his art, more than his formal innovations, which allies Lehmbruck most closely to the Expressionist painters of his generation.

Bronze, 39.4 x 26.7 x 16.8 cm (15½ x 10½ x 6⅝ in.)
Signed on back of right shoulder: *W. LEHMBRUCK*
Bequest of Robert H. Tannahill (70.215)

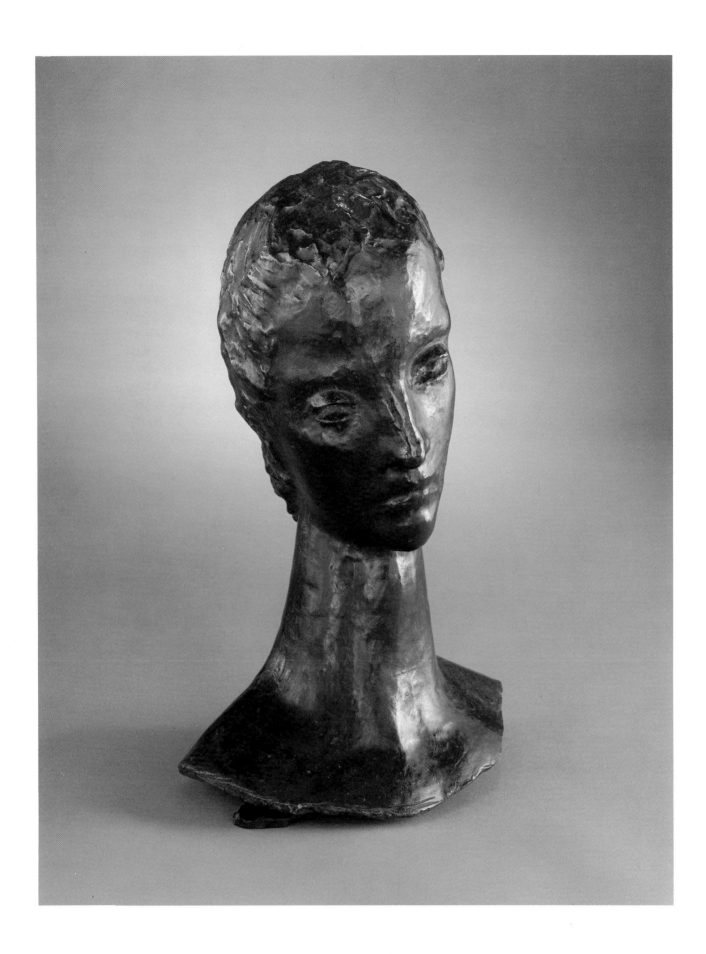

Melancholy is the keynote of Lehmbruck's works. Devoid of all narrative context, shrouded in the unfathomable secrets of their thoughts, his figures appear to be listening inwardly as if to far-off, mysterious voices. Meditative withdrawal is the element that also lends his statuette *Seated Girl* its elegiac mood, although the emphatic gestural line that accounts for the figure's lively silhouette is far removed from the repose of most of Lehmbruck's other sculptures. Yet spiritual lassitude and vigorous form are unified in this work in such a way as to reinforce the expressive character of the whole.

First conceived in 1912—as *Pensive Woman*, an etching from that year, demonstrates—the bronze was done sometime between 1913 and 1914. From the direct front or direct back the figure's expressive contours may be observed in their broadest sweep, as, beginning in the outstretched leg, the lines surge upward into the torso and the inclined head, from which the motion is guided through the arms and the sharply bent opposite leg to its original point of departure. Yet, each movement engenders a countermovement, and even a rhythmically active piece such as this one is allowed to rest entirely within itself. Some of Lehmbruck's boldest exaggerations of human proportions and most daring and simplified modeling are found in this work. The head, nearly devoid of all physiognomic detail, assumes the character of an abstract metaphoric image of introspection, a mood that reverberates throughout the figure. Despite Lehmbruck's stunning transformation of nature and spiritualization of form, the statuette, comparable to Mueller's poignant bathers and nudes (p. 165), retains a markedly

sensuous appeal, largely because of such details as the firm breasts and the sinuously curved thighs, alive with shimmering reflections.

With its expressive silhouette, *Seated Girl* demonstrates Lehmbruck's tendency to compose his figures according to what is essentially a linear rather than a truly sculptural conception. Indeed, Barlach, who looked upon the human figure in terms of its mass and weight, once admitted—in a reference to Lehmbruck's *Rising Youth*, 1913—that while he was able to appreciate the attenuated statue as a drawing, he felt compelled to reject it as a piece of sculpture, since it had not been sufficiently developed in three dimensions. Another fundamental difference separates the two sculptors. While both addressed themselves to man's lonely search for himself, Barlach derived the spiritual content and boldly generalized forms of his draped and bulky figures from late medieval German art, whereas Lehmbruck, working almost solely with the nude human body, imbued his statues with an air of calm and nobility that testifies to his roots in the tradition of classical idealism.

Bronze, 27.9 x 44.8 x 14 cm (11 x 17⅝ x 5½ in.)
Signed on back of base in center: *W. Lehmbruck*
Bequest of Robert H. Tannahill (70.216)

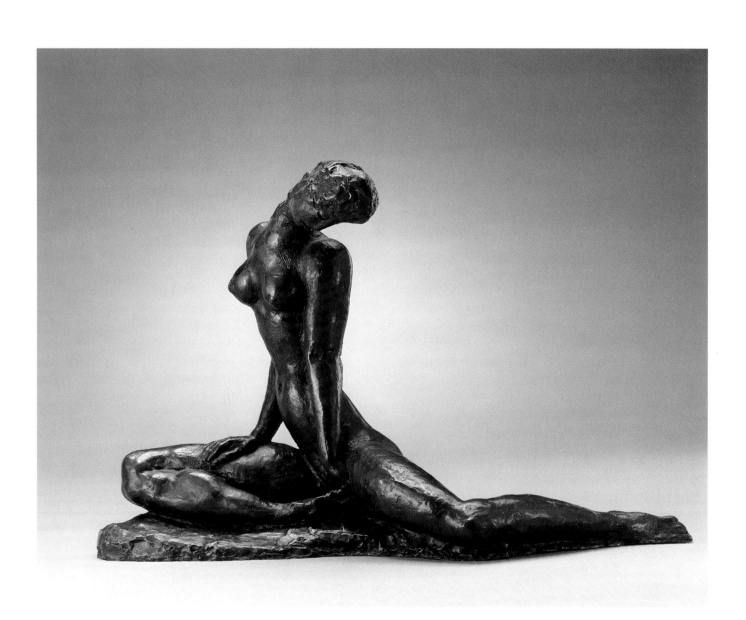

TWO WOUNDED MEN c. 1916–17

Although primarily known for his work in stone and bronze, Lehmbruck frequently reached for crayon, pencil, etching needle, or brush, jotting down his ideas with a freedom of invention not possible in the more arduous and time-consuming medium of sculpture. His drawings and prints, in particular, illustrate how he allowed an idea to develop and grow, striving for an ever greater concentration of his original conception. As a result, most of his drawings and prints are not finished in the conventional sense, but consist largely of studies which often combine such random details as partial figures and heads with a seemingly unrelated composition. The lyricism that distinguishes Lehmbruck's sculptures also pervades his drawings and prints; his subject, with rare exceptions, is again the nude human body. Like his attenuated statues, the individual figures reveal their meaning through appropriately expressive gestural lines. In contrast to Lehmbruck's three-dimensional works, however, which are devoted almost exclusively to single figures, his drawings and prints, and to a lesser extent his paintings as well, are dominated by multifigured arrangements which were evidently either too complicated or expensive to complete in bronze or stone. Often conceived in terms of dramatic action, they illuminate an additional aspect of his creative activity.

As a painter, draftsman, and etcher, Lehmbruck was especially attracted to thematic compositions, partly derived from the Bible or writers such as Dante and Shakespeare. A look at his treatment of such subjects as the Prodigal Son, Paolo and Francesca, or Macbeth demonstrates, however, that he was not interested in the anecdotal elements of a given story but in its universal implications, at the heart of which he always discovered the lonely and suffering human being, a theme he explored independently in numerous representations not tied to any literary source.

Two Wounded Men, a crayon sketch done around 1916–17, grew out of Lehmbruck's own anguish during World War I and is one of many drawings and prints in which men and women, wounded, dying, or mourning the dead, represent the collective misery of mankind brought on by the armed conflict. Like Barlach (p. 33), Lehmbruck did not depict the war in historical episodes, but symbolically, as epitomized in the Detroit drawing by the nudity of the figures. A few summary contours, reinforced in several places, delineate the bodies and define the organization of the limbs in terms of a simplified architectonic structure of horizontals, verticals, and diagonals, resulting—as in Lehmbruck's contemporary sculptures—in an expressive interaction of volumes and voids. Emphasis is on rhythmic contrasts, exemplified in the juxtaposition of frontal and profile views and in the calculated differentiation of the heads, one raised in poignant defiance, the other inclined in surrender and grief. Some of the adjustments Lehmbruck made in the gestures of the figures were subsequently covered with white wash, allowing the sketch to serve as a transfer drawing for a lithograph.

Less spectacular than his sculptures, and in the treatment of the individual anatomical details even awkward and crude, Lehmbruck's drawing nonetheless captures the essence of his art. Its timeless spirit, like that of all his mature works, stems from Lehmbruck's ability to render his feelings and perceptions within a universally human context.

Black crayon and white wash, 43.2 x 32 cm (17 x 12⅝ in.)
Signed in black crayon, lower right near center: *W. Lehmbruck*
Bequest of Robert H. Tannahill (70.309)

W. Lehmbruck

AUGUST MACKE

Although August Macke was a member of Der Blaue Reiter, his outlook was far removed from that of Kandinsky and Marc. Carefree, outgoing, and insatiably curious about life, he considered metaphysical speculations about art a waste of time and shared his friends' views on the spiritual value of color only to the extent to which they suited his own sensory perceptions of nature.

Born January 3, 1887, in the Westphalian town of Meschede, Macke grew up in Cologne and Bonn. He enrolled at the academy in Düsseldorf in 1904 but, dissatisfied with the school's outmoded curriculum, soon began to supplement his training by attending evening classes at the School of Arts and Crafts. During the winter of 1907/08 he studied with Corinth in Berlin. Seizing every opportunity to broaden his knowledge, Macke traveled extensively during these years. Three trips to Paris, undertaken between 1907 and 1909, were especially important for his development; they not only introduced him to the bright colors of French Impressionist painting, but also opened his eyes to the expressive use of pure color in the art of Gauguin and Georges Seurat. An exhibition of works by Matisse in Munich in February 1910 further strengthened his growing sensitivity to luminous color and simplified form. Macke, who was then living at Tegernsee in Upper Bavaria, also made friends with Marc at this time and soon established a loose connection with Kandinsky's circle. Having settled in Bonn in the fall of 1910, he took part in the first exhibition of Der Blaue Reiter in Munich the following year.

In September 1912, accompanied by Marc, Macke made another trip to Paris. And once again it was French painting that brought about a turning point

in his career. This time it was his discovery of the combination of transparent Cubist planes and pure color in the Orphist art of Delaunay that provided him with the means of translating his own joyous view of life into pictorial language of extraordinary poetic power. Macke's mature style, a synthesis of Cubism and Fauvism enriched by a tender response to nature, achieved its most personal expression in his radiant paintings executed at Lake Thun in Switzerland between the fall of 1913 and the following spring. These pictures evoke the haunting image of a civilized Arcadia, in which slender, elegant couples walk slowly by the shore of the deep blue lake, stopping occasionally to gaze dreamily into the water.

It was at Lake Thun that Macke conceived the idea of traveling to North Africa with Klee and the Swiss painter Moilliet. Though it lasted only two weeks, during this now-famous journey to the Tunisian city of Kairouan in April 1914 Macke produced hundreds of drawings as well as an astonishing group of glowing watercolors. Back home in his studio, he immediately set to work, hoping to elaborate on this wealth of ideas and motifs. But there was little time left to the artist. Among the first to be called up for service at the outbreak of World War I, the twenty-seven-year-old Macke left Bonn on August 8. Seven weeks later, on September 26, he was killed in action at Perthes-les-Hurlus in France.

NUDE STANDING BEFORE A MIRROR c. 1911

Unlike his friend Marc, who found man ugly and chose to paint animals because they symbolized for him a purer state of existence, Macke was captivated by human beings and throughout his career maintained an affectionate attitude toward man and his world. He did not care for weighty themes, preferring joyous subjects, such as young women gazing at the window displays of fashionable milliners, the cheerful ambience of the circus or the zoo, and elegant couples strolling leisurely through shaded parks. Indeed, Macke's art perpetuates in its subject matter the blithe spirit of Impressionism, except that his primary concern was not the creation of the illusion of forms bathed in light and atmosphere. Like all Expressionists, he was aware of the instinctual basis of art, and what he was after was a way of making colors, lines, and shapes—the whole arrangement of the composition—communicate the feelings he had for life. It is this aspect that allies his art in a fundamental way to the spirit of Der Blaue Reiter.

Macke's watercolor *Nude Standing before a Mirror*, datable on the basis of style to about 1911, is an essay in the contrast of warm and cool colors and curvilinear and straight lines. Sparkling washes of light and vivid green coalesce in the woman's hair and at the outer contours of her body in pools of blue and darker shades of green, accentuating her delicate flesh tones as well as the rich brown of the edge of the mirror in the upper right. By subtly emphasizing the vertical elements of the composition, the painter held in check the playful rhythm of repeated elliptical shapes he initiated in the model's upraised arms and echoed in the mirror's oval frame.

While much of the art of both Kandinsky and Marc rests upon complex intellectual foundations, Macke's watercolor, like the majority of his work, does not require any theoretical support in order to be understood. A feast for the eyes, despite the sheet's small dimensions, it reflects the artist's great love for nature and for simple, traditional themes. Allowing his extraordinary sensitivity to color to be his guide, Macke, like Matisse, whose work he so much admired, gave pictorial expression not to ideas, but to a serene and untroubled world.

Watercolor over graphite, 11.9 x 13.4 cm (4¹¹⁄₁₆ x 5¼ in.)
Bequest of Robert H. Tannahill (70.311)

FRANZ MARC

Franz Marc perceived nature as an interrelated whole, held together by a mysterious inner force. By substituting colors and forms from his imagination for those of the material world, he attempted to express metaphorically the hidden currents flowing through all creation, and he chose the image of the animal as a symbol through which modern man might vicariously experience a sense of cosmic unity with the forces of nature. This harmony is what he sought to make visible in his art.

The son of a minor landscape and genre painter, Marc was born February 8, 1880, in Munich. From 1900 to 1903 he attended the Munich academy, studying with Gabriel Hackl and Wilhelm Diez. A journey to Paris and Brittany in 1903 may have introduced him to French Impressionist and Post-Impressionist painting, though it was not until 1907, following a second trip to the French capital, that the academic character of his earliest works gave way to brighter colors and a more vigorous style.

The year 1910 was unusually important for Marc's development. It was then, through his friendship with Macke and Kandinsky, that he first became truly aware of the expressive power of color. By 1911, working on his first great series of animal pictures, he too was using color in a non-descriptive manner, painting horses and other animals in bold primary shades of red, yellow, and blue.

Marc became a driving force in the formation of Der Blaue Reiter and was responsible for the group's first exhibition, which opened December 18, 1911, at the Thannhauser Gallery in Munich. Throughout most of 1911 he and Kandinsky worked together on the first and—as it turned out—only issue of the yearbook *Der Blaue Reiter*, which they published the following year.

In the course of 1912, under the influence of early Cubist paintings by Picasso and Braque, Marc increasingly stylized the individual forms in his pictures and constructed more tightly the free-flowing rhythms of his compositions. A trip with

Macke in September 1912 to Paris, where they met Delaunay, as well as an exhibition of Italian Futurist painting in Munich at the end of the year, prepared the way for Marc's pictures of 1913–14. Weaving a bright spectrum of colors into an overlapping texture of dynamic Cubist planes, he was able to integrate his animal figures with their environment in an unprecedented unity of form and space. His yearning for a pantheistic harmony with nature found its full expression in these works.

In 1914 Marc, who had been living in the small town of Sindelsdorf in the foothills of the Bavarian Alps since 1909, moved to the village of Ried, near Benediktbeuern. Seeking to represent metaphorically the very genesis of life, he abandoned his stylized animal imagery for lyrical color improvisations suggestive of incipient organic forms. In August, following the outbreak of World War I, he was called up for military service. Although the war made it impossible for him to paint, he managed to continue his investigation of nonobjective forms in a series of pencil sketches. As the war progressed, he became increasingly concerned with what he called "nature's ugliness and impurity," and the extent to which modern man had made the world "look poisoned and distorted."[22] Dreaming of a new and better world, he kept thinking of the expressive possibilities of abstract painting, hoping to translate his conception of a purer state of being into an appropriately purified pictorial form. But he knew he would be able to do this only after the war was over, in the solitude of his house in Ried. "Back there it will happen," he wrote optimistically in 1915. "I often have the feeling that I hold in my pocket something secret, something very happy at which I must not look. I just put my hand on it once in a while and touch it from the outside."[23] Franz Marc was only thirty-six when he was killed in battle near Verdun on March 4, 1916.

Much Expressionist art arises from a rejection of the materialism of modern society and speaks of a desire for a simpler way of life which is frequently associated with an empathetic feeling for nature. The same search for an unspoiled state of existence that drew Mueller to the Gypsy camps of central Europe (p. 169) and Pechstein and Schmidt-Rottluff to the remote fishing villages of the Baltic Sea (pp. 191, 206) led Marc to the animal world. In animals he saw creatures truer than men, living in peaceful harmony with the world around them. "Very early I found people to be 'ugly,'" he wrote in a letter of April 12, 1915; "animals seemed more beautiful, more pure."[24] His distaste for man, however, only partly explains why Marc made animals the central motif of his art. In 1908 he spoke of his desire to intensify his sensitivity to what he called the "organic rhythm" of nature, by projecting his whole being into "the vibration and flow of the blood" of animals, trees, and air.[25] To uncover the mysterious currents that pervade all nature, to reveal the spiritual reality that lies hidden beneath appearances, was Marc's aim throughout his tragically short career. He sought an "animalization"[26] of art, and he chose the animal as the most fitting symbol of a harmonious state of being in a primeval world.

The formal vocabulary of the art of Delaunay and Umberto Boccioni, and the transparent, interpenetrating color planes of French Orphism and Italian Futurism allowed Marc to lay bare the inner structure of the world as he perceived it. In the pictorial rhythm of paintings such as *Animals in a Landscape*, painted in 1914, Marc sought to make manifest the secret pulse beat, order, and oneness of nature. Prismatic forms of pure red, yellow, blue, and green shoot across the composition. Intersecting each other, they weave the entire picture ground into one kaleidoscopic unity of color and form. The animals, shown as simplified hieroglyphs signifying the universal model from which all individual forms of nature are derived, are firmly bound to their environment. Their luminous, abstracted shapes, hovering in beams of colored light, literally have been absorbed into the pictorial structure of the painting as if to symbolize the integration of all living things in a great cosmic whole.

Marc's desire to communicate his experience of nature to his fellowman, as well as his belief in the underlying unity of nature, can be traced to the philosophies of men such as Novalis and Friedrich von Schelling and exemplify the intimate relationship between German Expressionism and the German Romantic tradition. In their expression of a deep, spiritual origin, Marc's paintings are comparable in many ways to pictures by Friedrich (fig. 14). But like the art of his fellow Expressionist Mueller (p. 165), whose languid nudes seem to be aware of the unbridgeable gulf that separates the real from the ideal, Marc's pictures barely disguise a gentle undercurrent of sorrow. His animals, sealed in a scaffolding of colored forms, belong to a remote and legendary world in which man is not included.

Oil on canvas, 110.2 x 99.7 cm (43⅜ x 39¼ in.)
Signed and dated: lower right, *M.*; verso, *1914*
Gift of Robert H. Tannahill (56.144)

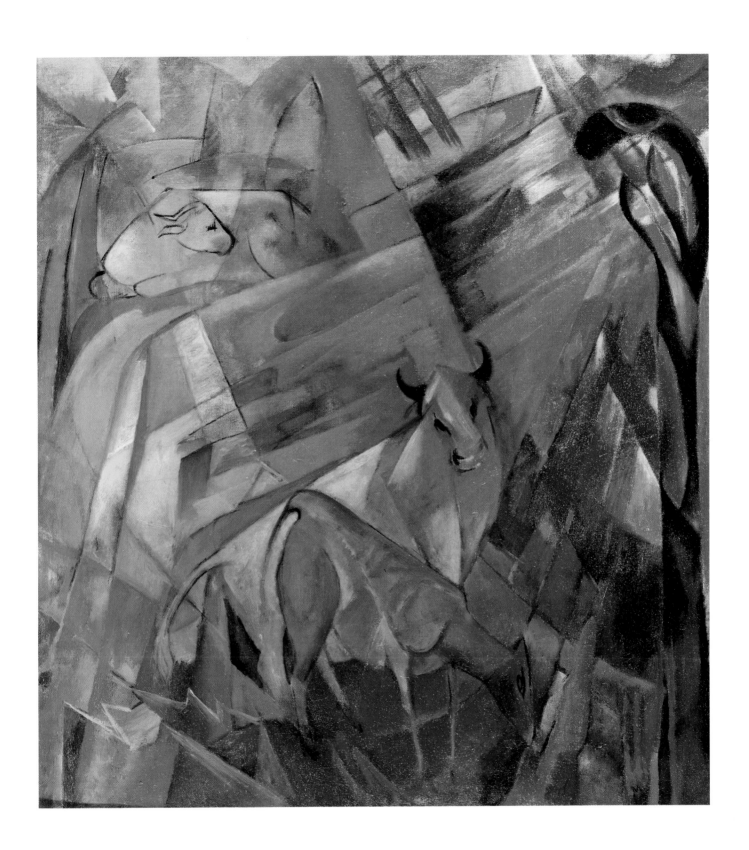

PAULA MODERSOHN-BECKER

"The most beautiful thing would be to give figurative expression to this instinctive feeling that often hums softly and sweetly inside me," the young Paula Becker wrote in her diary in 1898.[27] It was this keen sensitivity to her environment and the desire to discover the inner meaning of visible things that subsequently enabled her to understand the significance of Van Gogh, Gauguin, and Cézanne, and to develop—independently and earlier than any other German painter of the twentieth century—a pictorial language of expression.

The daughter of a railroad official, Paula Becker was born in Dresden on February 8, 1876, into a cultured home frequented by writers and intellectuals. In 1888 the family moved to the busy port city of Bremen. Though Becker took her first drawing lessons from a local painter at the age of sixteen, only after she had acquired a reliable means of self-support by completing a two-year training program at the Teachers Seminary in Bremen was she allowed to continue her studies in art. From 1896 to 1898 Becker attended the School for Women Painters in Berlin, where she received conventional academic training. In 1897, during a summer vacation in Bremen, she first visited the nearby village of Worpswede. It was there that

in 1889 Fritz Mackensen and his friend Otto Modersohn—joined by Hans am Ende, Fritz Overbeck, and Heinrich Vogeler—had founded an artists' colony. Rejecting the confining atmosphere of the academy and the materialism of the modern industrialized metropolis, they moved out into the countryside to live and paint. True offspring of the German Romantics, they perceived nature in poetic terms and sought to express their emotions in lyrical peasant scenes and melancholy landscapes. Paula Becker immediately felt drawn to the austere beauty of Worpswede, the silent moors and peat bogs, windswept birch trees, and fields of flowering heather traversed by black streams. She moved to Worpswede in the fall of 1898, taking lessons from Mackensen, who specialized in pictures of the local peasants. She also formed a close friendship with the sculptor Clara Westhoff, the future wife of the poet Rainer Maria Rilke. In February 1899, however, Becker realized that her own path would ultimately have to take her beyond the outlook of her friends. She began to paint in a broader and more simplified manner, relying increasingly on line to reinforce the structure of her pictures. Disappointed by the hostile reception at her first exhibition at the Kunsthalle in Bremen in December 1899, but unfailing in her belief in the soundness of her artistic instincts, the determined young painter left for Paris on New Year's Eve. Between January and July 1900 she attended the Académie Colarossi, took lessons in anatomy at the École des Beaux-Arts, and sought inspiration among the old masters in the Louvre. At the Ambroise Vollard Gallery she saw for the first time paintings by Cézanne.

In 1901 Paula Becker married Otto Modersohn, who had recently been widowed and was left with a young child. She returned for two months to Paris in the spring of 1903, studying once again at the Académie Colarossi and making drawings in the Louvre after ancient Egyptian and Greek sculpture. During a third visit, from February to April 1905, she attended the Académie Julian and came to know works by the Nabis and Van Gogh. An extended stay in the French capital from February 1906 to April 1907 deepened her understanding of Van Gogh, Gauguin, and Cézanne, bringing about a period of rapid artistic growth. Striving for ever greater conciseness and economy of form, she accomplished in a series of monumental nudes what had always been her aim: to clarify her emotions and define her experience of nature in a simple, truthful manner. "I am going to become something," she wrote to her sister from Paris. "I am living the most intensely happy period of my life."[28] Yet this happiness was obtained at a high price. Aware of the feelings and emotional needs of others, but unable to reconcile her duties as wife and mother with her burning desire to be an independent artist, she had left her husband early in 1906, a step which caused her untold anguish. In the fall of 1906 Modersohn—hoping to persuade her to renew their relationship—followed her to Paris. Pregnant, she returned with him to Worpswede the following spring. Her condition made it difficult for her to work during the summer. Early in November she gave birth to a daughter and three weeks later, on November 20, getting up for the first time from childbed, suffered an embolism and a fatal heart attack. She was thirty-one when she died.

In scarcely a decade Paula Modersohn-Becker produced over 500 paintings and close to 1,000 drawings. Though she looked upon many of these as student work, she would not necessarily have considered her art and her life fragmentary and incomplete. As a twenty-four-year-old painter, she wrote in her diary on July 26, 1900:

I know I will not live very long. But is this sad? Is a celebration more beautiful because it lasts longer? And my life is a celebration, a short, intense celebration. My sensuous perception is becoming sharper, as if I were supposed to take in everything, everything, in the few years that are offered me . . . and if I paint three good pictures, then I can leave willingly with flowers in my hands and hair.[29]

Despite her empathetic response to the beauty and manifold moods of nature, Modersohn-Becker's primary subject was the human figure. "Painting people is really better than painting landscapes," she wrote enthusiastically to her parents during her visit to Worpswede in July 1897, having just completed her first outdoor portrait of a blond, blue-eyed child.[30] Like Mackensen, with whom she studied briefly after moving to the artists' colony in the fall of 1898, she was especially attracted by the earthy simplicity of the local peasants. But unlike her teacher, under whose direction she did a series of meticulously executed portrait drawings, she eschewed the anecdotal and idyllic, seeking to define her perception of man as a primordial creature in a commensurately simple and monumental form. "The way Mackensen perceives the people around here is not broad enough for me," she wrote in her diary in December 1902. "It's too genre-like. Who can, should write them in runic script."[31]

Old Peasant Woman, one of Modersohn-Becker's most famous and important paintings, belongs to a series of peasant pictures done in Worpswede between the artist's return from Paris in April 1905 and her departure for her last trip to the French capital in the middle of February the following year. In it is epitomized that striving for an ever greater simplification of the pictorial means through which the young painter sought to reveal the inner meaning of things. Rejecting Mackensen's naturalism as well as that of her own earliest portrait drawings, Modersohn-Becker reduced the image to a few large forms, evocative of a sense of quiet dignity and repose. The determined strength emanating from the solemn figure is reinforced by the harmony of shades of ocher and blue and a green that becomes lighter in the stylized foliage of the flat background and forms a radiant glow around the old woman's head. In front of Modersohn-Becker's rugged and unsentimental picture it is impossible not to think of Van Gogh who, in his sympathetic portraits, wanted "to paint men and women with that something of the eternal which the halo used to symbolize."[32] Unlike Nolde, who subsequently translated the Dutchman's subjective manner into a pulsating and ecstatic style, and who, in his search for the archaic, discovered in the primitive the demonic and the grotesque

(p. 183), Modersohn-Becker not only shared Van Gogh's compassionate humanity, but was steadied in her quest for an expressive pictorial language by Gauguin's decorative color and line and Cézanne's abiding concern for form. Both her feeling for the structural clarity of the composition and the need to place her subjects within an unchanging, universal order of things link her work more closely to that of Cézanne than to that of any of the founders of German Expressionism, on whose early development the Frenchman had little influence. In a letter written just four weeks before she died, she spoke of her great desire to return to Paris, for she had learned that fifty-six Cézannes were on exhibition there.

Having stripped her subject of all anecdotal detail, Modersohn-Becker subordinated the specific to the symbolic. Even the sitter's gesture is hieratic and ceremonial, reinforcing the air of mythic grandeur that surrounds the woman who, like an ancient Norn, gazes with her heavy-lidded eyes beyond all time and space. Having crossed her hands over her breast, in a gesture seen in many Annunciation pictures at least as old as the fourteenth century, she obediently accepts, as the sprig of fresh flowers in her lap seems to suggest, her role in the rhythm of nature and in the everlasting cycle of birth, maturity, and death.

Modersohn-Becker's painting formerly belonged to the Kunsthalle in Hamburg, where it was one of the highlights of the modern art collection before the Nazis confiscated it in 1937. What they wanted in art were idealized representations of a Nordic "superman" or *Übermensch*, to use Nietzsche's inimitable word somewhat loosely. What Modersohn-Becker tried to suggest in her work was a glimpse of the *Urmensch*, the *primordial* human being.

Oil on canvas, 75.5 x 57.7 cm (29¾ x 22¾ in.)
Inscribed on the back: *Dieses Bild ist ein Original von Paula Modersohn-Becker/Otto Modersohn*
Gift of Robert H. Tannahill (58.385)

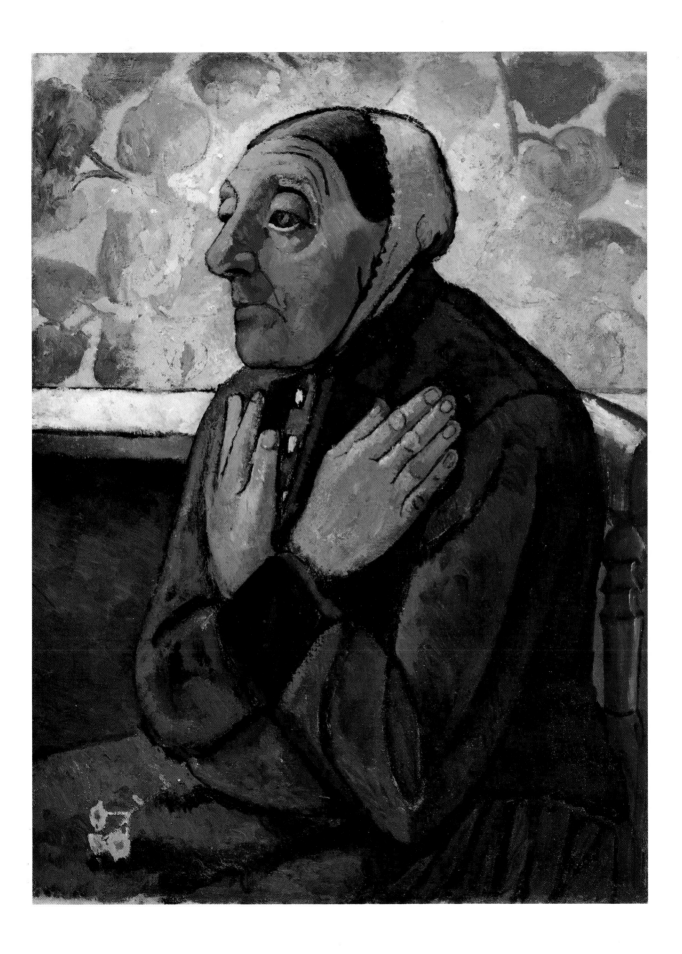

OTTO MUELLER

Born October 16, 1874, in the small Silesian town of Liebau, Otto Mueller was the son of a minor tax official. His mother, who had been raised in the household of an aunt of the writers Gerhart and Carl Hauptmann, was said to have been the illegitimate daughter of a Bohemian servant girl and a Gypsy. Though there seems to have been little justification for this rumor, Mueller not only never contradicted it, but perpetuated the legend by his interest in Gypsy subjects and by his own exotic appearance. Of medium height, the slender painter had blue-black hair, an unusually brown complexion, and dark, melancholy eyes. Fascinated by magic and the occult, he always wore an amulet around his neck to ward off evil spirits.

Mueller's career began in 1890 when he was apprenticed to a lithographer in Görlitz. From 1894 to 1896 he attended the academy in Dresden and was in frequent touch with the Hauptmann brothers. The character of the painter Arnold Kramer in Gerhart Hauptmann's drama *Michael Kramer*, 1900, as well as the hero of Carl Hauptmann's novel *Einhart the Smiler (Einhart der Lächler)*, 1907, were modeled on the young artist. Dissatisfied with his studies at the Dresden academy, Mueller went to Munich in the winter of 1898/99, working briefly in Stuck's atelier. Back in Dresden in the autumn of 1899, he met the sensuous and capricious Maschka Meyerhofer.

Meyerhofer, whom Mueller married in 1905, was a selfish and unstable woman whose affection turned from pettishness to hostility when the artist was unable to provide her adequately with the material comforts she demanded (see p. 167). Mueller, who never ceased to blame himself for the breakdown of their life together, continued to plead for her understanding and friendship until long after their divorce in 1921. His lifelong concern for her well-being not only contributed to the failure of his second marriage, to Elsbeth Lübke in 1922, but ultimately overshadowed the prospect of any other lasting relationship.

From 1899 to 1908 Mueller lived in relative obscurity in the Silesian mountains, painting dancers and bathers in a decorative manner reminiscent of the Jugendstil idealism of Ludwig von Hofmann and Stuck. In 1908 he moved to Berlin where he met Lehmbruck, whose sculpture encouraged him to pursue a more monumental approach to the human figure in his own work. Having had his entry rejected by the jury of the Berlin Secession in 1910, Mueller became the co-founder of the Neue Sezession, which brought him to the

attention of the artists of Die Brücke. Later that year he joined the group and remained an active member until it was formally dissolved in 1913. Aside from his thorough familiarity with the lithographic process, Mueller brought to Die Brücke his knowledge of distemper, a water-based medium made with glue-size, which eventually helped his friends to start painting in the large, flat planes that had already begun to distinguish their woodcuts. The years 1910 to 1915 were among Mueller's most creative and saw the development of his characteristic style, a somewhat more austere form of his earlier decorative pictures, epitomized by slim and graceful nudes in idyllic landscape settings.

Mueller was drafted in 1916 and the following year suffered a severe case of lung inflammation, the first sign of an ailment that was to plague him for the rest of his life. Though he never fully recovered, he continued to serve in the army until the end of World War I. He was appointed a professor at the academy in Breslau in 1919. In 1924 he began his annual trips to central Europe in search of Gypsy motifs. Upon the painter's return from a journey to Hungary and Bulgaria early in 1930, his illness became progressively worse. He died September 24 in Breslau, three weeks prior to his fifty-sixth birthday.

Within the Expressionist movement, Mueller's art is among the most gentle and lyrical as well as the most consistent in content and form. Once he had discovered his mature style, his work showed only subtle change. From about 1919 on his colors became somewhat more somber, his contours more emphatic and expressive, and his lyricism tinged with melancholy. The fact that he did not date his paintings and prints makes it even more difficult to fit them into a precise chronological order. Since, aside from a few self-portraits and the Gypsy subjects done during his last years, Mueller's work consists largely of bathers and nudes, he has been accused of being monotonous. A more sympathetic interpretation of his gentle art is that he always repeated the melody of an old, familiar tune.

BATHERS c. 1920

Mueller's pictures present an idyllic world of forest glades and shaded ponds where graceful nudes, bathing or moving silently among the reeds and slender trees, evoke a haunting image of primeval innocence. Yet the state of Arcadian bliss suggested in his art is always tempered by a touch of melancholy. In contrast to the robust vitality emanating from the powerful and sensuous nudes of Pechstein (p. 191), there is something sorrowful about the languid movements of Mueller's adolescent figures, whose shrouded eyes seem to hide an unfulfilled longing for a life of beauty and harmony.

The emphatic contours circumscribing the simplified figures suggest that *Bathers*, a painting which in both content and form epitomizes Mueller's introspective lyricism, dates from around 1920. Deceptively simple, the picture's compositional structure—a rhythmic interplay of verticals, horizontals, and diagonals—is determined by the poses and gestures of the two female nudes, one standing in a pond, arranging her hair, the other, wearing a conical hat, seated by the shore, gazing wistfully at the water. Despite the willful stylization of the pointed limbs, which sets in motion a rhythmic pattern of triangular shapes reverberating in the tufts of grass and the angular forms of the terrain, the bodies retain their graceful pliancy and a potential for free movement.

Like the nineteenth-century German painter Marées, who achieved a similar internalization of mood by comparable pictorial means (fig. 13), Mueller, through his skillful fusion of subject and form, managed to evoke an ordered world of classical calm. The principal source for his inspiration, however, derives not from Marées's classicism but—as Mueller himself stated in connection with an exhibition of his work at Paul Cassirer's gallery in Berlin in 1919—from the art of ancient Egypt. Egyptian wall paintings and reliefs present the closest parallels to the German painter's two-dimensional designs and the rhythmic contours which define the measured movements of his angular figures. Mueller's generally subdued colors—in the Detroit painting, creamy flesh tones and shades of a light grayish green have been placed against a flat background of dark blue—also can be traced to the same source. They are the result of his use of distemper, a water-based tempera whose qualities the artist had discovered in the course of his efforts to emulate the dull and chalky surface of ancient Egyptian painting. Since it dries rapidly, distemper must be applied swiftly in uniform, thin layers over relatively large areas, demanding that the artist simplify his individual forms and eliminate superfluous details. If, as is the case in the Detroit painting, the pigments are permitted to soak into a rough-textured canvas, the final effect is not unlike that of an old tapestry or fresco.

As both the subject and composition of *Bathers* indicate, the symbolic union of man and nature Mueller sought to evoke is a typically Expressionist utopia. However, his peaceful scene has nothing in common with the ebullience of Pechstein, the nervous excitement of Kirchner, or the crude and primitive strength of Schmidt-Rottluff. Mueller's lyricism shows some affinity only with Heckel's art, without achieving the same measure of poignancy and psychological depth. Like Lehmbruck, whose statues project a similar mood of tranquility and introspection (p. 147), Mueller is best described as a traditionalist within the Expressionist movement. In his compositions the vivid color and hectic calligraphy characteristic of the art of Die Brücke are transformed into a eurhythmic pictorial language that never loses touch with the grand tradition of nineteenth-century figure painting.

Distemper on canvas, 94.6 x 78.7 cm (37¼ x 31 in.)
Signed, lower left: *O.M.*
City Appropriation (21.210)

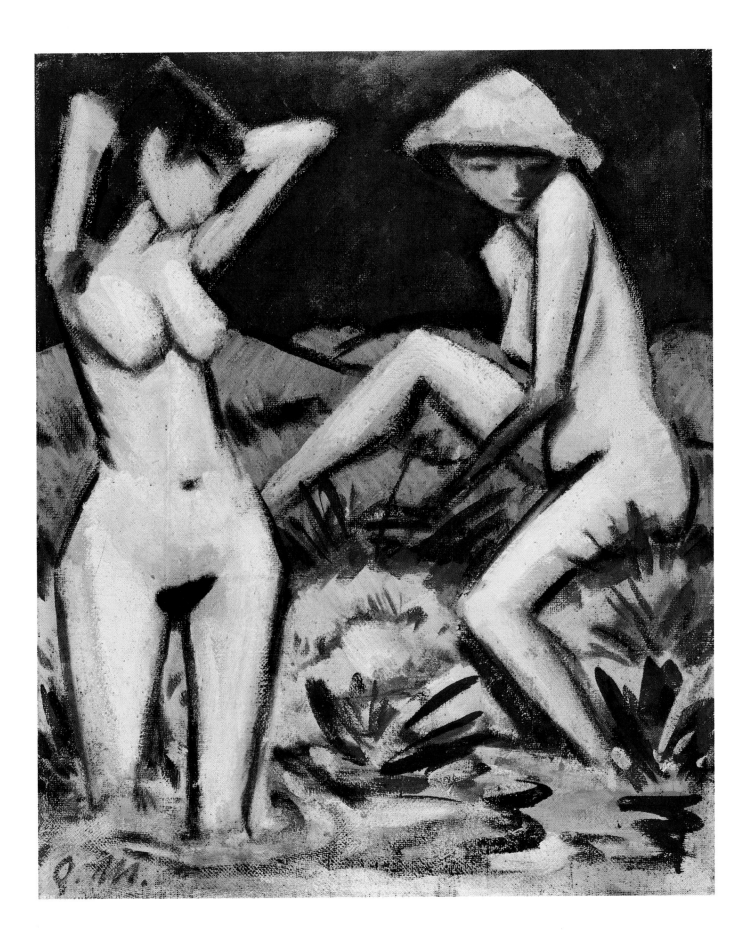

SELF-PORTRAIT WITH MODEL AND MASK c. 1922

Troubled by poor health and two unsuccessful marriages, Mueller's life was far from tranquil and suggests that his graceful bathers and nudes, evoking so unequivocally the promise of a harmonious accord between man and nature, were metaphoric images of his plea for an ideal human existence. *Self-Portrait with Model and Mask*, one of ten lithographs published in 1922, is a poignant variation on the same theme. Augmented by the painter's awareness of the fragility of human relationships, it belongs to a series of paintings and prints in which a male figure—frequently a barely disguised self-portrait—gazes longingly, though with sad resignation, at a sensuous woman who is seemingly oblivious to her partner's presence. In this lithograph the spiritual isolation of the two figures is reinforced by their physical proximity to each other within the confines of the cramped pictorial space, while the starry-eyed mask in the upper right, playing a major part in both the structure and the meaning of the composition, adds a disturbing note to the print's pensive and introspective mood.

In contrast to the male figure which, despite the stylized rendering of the gaunt face, shows a fairly good likeness of the artist's exotic features, the female head in the lower right cannot be identified but depicts a type that recurs with minor variations in many of his compositions. Given the instability of Mueller's relationships with women, this figure, too, evidently has autobiographical significance and most likely illustrates the painter's psychological dependence upon his first wife Maschka Meyerhofer. Although they were divorced in 1921, in September 1926 he wrote her:

I am deeply unhappy and am working feverishly in order to forget my loneliness. And if by chance I am with someone I love, I am overcome by the great fear that someone hostile will take that person away from me, thereby destroying me completely. For I would not know how to go on living.[33]

It is within this context that the mask in the upper right corner of Mueller's print, hovering like an ominous image of foreboding above the idealized head of the woman, is best understood. Yet, in keeping with his gentle spirit, the lyricism of Mueller's elongated forms and the soft modulations of the lithographic crayon—his favorite graphic medium and one especially well suited to his disposition—permitted him to translate even the sharp sting of his most persistent anguish into mute sorrow.

Lithograph, image 38.5 x 29 cm (15¼ x 11⅜ in.), sheet 53 x 35.8 cm (20⅞ x 14⅛ in.)
Signed in pencil, lower right: *Otto Mueller*
Gift of Robert H. Tannahill (47.63)

GYPSY ENCAMPMENT c. 1925

As a child Mueller was spellbound by the sight of migrating Gypsies who, on foot and in mule-drawn carts, frequently passed through Liebau. Whether it was their freedom from accepted social conventions or the artist's supposed ethnic heritage that subsequently led him to devote many paintings and prints to this subject matter is difficult to say. It may have been both. To seek inspiration in the unconventional and primitive, be it in the dives of the modern metropolis (pp. 81, 99) or at the remote beaches of the Baltic Sea (pp. 191, 205), was, of course, a typically Expressionist concern. Mueller's pursuit of the primitive lifestyle of the Gypsies in the tiny villages of Rumania, Bulgaria, and Hungary was part of the characteristic search for the remote origins of art and life that took Nolde and Pechstein to the islands of the South Pacific and Modersohn-Becker (p. 161) to the somber peat bogs of rural Worpswede.

Between 1924 and 1930 Mueller spent several weeks each year traveling through central Europe, living among various Gypsy tribes. In particular Szolnok, a small town near Budapest, inspired many of the motifs that eventually found their way into his celebrated *Gypsy Portfolio*, a group of eleven color lithographs published in 1927.

Gypsy Encampment, probably done in 1925, is one of several variations on the theme of Gypsies resting in the countryside and illustrates, as do most of Mueller's mature works, the artist's indebtedness to ancient Egyptian wall painting. The four figures and the mule, shown in either frontal or profile views, are arranged in a spatial setting whose boundaries are summarily defined by the large tent in the center. Yet their friezelike arrangement across the canvas and the generalized treatment of each form maintain the integrity of the two-dimensional picture surface. The composition is remarkably simple, with the flat, geometric shapes of the tent and the adjoining upper left and right corners of the painting balanced against the quickening rhythm of the angular limbs of the figures. Mueller's restrained colors, dominated by earth tones, reinforce this equilibrium. For even the medium-blue sky, yellow sunflowers, and pink skirt of the Gypsy girl seated on the right, gravitate toward gray and do not disturb the muted tonality of the whole.

The austerity of both form and color in the Detroit painting, done in chalky distemper on a rough-textured canvas, could not be more appropriate to the humble subject. Yet *Gypsy Encampment* is not an ethnological document. Rather, it is an idealized image somewhat akin to the Tahitian pictures of Gauguin (fig. 7), in which details observed from life merge into what is ultimately a decorative composition meant to convey the unspoiled essence of a simple existence. Ignoring the unattractive aspects of a meager nomadic life, Mueller dwelt on the exotic and the picturesque, projecting a conception of the primitive that is no less idyllic than the dream world of his bathers and nudes.

Distemper on canvas, 105.4 x 144.8 cm (41½ x 57 in.)
Signed, lower left: *O.M.*
Gift of Robert H. Tannahill (57.182)

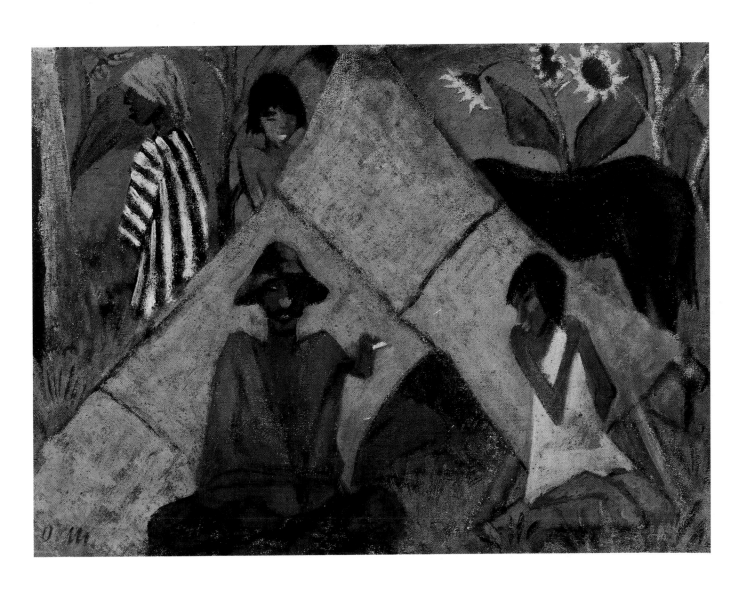

EMIL NOLDE

The work of no other painter illustrates the intuitive character of German Expressionism as fully as that of Emil Nolde. Solitary, introspective, and steeped in the simple piety of his Protestant forebears, he keenly identified with nature and throughout his life took refuge in daydreams that gave rise to a world of phantoms and primordial beings. His art encompasses a vast range of subjects and includes a remarkable series of prints. But it was above all through color that Nolde gave tangible expression to his feelings—color that heightens his evocative landscapes and flower pictures, his fervid religious paintings, and splendid figure compositions. His gemlike watercolors, in particular, are landmarks in the history of German Expressionism.

Nolde, who rejected the term *expressionist* as far too narrow a classification, preferred to think of himself as a "German" painter. Indeed, his art cannot be separated from the land his ancestors had tilled for generations. The vast, windswept meadows and marshlands of the north German plain between the Baltic and the North Sea lie at the heart of his pictures; nearly all of them were painted there.

Emil Hansen was born August 7, 1867, on his father's farm in Nolde, a small village by the edge of the North Sea close to the German-Danish border, and from which he later took his surname.

He was trained as a woodcarver and furniture designer and, following several jobs as a commercial draftsman in Munich, Karlsruhe, and Berlin, taught industrial design at the Museum for Arts and Crafts in Saint Gall, Switzerland. Though he had begun to draw and paint a number of years earlier, it was not until 1898, at the age of thirty-one, that he decided to study art in earnest. Having been refused admission to the Munich academy, he spent the summer of 1899 in nearby Dachau, where he came under the influence of Adolf Hoelzel, one of the most important teachers in the development of twentieth-century art. Hoelzel, who painted moody landscapes in which the essential features were emphasized through evocative colors and simplified forms, encouraged Nolde's own inclination toward emotive and antinaturalistic rendering.

Following a sojourn in Paris, where he studied briefly at the Académie Julian, Nolde returned to north Germany in 1900. He married Ada Vildstrup in 1901 and the same year, as if to signal the beginning of a new life while affirming his roots in the old, adopted the name of his native village as his own. In 1903 Nolde and his wife moved to the island of Alsen, just off the east coast of Schleswig. Here, in the isolation of his small studio on the beach, he began a series of glowing garden and flower pictures which, though inspired by Impressionism, surpass their prototypes in both intensity of color and boldness of execution. When some of these forceful paintings were exhibited in Dresden in 1906, the artists of Die Brücke greeted them with enthusiasm and invited Nolde to join

them in their efforts to bring about a renewal of German art. Nolde became a member of Die Brücke in 1906, but withdrew by the end of the following year, fearing that his own more advanced ideas might be weakened if adopted by the group.

In 1908 Nolde achieved full artistic maturity in a series of watercolors of remarkable spontaneity and force of expression. One year later, while recovering from a serious illness at Ruttebüll, a small hamlet near his native village, he painted his first religious pictures, abandoning the last vestiges of Impressionism in favor of a more arbitrary treatment of color and form, and heightened emotional impact. From 1909 on he also began to spend the winter months in Berlin, returning each spring to his beloved Schleswig. In 1913 he and his wife participated in an expedition to New Guinea. The year 1917 saw their move to a lonely farmhouse amidst the marshes of west Schleswig at Utenwarf, only a short distance from the painter's birthplace. When new dike constructions threatened to destroy the wilderness at Utenwarf, Nolde looked for a new home, settling in 1927 at nearby Seebüll.

Nolde was made a member of the Prussian academy in Berlin in 1931. In 1935 he was stricken with cancer of the stomach. Following long weeks of hospital care, surgery was unexpectedly successful. Meanwhile, National Socialist propaganda against modern German art had begun, and, although Nolde had joined the party in 1933, from the beginning he was one of the artists attacked. More than 1,000 of his works were confiscated in 1937, and nearly thirty were included in the Degenerate "Art" exhibition and illustrated in the accompanying guide as typical examples of artistic and racial inferiority. In August 1941 Nolde was forbidden to paint or to engage in any related professional activity on the grounds of cultural irresponsibility. He suffered acutely from this prohibition. Moreover, he worried about the safety of his confiscated pictures. Having always treated his works protectively, as if they were his children, it was a severe blow to him when he learned in 1942 that his studio in Berlin, containing several paintings and nearly his entire stock of drawings and prints, had been destroyed by Allied bombs.

It was under these conditions that Nolde, who was in his seventies at the time, set to work in a tiny room in his isolated house at Seebüll, producing what eventually amounted to more than 1,300 small watercolors, usually measuring no more than eight by six inches, not daring to do any oil paintings for fear that the smell of the pigment might betray him in the event of a surprise inspection. After the war, between 1945 and 1951, he translated nearly 100 of these radiant "unpainted pictures," as he called them, into oil paintings. Nolde was eighty-eight years old when he died at Seebüll on April 13, 1956.

Although Nolde remained all his life a man of the soil and was quick to denounce the encroachment of technology upon nature, both the modern metropolis and the world of industry provided his source of inspiration for a number of outstanding works. *Hamburg: Landing Pier* belongs to a series of nearly twenty etchings done in early 1910 while Nolde visited the teeming seaport for several weeks. Having rented a room at a sailors' hostel near the water, he spent his days on the docks and frequently accompanied laborers on their clanking tenders and barges, experiencing and absorbing the sound and smell of the industrial port. At night, back in his dingy quarters, he proceeded to record his impressions on a set of steel plates.

Though his earliest etchings date from 1898, it was not until Nolde worked on his prints of Hamburg harbor that he achieved complete mastery over the medium. The example in Detroit, one of a relatively small number of impressions, illustrates his virtuosity especially well. The resinous ground with which the plate was coated prior to its submission to the acid bath was applied with remarkable skill. Subtle modifications in the thickness of the ground, which Nolde is known to have achieved by using both stiff and soft bristle brushes and a spatula as well as his fingers, permitted the acid to attack the plate at uneven rates, resulting in random aggregates of tiny black spots which cover the entire surface as with a transparent veil. Moreover, by combining line etching and aquatint, Nolde obtained an extraordinary range of tonal gradations, extending from diaphanous, washlike shades—especially noticeable in the waves and smoke-shrouded silhouettes of the distant warehouses—to the most sumptuous velvety black in the wood piles of the pier.

Nolde depicted the harbor with controlled objectivity, paying close attention to nuances of atmosphere and light. Yet his print is not necessarily an eye-dazzling, optimistic celebration of technological progress. Indeed, the empty expanse of the pier evokes a sense of isolation that is matched only by the bleakness of the mighty piles and smoke-enveloped wharves. Nonetheless, as the well-ordered composition of the print demonstrates, Nolde maintained psychological distance. He balanced the dense mass of black lines in the upper half of the sheet carefully with a somewhat larger area of comparably greater transparency below and tempered the diagonal thrust of the pier by allowing the viewer to gaze beyond the water at the right, stabilizing both recessional movements by means of repeated and forceful vertical accents. Whatever expressive notions his print contains, Nolde's pictorial logic keeps them, at least for the moment, safely at a distance.

Etching and aquatint, plate 30.5 x 40.5 cm (12 x 15 15/$_{16}$ in.), sheet 46 x 62.5 cm (18^{1}/$_{16}$ x 24^{5}/$_{8}$ in.)

Signed and inscribed in pencil: lower right, *Emil Nolde.*; lower center, *Hamburg: Landungsbrücke*

City Appropriation (30.86)

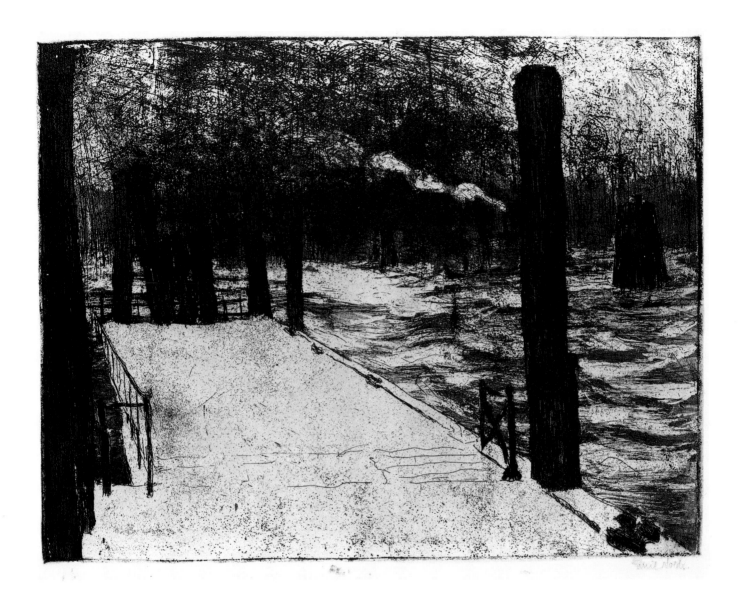

THE STEAMER c. 1910

In his efforts to discover a pictorial language with which to express his innermost feelings, Nolde's watercolors played an important role. *The Steamer*, for example, probably dating from 1910, illustrates to what extent he freed himself in this more fluid medium from the descriptive, Impressionist method exemplified by his prints of Hamburg harbor done the same year. Utilizing a technique he first developed in 1908, Nolde saturated the fibrous Japan paper with green and blue washes, permitting the individual colors to flow into each other and to collect in random pools of varying hues. Once the paper had dried, the image of the churning boat, emitting thick plumes of smoke, was rapidly executed by dragging a brush dipped in black across the evocative ground. A final dab of reddish brown served to add definition to the hull of the vessel. Light and atmosphere are no longer the results of observation. Natural light has been replaced by pictorial light. Light has become a function of color. Similarly expressive is the compositional structure of Nolde's watercolor, which has been skillfully contrived to enhance the character of the whole. By placing the boat close to the right margin of the paper and by seeming to permit the bands of wash to extend beyond the confines of the frame, Nolde managed to create the illusion of an infinite expanse of sea above which the viewer remains precariously suspended. The psychological distance which he so carefully preserved in his etchings of 1910 has been abandoned in favor of a more direct emotional participation.

While the subject matter of *The Steamer* recalls the artist's visit to Hamburg, the question of whether it is based on a specific incident, a possibly violent voyage by sea, is here no longer important. For Nolde's watercolor belongs—if not to the world of fantasy—to that realm in which things remembered are sublimated in vivid images that transcend verifiable fact. Moreover, Nolde's imagination is known to have been especially receptive to the elemental forces in nature irrespective of the conditions of his surroundings. Reporting on the progress of his work at Lildstrand, a small fishing village on the lonely coast of north Jutland, he wrote to his fiancée during the early months of their courtship:

I stood peacefully behind the dunes, painting two small houses, their outlines growing indistinct in the dusk. The wind began to blow, the clouds grew wild and dark, a storm blew up, and the gray sand swirled high above the dunes and the little houses. A raging storm—then, suddenly, a powerful brush ripped through the canvas. The painter came back to himself and looked around. It was still the same quiet and beautiful evening hour. Only he had been carried away and lived through a storm in his imagination. The image disappeared.... That's the kind of thing that happens to me.[34]

This letter was written on August 7, 1901. Nolde had tried to express his feelings for the elemental in nature at that time in a series of small drawings depicting strange and fantastic creatures by the sea. About a decade later, in a work like *The Steamer*, he was able to transmute directly into pictorial form his image of nature as an ominous force.

Watercolor on Japan paper, 19.5 x 14 cm (7 11/16 x 5½ in.)
Signed in black ink, lower left: *Nolde.*
Bequest of Robert H. Tannahill (70.322)

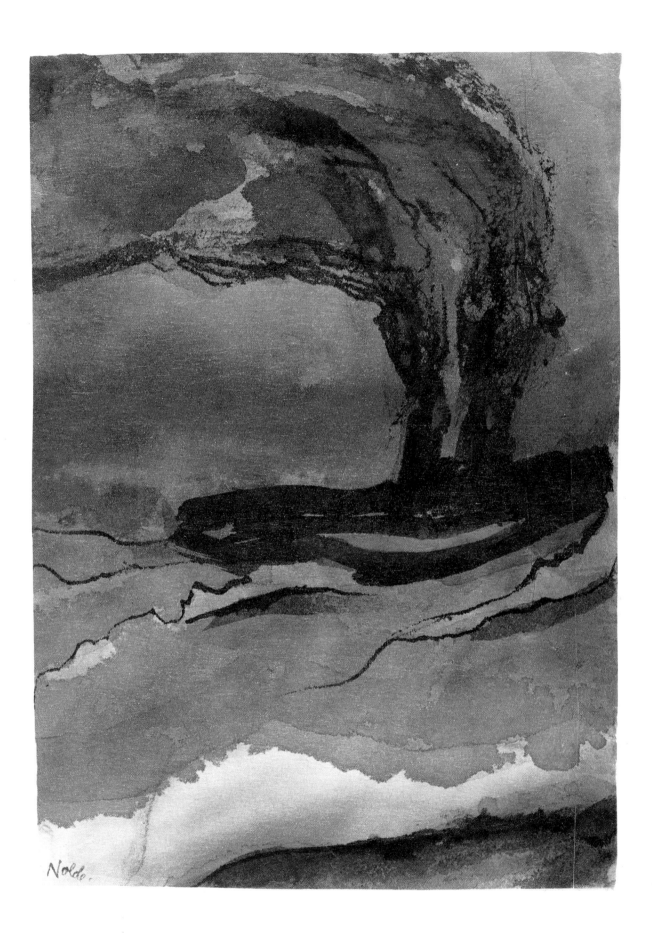

Nolde's earliest boyhood encounter with painting was his discovery of a series of wood panels decorated with scenes from the life of Christ. Throughout his life he turned intermittently to biblical themes, painting what surely must be among the most fervent religious pictures in modern art. Their importance for his development can hardly be overemphasized, for it was in these works that his forceful Expressionist style first manifested itself fully. The earliest examples date from the summer of 1909 and were done at Ruttebüll, where, while recovering from a brief, but serious illness, Nolde, as he later recalled, painted his first religious pictures "without much intention, knowledge, or thought," driven by an "irresistible desire to depict profound spirituality, religion, and tenderness."[35] Working with feverish intensity, as if in a trance, he completed in a matter of weeks three paintings—*The Last Supper* (Ada and Emil Nolde Foundation, Seebüll), *The Mocking of Christ* (Collection Hanna Bekker vom Rath, Hofheim), and *Pentecost* (Statens Museum for Kunst, Copenhagen)—all densely packed compositions filled with stark, primitive half-length figures, their faces illuminated by intense colors. Nolde considered these pictures milestones insofar as they signaled a change from his reliance upon external optical stimuli to the expression of deeply felt emotions.

Scribes, one of seven etchings of religious subjects done in 1911, illustrates to what extent this transition made itself felt in Nolde's prints. Gone are the vestiges of Impressionism that distinguish his etchings of Hamburg harbor completed the previous year. Instead, the individual forms have been simplified, the tonal gradations reduced to broad patterns of gray and black. Nonetheless, by combining line etching and aquatint, Nolde achieved a richly variegated, dark and mysteriously glowing ground. In a work reminiscent of the crowded composition of Dürer's famous panel *Christ among the Doctors* (Thyssen-Bornemisza Collection, Lugano, Switzerland) as well as his own pictures from Ruttebüll, Nolde made use of conspicuous silhouettes and brought the figures so close to the picture frame that they seem to exist in the space of the viewer. With etched features looking like runes hewn in stone, their archaic faces evoke a remote and legendary past.

The subject of Nolde's print cannot be identified specifically, since the New Testament mentions various encounters between Christ and the scribes. While Nolde's composition, with Christ standing amidst his sneering detractors, may refer to any one of several episodes, it is doubtful that the print was ever intended merely to illustrate a particular story. In view of Nolde's need to penetrate to the essence of things, it is much more likely that *Scribes* represents a condensation of the various incidents in terms of their fundamental meaning, the opposition of good and evil, here so eloquently portrayed in the transfigured countenance of Christ, reminiscent of a Romanesque crucifix, and the malicious features of those who surround him.

Etching and aquatint, plate 26.7 x 29.3 cm (10½ x 11 9/16 in.), sheet 44 x 45 cm (17 5/16 x 17 11/16 in.)

Signed and titled in pencil: lower right, *Emil Nolde.*; lower center, *Schriftgelehrte*

City Appropriation (31.9)

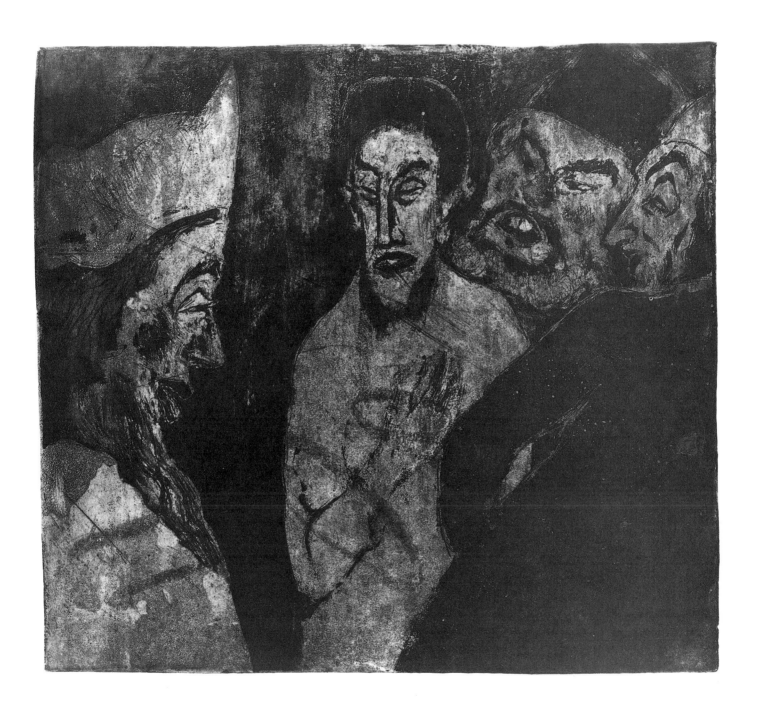

In a letter dated May 7, 1899, Nolde wrote to his friend Hans Fehr:

In order to create a work of art—in the highest sense of the word—three things are necessary: talent, fantasy, and poetic invention. A great many painters possess the first. Few, however, can boast of two of these gifts, and only a very few have all three to any significant degree.[36]

Nolde was not only endowed with all three, but enjoyed an extra measure of fantasy. His earliest works, done in the mid-1890s while he was still teaching industrial design in Saint Gall, include several drawings of grotesque masks illustrating human passions, as well as a series of watercolors in which the Swiss mountains are represented as personified forces of nature. His first oil painting (present location unknown), completed in 1896 and derived from these watercolors, depicts the Alps as a race of mythical giants, while a canvas of 1901, *Before Sunrise* (Ada and Emil Nolde Foundation, Seebüll), shows fabulous monsters flying among the mountaintops at dawn. The ability to divest himself of such fantasies in pictorial form must have played an important role in Nolde's decision to become an artist. Throughout his life his imagination remained open to a world of wondrous beings whose sources and meaning are difficult, if not impossible, to explain.

The enigmatic figures in his etching of 1922, *Apparitions*, silhouetted against a somewhat atmospheric though impenetrable ground, defy rational interpretation. Are they echoes, perhaps, of some long-forgotten Norse myth, hobgoblins the artist vaguely remembered from fairy tales heard long before? Is the bearded fellow in the foreground by chance the evil Nis Puck or some magician whose mysterious gestures can spellbind human beings and demons alike? Although pictorial analogies in some of Nolde's other prints of a similarly fantastic nature are helpful up to a point, the true meaning of *Apparitions*, if indeed there is one, may never be fathomed. The young boy, for instance, seemingly miraculously suspended in midair, recalls *Forest Children*, a drypoint of 1911 in which several such nude figures, dancing ecstatically, evidently personify spirits of the woods. The horned creature in the upper right, as well as the robed wizard, seem to be related to figures in an etching appropriately titled *Strange Beings*, also done in 1922. Since several impressions of the latter print also bear the title *Flying and Walking*, it is possible that Nolde, as on many other occasions, translated what might be considered quite ordinary perceptions and states of experience into images of sheer fantasy. Whether similar explanations may be applied to *Apparitions* is impossible to say. Although he recognized that they would be difficult to understand, Nolde himself never commented on these cryptic tokens of his imagination, except to caution against seeing in them strange and demonic things precisely where he had expressed humor and vivacity. How remarkably consistent it was of Nolde to have shrouded even these admittedly light-hearted expressions in mystery.

Etching and aquatint, plate 32.5 x 24.5 cm (12¹³⁄₁₆ x 9⅝ in.), sheet 62.2 x 45 cm (24½ x 17¹¹⁄₁₆ in.)
Signed and titled in pencil: lower right, *Emil Nolde.*; lower left, *II. 6. Erscheinungen*
City Appropriation (31.8)

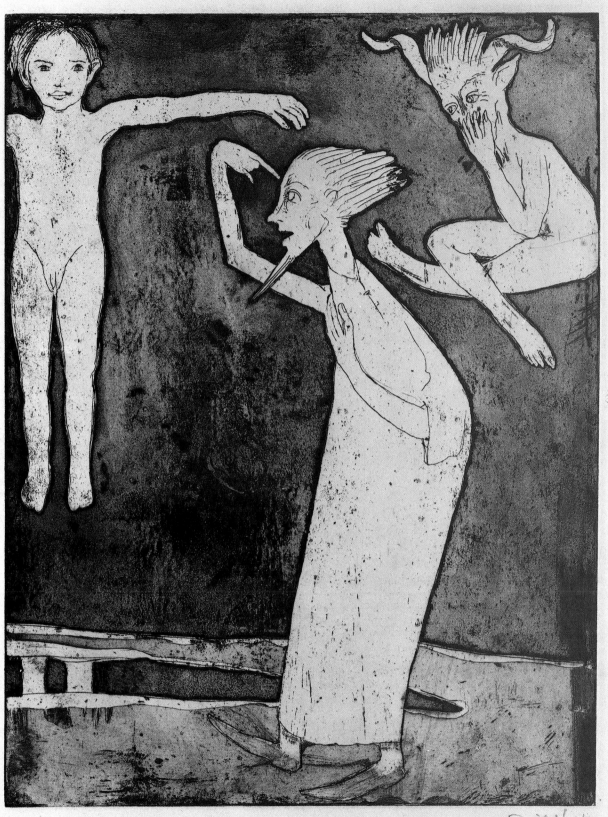

Emil Nolde

"I believe...in the moon...and in the sun. I feel their influence. I believe there is a fire blazing in the bowels of the earth and that it influences us mortals."[37] This credo, dating back to Nolde's years in Switzerland in the mid-1890s, demonstrates how intimately linked he felt to the powers of nature. He expressed this union throughout his career not only in visionary images and landscapes of epic breadth, but also in flower pictures imbued with an intensely personal feeling. After his beloved north German marshes and the sea, flowers were especially close to his heart. Wherever he lived he surrounded himself with a luxurious garden. Even on the island of Alsen he managed to lay out a lavish patch of flowers near his fisherman's hut right on the beach. It was here, between 1904 and 1908, that he first approached color for its own sake in a series of vigorous flower pictures. Nolde's lushest garden grew at Seebüll, where he lived from 1927 on. Filled with every conceivable variety of garden flower and protected from the strong west wind by the gentle slope of the mound upon which Nolde had built his studio, the flower beds were planted to form the initials *A*, for his wife Ada, and *E*, for Emil. This blooming paradise, reminiscent of Monet's garden at Giverny, provided an important source of inspiration for many of Nolde's finest paintings and watercolors during the last thirty years of his life.

Nolde perceived in flowers a parallel to human existence and empathetically identified with their growth and subsequent death. "I loved the flowers in their fate," he once wrote, "shooting up, blooming, glowing, decaying, and thrown away into a pit. Our own life is not always so logical and beautiful, but it too always ends in the fire or the grave."[38]

Sunflowers, painted at Seebüll in 1932, is such a metaphoric image. Orange and greenish-yellow petals stand out boldly against the somber blue sky, while large disks, touched here and there with a speck of purple and red, bend heavily under the weight of their seeds toward the earth. Like a portrait of two old friends, they are seen from up close and removed from all environmental allusions. Their individual forms loom large, their simplicity matched by the picture's broad areas of color which, in turn, are restricted to narrow modulations of the three primaries: red, yellow, and blue. Like Van Gogh, Nolde often painted sunflowers, responding to their simple beauty with deep feeling. Especially among his watercolors there are many examples in which the young flowers emit a glow of effervescent strength. The picture in Detroit, by comparison, is pervaded by melancholy. In fact, the artist felt moved to document the autumnal mood of the painting by inscribing the stretcher of the canvas with the words *Reife Sonnenblumen* (Ripe Sunflowers). Since the summer of 1930 Nolde had been experiencing recurring fits of depression and in 1932, the year the picture was painted, began to suffer from the symptoms of what was eventually diagnosed as cancer of the stomach. Given Nolde's mystical identification with nature, the meaning of *Sunflowers* takes on autobiographical as well as universal connotations.

Oil on canvas, 73.7 x 89 cm (29 x 35 in.)
Signed and inscribed: lower center, *Emil Nolde*; across top of stretcher, *Emil Nolde. Reife Sonnenblumen*
Gift of Robert H. Tannahill (54.460)

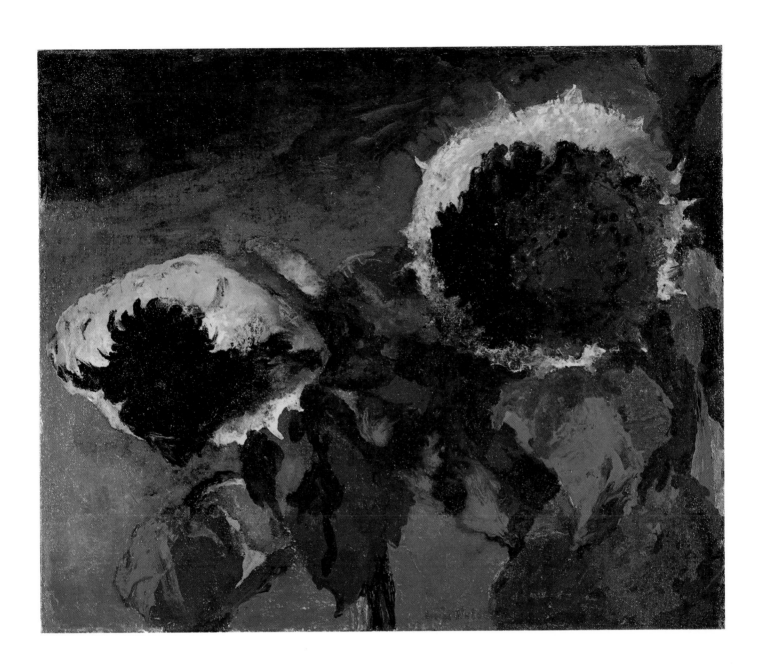

TWO PEASANTS

Nolde, the son of Frisian farmers, spent nearly his entire life among peasants, and found in their stolid features some of his earliest sources of inspiration. Several drawings done in Switzerland in 1892, portrait studies of shepherds and natives of Appenzell, a small village near Saint Gall, reveal to an astonishing degree his desire to penetrate surface appearances. In these early drawings the faces are harsh, as if chiseled in stone, suggesting their kinship to their mountain homeland. Nolde's need to give pictorial expression to the very essence of things eventually attracted the artist to painted carvings and masks from the South Sea Islands, in which he recognized a creative spirit not unlike his own. The faces in his pictures of Russian peasants encountered at remote stops of the trans-Siberian railway on his way to New Guinea in 1913 are in fact best described as masks of experience, signifying a whole range of emotions: fear, resignation, and unshakable faith.

As Nolde's watercolor *Two Peasants* illustrates, his search for the archaic and primitive frequently led him to exaggerations bordering on the grotesque. The features of the two gossiping figures, a man and a woman, have been not only grossly distorted but also pushed to a demonic level. Seen from up close, indeed cropped by the frame, their robust strength belies the small dimensions of the paper upon which they were painted. Nolde's intentionally crude draftsmanship accounts for much of the picture's raw power. Its sense of mystery, on the other hand, is a function of color alone.

Nolde saturated moist Japan paper with varying hues, permitting the colors to seep into each other, controlling their flow with wet brushes and a tuft of cotton until the entire surface was covered. Contours and highlights were added after the colors had dried. This is a technique that he had begun to develop in 1908 when—by accident—he had first become aware of the evocative power of the watercolor medium. Working out-of-doors one day in extremely cold weather, Nolde discovered that the wet colors had frozen on the paper, forming random crystalline patterns that caused the picture to take on a dreamlike appearance. Nolde welcomed nature's collaboration as an unexpected expressive dimension and was enthralled by the natural unity that embraced the painter, his subject, and the work as a whole.

Fascinated by their autonomy, he eventually permitted colors to display themselves freely and to exert a formative influence on a picture, determining both its composition and atmosphere. As images emerged from the colored ground, he surrendered to their prompting, improvising until the subject finally took form.

In *Two Peasants* the three primaries—red, yellow, and blue—blazing forth from a ground of earth colors that modulate from ocher to brown, apparently suggested to the artist a concept of strength even before the image was embodied in a specific theme. The painter then was able to capture the discovered picture within an appropriately rugged configuration.

These watercolors, in most cases, are impossible to date. Occasionally softer transitions between individual hues, as well as a pronounced lyricism that is documented in Nolde's oil paintings beginning in the mid-1930s, may be observed. Otherwise, the watercolors show little stylistic change. Moreover, since chronological classification seemed unnecessary to Nolde, he never dated any of his works and destroyed all lists that might indicate when they were done. A careful catalogue of the oil paintings was kept by his wife, and continued after her death in 1946 by Joachim von Lepel, the first director of the Ada and Emil Nolde Foundation in Seebüll. But, unfortunately, this catalogue does not include the artist's watercolors and drawings.

Watercolor on Japan paper, 19.7 x 14.5 cm (7¾ x 5¾ in.)
Signed in black ink, lower center: *Nolde.*
Gift of John S. Newberry, Jr. (45.461)

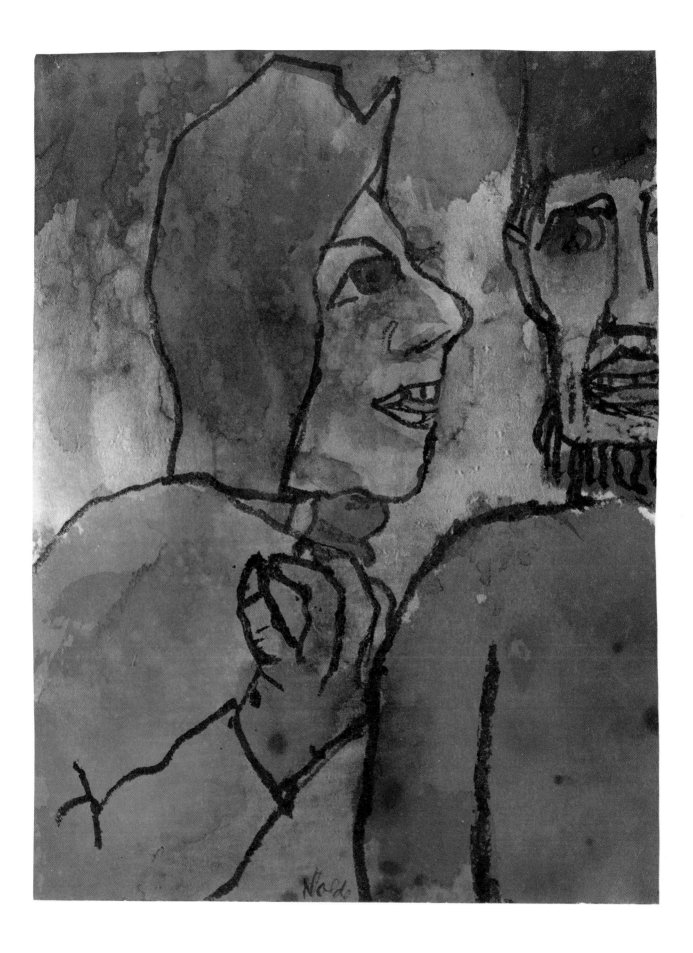

REFLECTIONS

Despite his many journeys, which took him far beyond the borders of Europe to the Orient and the South Sea Islands, Nolde always retained a keen sense of belonging to the soil of his native Schleswig. In and around the villages of Ruttebüll, Utenwarf, and Seebüll, he came close to seeing fulfilled his longing for a primitive state of human existence, which is so basic to German Expressionism. As late as the sixteenth century this hauntingly beautiful landscape was still part of the North Sea and consisted of a few inhabited islands surrounded by vast marshes that were flooded at high tide. Even after dikes had been erected to protect the land from the sea, large areas lay submerged from autumn to spring under water from rivers further inland. For months the lonely farms stood on their manmade knolls as if on tiny islands. As the west wind hurled the waves against the dikes, the houses themselves appeared to be sinking slowly into the sea. Such was the character of the landscape when Nolde painted *Reflections*, though today the broad expanses of water have given way to green meadows and the lake which once linked Seebüll with Ruttebüll has nearly disappeared.

Like all his watercolors, *Reflections* is difficult to date, though it may have been done in the mid-1930s when, perhaps as a result of Nolde's unexpected recovery from cancer, a notably lyrical quality began to manifest itself in his art. *Reflections* is a tender work, inspired by the long northern twilight which, in this region by the sea, especially in autumn, pervades everything with a magic glow. Nolde, who had such a pronounced affinity for elemental nature, and who had been drawn so often to vivid contrasts of hues, here delighted in remarkably subtle effects. Land, sea, and sky are enveloped in a radiant blue that is skillfully modulated so as to achieve the most delicate transitions between varying degrees of saturation. The contrasting yellow and greenish reflections of the distant lights hardly disturb the stillness of the luminous ground. Neither does the calligraphy which Nolde added after the original washes had dried, outlining swiftly the salient features of the landscape, including a fence by the edge of the water, a dike crossing the lake to the opposite shore, and what probably is an ancient windmill which has lost its vanes. Yet Nolde's watercolor transcends topographical fact; the mood of the picture is embodied in color, raising the subject to the level of poetry.

Watercolor on Japan paper, 33.9 x 47 cm (13⅜ x 18½ in.)
Signed in black ink, lower right: *Nolde.*
Bequest of Robert H. Tannahill (70.320)

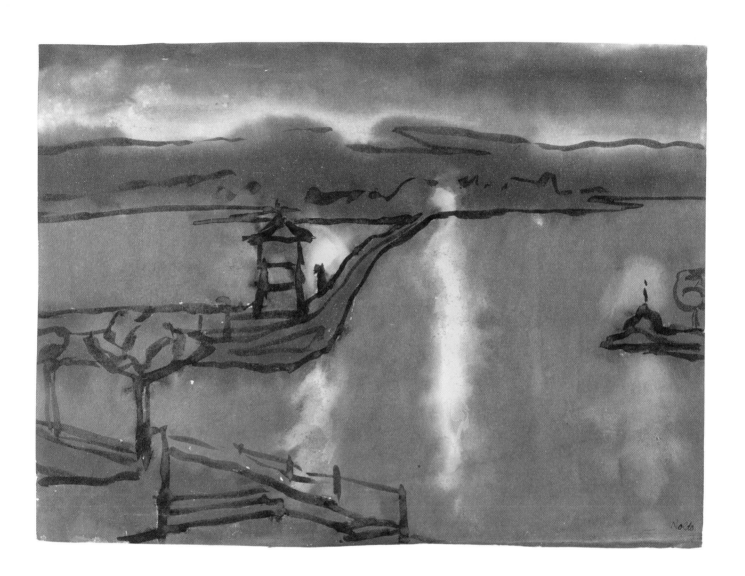

Nolde's art is an art of universals, not of specifics. Always drawn to the essence of things, he sought their meaning in primeval states of experience. Looking for the fundamental, he discovered the mask. This no doubt explains why he painted relatively few portraits. When faced with a specific personality, he transformed the sitter into a type, reinforcing the anonymity by giving his portraits generic names. Even his portrait of Gustav Schiefler, the famous collector of prints by Munch and the German Expressionists and author of the catalogue of Nolde's graphic work, is simply entitled *Mr. Sch.* (Brücke-Museum, Berlin). In his portraits Nolde always maintained psychological distance which, considering his remarkable empathy with nature, at first may seem surprising. But he was a reticent man and did not make friends quickly. While he was able to express his feelings in figure compositions, landscapes, and flower pictures, his natural shyness evidently made analysis of his sitters impossible.

Nolde's self-portraits are equally reserved, no doubt for the same reason. They are also rare. While their number among his watercolors and drawings is not known, only four were painted in oil, each one seemingly intended to record a special moment in his life. The first was done in 1899, at the end of his apprenticeship; the next two date from 1917, when the artist was fifty; the fourth was completed in 1947, his eighty-first year.

Nolde's watercolor *Self-Portrait* in Detroit may be a relatively late work, given the extraordinary transparency of the individual hues. Here the artist's world of fantasy and searing emotions has been set aside in favor of the most gentle lyricism. A bright lemon yellow creates the cheerful ambience from which the greenish yellow Panama hat with its contrasting black band and the bright blue of the artist's shoulder emerge as if of their own accord. Red accents give definition to mouth and ears. The eyes remain shrouded in deep pools of blue. No superimposed lines interfere with the effortless rise of the colors from the white paper ground. The picture seems to have grown miraculously under the painter's hand, echoing the processes of nature. "I like it when a picture looks as if it had painted itself," reads an aphorism that Nolde wrote in his notebook on August 19, 1947.[39] In the Detroit *Self-Portrait* he achieved the goal toward which he had been striving all his life: to shape his vision out of color.

Watercolor on Japan paper, 21.4 x 17.3 cm (8⅜ x 6⅞ in.)
Signed in brown ink, lower right: *Nolde.*
Bequest of Robert H. Tannahill (70.319)

In 1908, three years earlier than Kirchner, Schmidt-Rottluff, and Heckel, Pechstein settled permanently in Berlin. In the spring of 1910, following the rejection by the Berlin Secession of his own entries, as well as those of his friends from Dresden and a host of other young artists, Pechstein organized the Neue Sezession and arranged a series of exhibitions which for the first time brought Die Brücke to the attention of a wider public. In 1911, together with Kirchner, he founded a private art school, the MUIM-Institut.[40] Although intended to give the two painters financial security, the enterprise soon failed. Pechstein was expelled from Die Brücke in 1912 since, by exhibiting his work on his own in the Berlin Secession, he had refused to act in accord with the group's decision to show their work only jointly.

Like all the Expressionists, Pechstein was fascinated by the origins of man and in 1914 departed for the Palau Islands, at that time a German colony to the east of the Philippines. With the outbreak of World War I, these islands were occupied by the Japanese, who captured the artist and his wife and shipped them to Nagasaki, where they were set free. After an adventurous trip that took them by way of Shanghai and Manila to San Francisco and New York, they finally returned to Germany in the autumn of 1915. Pechstein served in the German army until the end of the war and in November 1918 founded, with the painter Klein, the Novembergruppe, which was dedicated to the promotion of modern art in the new Weimar Republic. In 1922 Pechstein became a member of the Prussian Academy of Fine Arts in Berlin. The Nazis expelled him from that organization in 1933 and prohibited him from showing his work. Many of his paintings and prints were subsequently confiscated and branded "degenerate." In 1945 the painter emerged from his enforced retirement in Pomerania to accept a professorial appointment at the Academy of Fine Arts in Berlin. He died in Berlin on June 29, 1955.

Pechstein's finest works are generally considered to be those dating from the period of his association with Die Brücke. After 1918 his art, which even during the earlier years was less aggressive than that of his friends, began to lose much of its robust energy. Well-composed and brilliantly colored, Pechstein's paintings of the early 1920s on have a charm that has little to do with Expressionism.

The longing for primitivism which led Pechstein, like Nolde, to the South Pacific, is epitomized in *Under the Trees*, painted in 1911 at Nidden, a remote fishing village on the Baltic Sea. Like offspring of an ancient earth goddess, the massive nudes, moving majestically in a natural world, seem never to have known another habitat, so easily do they assume their places within the flow of the composition. Echoing the mellifluous growth of the trees, they stretch, stride, and bend in rhythmic harmony with the curvature of the terrain. The swirling lines of the empathetic brush strokes and the vibrant colors—shades of reddish brown and ocher and a complementary dark green, gleaming with streaks of yellow and blue—imbue the picture with pulsating energy.

This splendid painting, one of the finest in a major series Pechstein did of bathers in Nidden, exemplifies the artist's fully developed Expressionist style and illustrates eloquently why his work won public acclaim so much earlier than that of any other member of Die Brücke. In contrast to the shouting colors and brutally splintered forms of contemporary figure compositions by Heckel, Schmidt-Rottluff, and Kirchner, Pechstein's picture is not only more sensuous and decorative but—in conventional terms—much better painted. Despite the rigorous simplification of the limbs, his nudes retain a degree of physical idealization—the sheen of their flesh is made palpable through an assured handling of light and shade—which has its roots in the artist's solid academic training. The feeling of ease, noticeably absent from the pictures of the other Brücke painters, is increased by Pechstein's skillful assimilation of the art of Matisse. As in Matisse's *Joie de vivre* of 1905–06 (Barnes Collection, Merion, Pa.), a similarly sun-drenched Arcadian scene, the subject is transformed into a play of rhythmic arabesques which extend over the whole picture; and where the melody of the composition demands it, as in the arms and breasts of the nude in the lower left, the natural appearance is spontaneously distorted in order to fit it into a harmonious pattern. Still, Pechstein's painting is not French; it is unmistakably German. Whereas Matisse reduced nature to intellectualized patterns of seductive grace and classical calm, Pechstein's conception of form is robust and aggressively energetic.

Oil on canvas, 73.7 x 99 cm (29 x 39 in.)
Signed and dated, lower left: *Pechstein 1911*
City Appropriation (21.206)

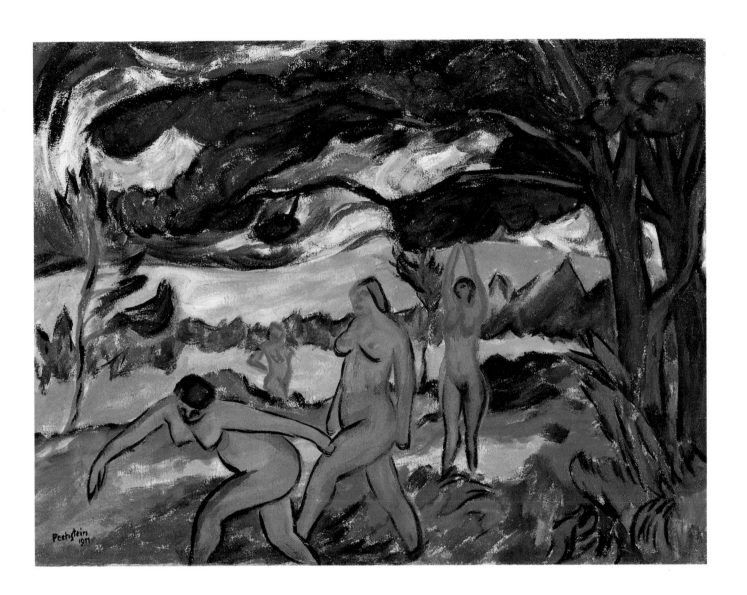

"AND FORGIVE US OUR DEBTS" 1921

Man in need of redemption is the subject of a cycle of twelve woodcuts that Pechstein did in 1921 illustrating the Lord's Prayer. Possibly guided by a concept such as that of Dürer, who in his famous woodcuts of the Apocalypse heightened the dramatic impact of Saint John's eloquent text by condensing its imagery into a series of self-contained pictures, Pechstein divided the text of Martin Luther's translation of the passage in Matt. 6:9–13 in which Christ gives his disciples instruction on how to pray, into a set of individual prints, each illustrating concisely a phrase, with the words carefully worked into the design.

Abandoning here his sensuous and mellifluous style for an atypical Gothic stiffness and angularity, Pechstein, in the wake of the recent war experience, interpreted the prayer with marked pessimism. The individual figures either gesticulate, as if in paroxysms of anguish, or raise their hands numbly and touch each other in silent grief. The Detroit print, illustrating the words *und vergieb uns Unsre Schuld* (and forgive us our debts), is indeed apocalyptic in mood.

Reminiscent of Saint John's compelling vision of the Godhead, whose "eyes were as a flame of fire" and whose "countenance as the sun shineth in his strength" (Rev. 1:14–16), the majestic face of the Lord in the upper left emits rays of dazzling light, as several men, their fragile bodies surmounted by large heads that have turned into masks of suffering, kneel barefoot on the ground and reach upward with elongated hands, seeking spiritual redemption through forgiveness of their sins.

Hand-colored woodcut, image 39.9 x 29.7 cm (15¹¹/₁₆ x 11¹¹/₁₆ in.), sheet 59.7 x 41.5 cm (23⁷/₁₆ x 16⁷/₁₆ in.)
Signed in pencil, lower right: *HMPechstein*
Gift of Dr. and Mrs. Barnett Malbin (72.798)

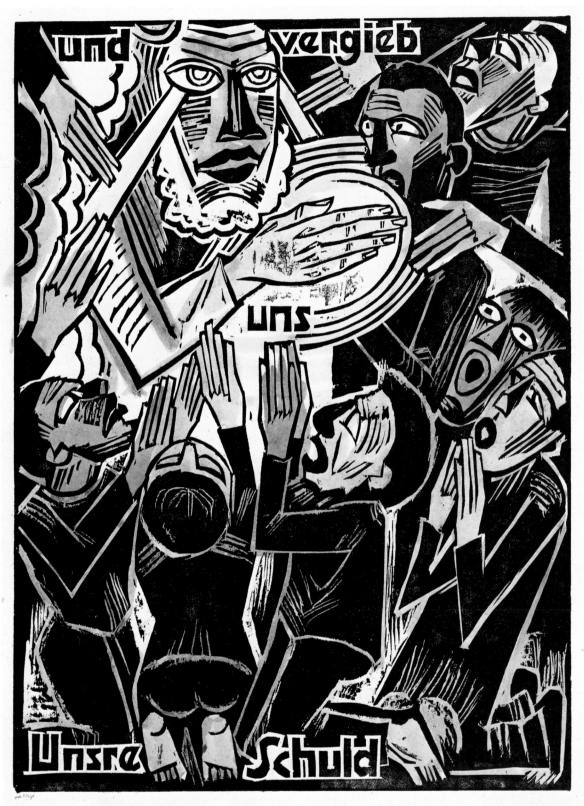

CHRISTIAN ROHLFS

A generation older than Kirchner and Marc, more than three years older than Van Gogh, Christian Rohlfs developed slowly and did not experience the real unfolding of his creative talent until he was well into his sixties. He was born into a peasant family on December 22, 1849, in Niendorf in the north German province of Schleswig-Holstein, and most likely would have become a farmer had not a leg injury, incurred at an early age, prevented him from working in the fields. Bedridden for years, he began to draw and showed such talent that the writer Theodor Storm, a relative of the local doctor, advised the boy's parents to permit him to take up painting professionally. With Storm's help, Rohlfs attended the Weimar academy where, except for periods of renewed illness which resulted in 1873 in the amputation of his right leg, he studied from 1870 to 1881. Following the completion of his academic training, Rohlfs remained in Weimar for twenty years, painting lyrical landscapes whose intimate realism in time gave way to an increasingly painterly dissolution of form closely akin to French Impressionism.

In 1901 the Belgian designer Henry van de Velde brought Rohlfs to the attention of the collector Karl Ernst Osthaus, suggesting that the painter be appointed as art consultant at the Museum Folkwang, which Osthaus had recently founded in Hagen. It was there, in the stimulating atmosphere of what was to become a major center of modern European art in Germany, that Rohlfs first came into contact with a wide variety of Impressionist and Post-Impressionist trends. Most important was the Van Gogh exhibition held at the Museum Folkwang in 1902, which introduced him to concepts of color and form that were critical to his

subsequent development. Encouraged by Nolde, whom he met in the winter of 1905/06 in the old Westphalian town of Soest, Rohlfs gradually began to paint with greater expressive force. By 1912 color had become the dominant element in his work, setting the basic mood of his pictures. At this point in his career, Rohlfs might have found his way to a style as crudely expressive as that of the artists of Die Brücke, had not his lyrical temperament led him to choose a more poetic approach. His colors, most frequently subdued shades of red, blue, and green, accompanied by gradations of adjacent hues, are far more insubstantial than Nolde's, for instance; his simplified forms, seen as if through a transparent veil, are less

violent. Only in his woodcuts does his art achieve the same raw strength that characterizes the graphic works of the younger generation (p. 197).

Beginning in 1927 Rohlfs spent the greater part of each year at Ascona on Lake Maggiore, painting flower pieces and landscapes in which his Expressionist lyricism reached its final fruition (p. 201). He completed many of these late works in the face of the most vicious defamation at home. As early as 1930 some of his prints were ordered removed from exhibitions by Nazi sympathizers. In 1937 more than 400 of his works were confiscated. Many were destroyed. Only the early paintings and watercolors executed in Weimar prior to 1901 were tolerated. Expelled from the Prussian academy, of which he had been a member since 1924, and publicly disgraced as a "degenerate" artist, Rohlfs died in his studio in Hagen on January 8, 1938.

THE SERMON ON THE MOUNT 1916

During World War I religious subjects occupied Rohlfs's imagination again and again and virtually dominated his graphic output between 1915 and 1918. He was profoundly disturbed by the misery the war inflicted upon millions, and his biblical paintings and prints provided him with not only a spiritual refuge from the distressing events of the time but also a means through which to translate his compassion for his fellowmen into universal symbols of human suffering and redemption. Entirely in keeping with Rohlfs's warm and gentle personality, however, nowhere in these works is there a sign of bitterness, hatred, or anger. Only rarely are such Old Testament subjects as the Flood or the Expulsion from Paradise allowed to interrupt the sequence of more conciliatory themes, like the Return of the Prodigal Son, a paradigmatic motif of love and forgiveness Rohlfs treated repeatedly during these years in paintings, drawings, and prints. Hope and the promise of a better life also attracted him to the famous passage in Matt. 5:1–12, in which Christ, having ascended a hill overlooking the Sea of Galilee, spoke to the many that had come to hear him of the blessedness of the poor and the sorrowful, the humble and pure in heart, the merciful and the peacemakers, and all those who aspire to righteousness and are persecuted for righteousness' sake.

In his woodcut *The Sermon on the Mount* Rohlfs illustrated the story with characteristic simplicity and directness. His hand outstretched in a gesture of teaching, Christ looms above the people gathered at his feet. The bold contrasts of light and dark and the deliberately archaic quality of Rohlfs's print, done in 1916, are reminiscent of fifteenth-century German woodcuts, while the powerful angularities of the individual forms and the incisiveness with which they have been carved out show unmistakable affinities to contemporary woodcuts by artists of Die Brücke (p. 79). Still, if

compared to the decorative stylizations of Pechstein or the stark monumentality of Schmidt-Rottluff's religious prints from the immediate postwar years, Rohlfs's woodcut is far more naturalistic and lyrical in both form and conception. Great warmth radiates from the features of Christ. Of those who have come to listen to him, some gaze upward humbly and with trust, while others ponder his words or turn away with expressions of skepticism.

Forever impatient with traditional techniques, Rohlfs used a brush rather than a roller to ink the woodblock, which retained the artist's strokes in the final impression, animating with fine striations the flat surface of the dark, uncut areas. Light, cut-away surface patterns dominate the composition and create a general feeling of airiness. In addition to making black-and-white impressions, Rohlfs also used various colors to ink his woodblocks, and frequently even hand-colored with oil paint some of the prints made from the outline plate. Since this process could not yield the same results twice, images such as *The Sermon on the Mount* exist in a variety of color combinations. Long recognized as a high point in Expressionist art, each of these colored woodcuts is unique, despite their identical graphic contours.

Woodcut, 44.4 x 41.6 cm (17½ x 16⅜ in.)
Signed: in the block, lower left, *CR*; on composition in black ink, lower right: *Chr. Rohlfs.*
Founders Society Purchase, Hal H. Smith Fund (31.10)

During the bitter years of World War I, Rohlfs expressed his compassion for mankind repeatedly in paradigmatic representations of human anguish. Yet man was never the subject of psychological examination. The human face as a mirror of emotions, which fascinated so many of his younger contemporaries, was of no interest to him, and sensitive, probing portraits and self-portraits such as those by Kirchner, Kokoschka, or Heckel (pp. 83, 121) are entirely absent from his work. Only once, in 1918, did he paint a self-portrait. Prompted not by any desire for self-analysis, but painted in response to a request from a friend, this picture, too, is far from being psychologically revealing. Prior to his marriage at the age of seventy, Rohlfs lived alone and in relative seclusion. Possibly his shyness and need for privacy made it difficult for the artist to enter into an analytical dialogue with the face of a specific sitter. At the same time, man was never for Rohlfs a subject for social comment. He did not view human beings either derisively or with bitterness, as did artists such as Beckmann, Dix, and Grosz (pp. 41, 73).

Rohlfs was a kind and loving man, and satire and caricature were inimical to his personality. What he did possess, however, was a profound sense of humor that led him not only to invent stories and legends and to illustrate them, but also to imagine faces. Often, especially in his prints, they tend to be humorous and bizarre, reminiscent of some of the early grotesque subjects of Nolde. Sometimes, as in the watercolor of 1935, *Men in Silk Hats*, showing two shadowy figures in formal attire, they appear half fairy-tale-like and half as if observed from life. Indeed, for Rohlfs a face was first and foremost a pretext for developing an expressive composition. In the Detroit work, for instance, the two half-length figures have been translated into hulking abstractions that fill the pictorial space and convey their emotive content in an unmistakable way. The effect of the menacing and masklike faces is sinister, while the colors, somber shades of brown and blue laid on in a dry and brittle manner, reinforce the ominous mood. Spellbound by the physical proximity of the two figures, the viewer is lured into a mysterious world, where fantasy and reality meet.

Watercolor, 78.7 x 55.9 cm (31 x 22 in.)
Signed and dated in brown pencil, lower right: *CR 35*
Gift of Mrs. Lillian H. Haass and Walter F. Haass in memory of the Rev. Charles W. F. Haass (36.18)

The mystery that shrouds the two figures in *Men in Silk Hats* developed into a transcendental, unearthly feeling in Rohlfs's late watercolors of flowers and views of Lake Maggiore where, from 1927 until shortly before his death in 1938, he spent nine months of each year. His contact with the limpid light of the Ticino district, the massive mountains, and tropical vegetation more luxuriant than the painter from the north German plains had ever before seen, brought about an ultimate change in his style, effecting a growing dissolution of form into subtle nuances of color. These were years during which the aging artist, then in his eighties, embarked on a period of fruitful experimentation, using color with the utmost freedom.

In *Violet Moonlight II*, one of several nocturnes painted in 1935, shades of reddish blue determine the lyrical mood of the watercolor. Lake, mountains, and sky are enveloped as if in a veil, and all matter seems to be on the verge of becoming transparent—an effect Rohlfs achieved by applying the color all over the heavy paper and subsequently holding it under a jet of running water, causing the washes to blend and dilute. Repeating this process several times, he added new color until he had achieved the desired texture and coloristic scale. Frequently, as the example in Detroit illustrates, he worked the paper with a stiff bristle brush, gently abrading the colored surface. The many fine lines torn into the paper seem to hover above the composition like the mesh of a fine net, congealing in areas of greater concentration into milky pools of evanescent light. Glowing shades of either predominantly blue, red, or brown hues provide the basic tonalities of these works.

Rohlfs, who painted Lake Maggiore from the terrace of his house at Ascona during all seasons and at all times of the day, admitted that he never perceived the timeless beauty of nature and the abstractions inherent in the forms of the natural world as consciously as at night, when the moon could be seen casting its light upon the wooded slopes of Mount Tamaro and the quiet water of the lake. In contrast to the ecstasy and often troubled spirit that pervade the watercolors that Corinth painted toward the end of his career at the Walchensee (p. 59), Rohlfs's late works radiate an air of serene detachment and peace. Without subordinating nature entirely to his imagination, he dematerialized the individual forms in glowing color harmonies that elevate the real to a mystical ideal.

Watercolor, 78.1 x 56.2 cm (30¾ x 22⅛ in.)

Signed, dated, and titled in pencil: lower right, *CR 35*; verso, *Violetter Mondschein II, 1935*

Gift of John S. Newberry in memory of Dr. William R. Valentiner (59.12)

KARL SCHMIDT-ROTTLUFF

Karl Schmidt-Rottluff, the youngest of the founders of Die Brücke, left no written analyses or theoretical explanations of his art. "I have no program," he wrote to the editor of *Kunst und Künstler* in 1914, "only the inexplicable yearning to grasp what I see and feel."[41] Reticent as he was in his comments, his work too reveals far less of his inner life than does that of the nervous and sensitive Kirchner or the romantic Heckel. Instead, his paintings and prints bear the mark of a steadfast and rugged temperament that found its most succinct expression in an unfailing sense of pictorial order. This feeling for structure, when translated into the rigorously simplified forms and bold planes of color that are the hallmarks of his mature style, infuses his compositions with a raw strength unmatched by any of his contemporaries.

Karl Schmidt was born December 1, 1884, in Rottluff, a suburb of Chemnitz, in Saxony; his father was a miller. In 1901, while still in school, he met Heckel, whom he followed in 1905 to the Technische Hochschule in Dresden to study architecture. In Dresden Heckel introduced him to Kirchner and Bleyl, and soon the newcomer was ready to join the others in their decision to abandon the architect's T-square in favor of the painter's brush and canvas. Karl Schmidt suggested that the fledgling group, which they founded in the second half of 1905, be called Die Brücke to signify a bridge toward a new art and a new life. With the creation of Die Brücke, the painter added Rottluff, the name of his birthplace, to his own, as if to signal a beginning in his own life.

Schmidt-Rottluff's earliest paintings derive from French Post-Impressionism and include landscapes and interiors. Done in a nervous and impetuous manner, they are reminiscent of early pictures by Nolde, alongside whom he worked during the summer of 1906 on the island of Alsen. Between 1907 and 1912, while painting at Dangast, a small resort town on the North Sea, Schmidt-Rottluff

developed a personal style distinguished by generalized forms and broad, unmodulated fields of color. Only his woodcuts with their violent black-and-white shapes exceeded these pictures in expressive strength. In the fall of 1911 Schmidt-Rottluff, like Kirchner and Heckel, moved to Berlin. His subsequent development, interrupted by military service from 1915 to 1918, is manifest in a series of variations on the pictorial language first defined at Dangast, except that the works that immediately preceded and followed World War I are pervaded by a notably romantic feeling (p. 205) which, in the early 1920s, became once again subsumed by a greater preoccupation with problems of pictorial form (p. 209). From the mid-1920s on, the stridency of Schmidt-Rottluff's Expressionism began to soften, as the painter placed more emphasis on the decorative treatment of the composition and on a closer approximation to nature (pp. 213, 215).

Schmidt-Rottluff, who had been appointed to the Prussian academy in 1931, was forced to withdraw from the organization under Nazi pressure in 1933. By the end of 1938 almost 650 of his works had been confiscated; fifty-one were included in the *Degenerate "Art"* exhibition. In 1941 Schmidt-Rottluff, like so many others, was barred from engaging in any professional activity and forbidden to paint. After Allied raids on Berlin in 1943 demolished his studio, destroying all his drawings, many paintings, watercolors, and prints, the artist withdrew to Rottluff. He returned to Berlin in 1947 in response to a professorial appointment at the Academy of Fine Arts, where he taught until his retirement in 1954. In 1967 he gave a large part of his work to the city of West Berlin, a donation which, augmented by a generous gift from Heckel, led to the creation of the Brücke-Museum the same year. Widely honored as the last surviving founder of the German Expressionist movement, Schmidt-Rottluff was ninety-one when he died in Berlin on August 10, 1976.

With the possible exception of Nolde (p. 185), no painter sought his inspiration more consistently in the austere beauty of the north German seacoast than did Schmidt-Rottluff. From 1907 until the early 1960s, when the infirmities of old age forced him to curtail his travels, he spent virtually every summer in this region. Dangast has long been associated with the emergence of his Expressionist style. Between 1907 and 1912, while painting in the marshes and moors near Dangast, he abandoned his experiments with Post-Impressionist techniques in favor of a more concise pictorial structure and the use of broad, well-defined patterns of pure color.

Evening by the Sea, done during the summer or early autumn of 1919 at Hohwacht, a remote fishing village on the Baltic, illustrates a further stage of this development and epitomizes both the architectonic clarity of composition and the boldness of color and form that endow Schmidt-Rottluff's most typically Expressionist paintings with their characteristic crudeness and strength. Each form has been simplified and reduced to its essential features. In a dreamlike landscape a lone figure of indeterminate sex, its small and immaterial body surmounted by a large greenish head reflecting the light of the sea, glides silently along the beach. Reminiscent of African masks and certain proto-Cubist paintings by Picasso, the massive head of the mysterious figure has been willfully subjected to the artist's sense of design. Except for the brown dunes in the distance and the dazzling white of the stylized crest of the wave in the lower left, the colors are equally arbitrary and have been juxtaposed in large flat areas of cherry-red and green.

The theme of man in nature, one of the fundamental subjects of German Expressionism, did not appear in Schmidt-Rottluff's work until 1913, and was only fully developed the following summer when he first visited Hohwacht. At that time he completed a series of paintings and woodcuts of men and women, alone and in small groups, looking silently out toward the sea. Others stand or sit together quietly, as if in a trance, or bend toward each other with dignified composure. Unlike Pechstein's exuberant nudes, moving freely and in complete harmony with nature (p. 191), Schmidt-Rottluff's figures seem self-conscious and poignantly aware of their isolation. This series of sensitive and romantic pictures came to an end early in August 1914 when news of war reached the village, forcing the artist to go back to Berlin and enter military service.

When Schmidt-Rottluff returned to Hohwacht in 1919, he sought to recapture in his art the introspective mood out of which he had been so suddenly and totally jolted five years earlier. Once again he painted a series of quiet landscapes with figures. By this time, however, the meditative character of his pictures was enriched by an increased awareness of the transcendental and supernatural. The direct result of his war experience, this mysticism is expressed most eloquently in religious woodcuts he did in 1918. Of the various landscapes painted at Hohwacht in 1919, *Evening by the Sea* is the most enigmatic. The gaze and gesture of the mysterious figure seem to beckon the viewer, but as in the painter's portraits and self-portraits of this time, the eyes, one black, the other a reddish brown, look inward into a world that is far beyond the viewer's reach.

Oil on canvas, 86.4 x 100 cm (34 x 39¾ in.)
Signed, lower right: *S. Rottluff*
Bequest of Dr. William R. Valentiner (63.135)

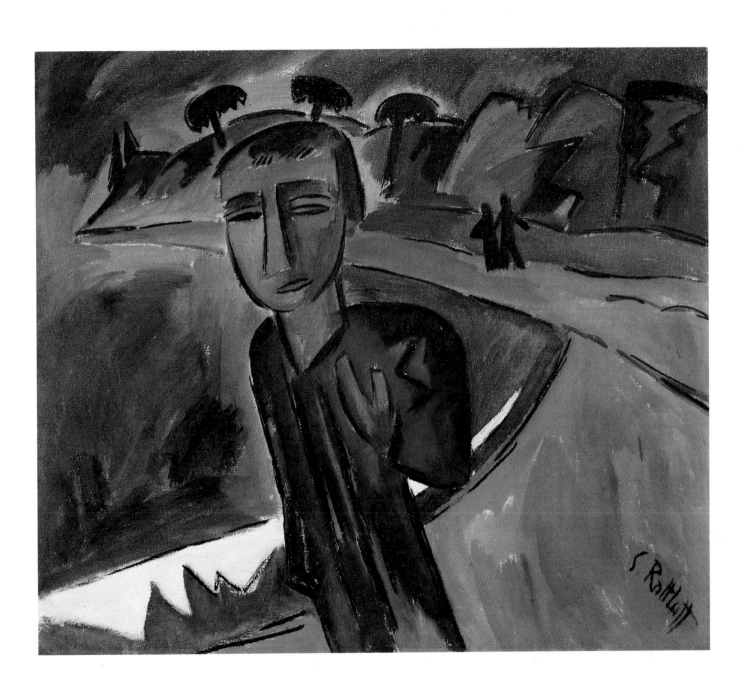

Schmidt-Rottluff, like Corinth (p. 57), painted most of his still lifes during the later years of his career. Only in the mid-1950s, when the artist was entering his seventies, did they begin to assume a dominant role in his work. This is doubtless because they could be set up anywhere without much preparation, and required considerably less physical effort to complete than subjects such as landscapes and portraits. And, in their own inimitable way, they fulfilled the aging artist's need for that stillness and solitude he had formerly sought along the lonely shores of the Baltic and the North Sea. Unlike Corinth, however, who transposed his joys and sorrows into flower paintings of a remarkably wide range of expression, Schmidt-Rottluff approached his still lifes with relative detachment. Compared with his more subjective landscapes and portraits, his still lifes betray a loving, but ultimately objective commitment to things themselves. With the clarity of composition he retained throughout his career, Schmidt-Rottluff nonetheless managed to endow even the most humble object with its own measure of monumentality.

An early still life, *Cactus in Bloom* dates from 1919, the same year Schmidt-Rottluff painted a series of romantic landscapes at Hohwacht as well as several evocative portraits and self-portraits. With the exception of the brown table top, which tilts emphatically upward as if in obedience to the two-dimensional surface of the canvas, the Detroit still life shows little of the willful distortions characteristic of those pictures. The curve of the flower pot, casting a shadow across the table, as well as the spatial depth implied by the dense mass of thick, fleshy foliage and the carefully foreshortened blossoms, assert forcefully the tactile features of the subject. On the other hand, the expressive character of the picture has been heightened by the use of robust colors —a quality present in Schmidt-Rottluff's contemporary landscapes and portraits—as patches of deep green and a strong Prussian blue contrast boldly with bright red and duller hues of ocher and brown. Moreover, in the Detroit picture the paint has been applied so thinly that in many places the unusually rough-textured canvas is still visible, reinforcing the energy of the sonorous colors with an added touch of primitive strength.

Oil on canvas, 66.7 x 75 cm (26¼ x 29½ in.)
Signed and dated, lower left: *S. Rottluff 1919*
City Appropriation (21.207)

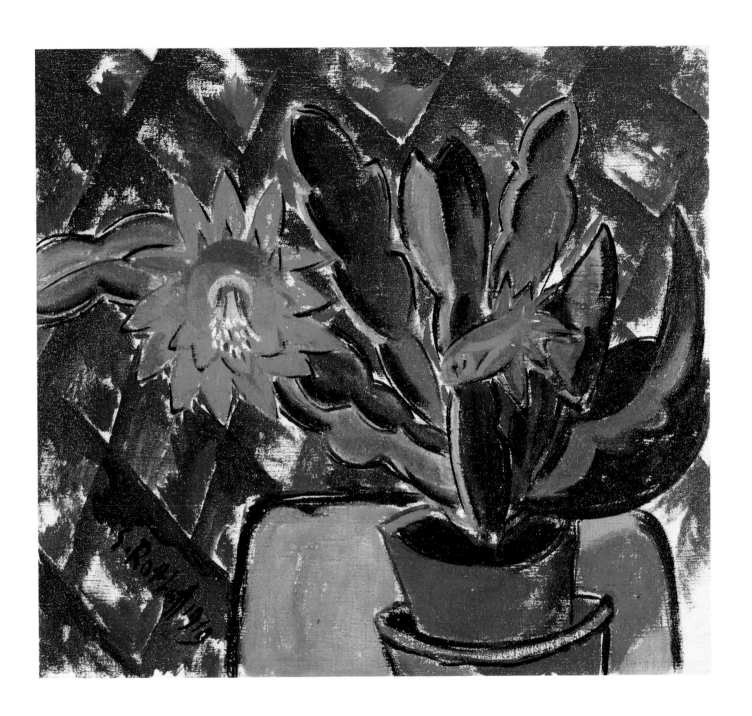

Painted soon after his pictures of 1919, Schmidt-Rottluff's *Man with a Green Beard*, with its unusually abstract composition, comes as something of a surprise. Especially when compared to his romantic landscapes of Hohwacht in which mood predominates, this painting illustrates an overriding concern for the aesthetic problems of pictorial structure and color. Only with some difficulty, in fact, can the individual components of the picture be separated from the brightly colored surface of the canvas to form the coherent image of a fisherman in half-length whose simplified face, shown in profile and enveloped by a mass of green hair, is painted in a bright blue from which a frontally placed eye gleams with a white gaze. Flanked by patches of brown and blue which vaguely recall shadows but actually serve to link the central and peripheral color zones into a two-dimensional pattern, the figure is embedded in a ground of flaming yellow and red.

Man with a Green Beard was painted at Jershöft, a small hamlet on the Baltic Sea, where Schmidt-Rottluff spent every summer between 1920 and 1931. Done sometime between 1920 and 1923, it is closely associated with a series of pictures devoted to the life and work of peasants and fishermen, all of which are equally abstract and exhibit the same bright instrumentation of color. Although not entirely new in Schmidt-Rottluff's work—the artist did a handful of prints of fishermen and peasants around 1910—at no other time did he deal with the life of the working man so comprehensively as during these first summers at Jershöft. Exactly why this subject matter should have gained such prominence in his work at this particular time is difficult to say, especially since Schmidt-Rottluff (unlike Kirchner, Heckel, and Nolde) was never attracted by the glittering world of the theater, circus, or cabaret. It is possible that these pictures are related to ideas current at the end of World War I when, in the confused social and political situation following the German defeat, many idealistic artists and intellectuals resolved to take an active part in the construction of a new society.

Motivated by the belief that the creative energies of an artist should be put at the service of all people and not enjoyed by just a privileged few, organizations such as the Novembergruppe not only dealt with questions relating to the role of the artist in the new socialist state, but also proclaimed goals that aimed at the inclusion of people from all walks of life, especially the working class, in the creation and understanding of the arts. Much of the program of the Novembergruppe, whose members included virtually all major Expressionist painters and sculptors, composers and playwrights like Kurt Weill and Bertolt Brecht, architects like Walter Gropius, and art historians like Valentiner (see p. 211), was never realized. Nevertheless, the enthusiasm that the movement generated may well explain both Schmidt-Rottluff's brief fascination with types such as *Man with a Green Beard* and the audacious and unromantic manner in which he executed pictures such as this one.

Oil on canvas, 90.2 x 76.8 cm (35½ x 30¼ in.)
Signed, upper left: *S. Rottluff*
Bequest of Dr. William R. Valentiner (63.134)

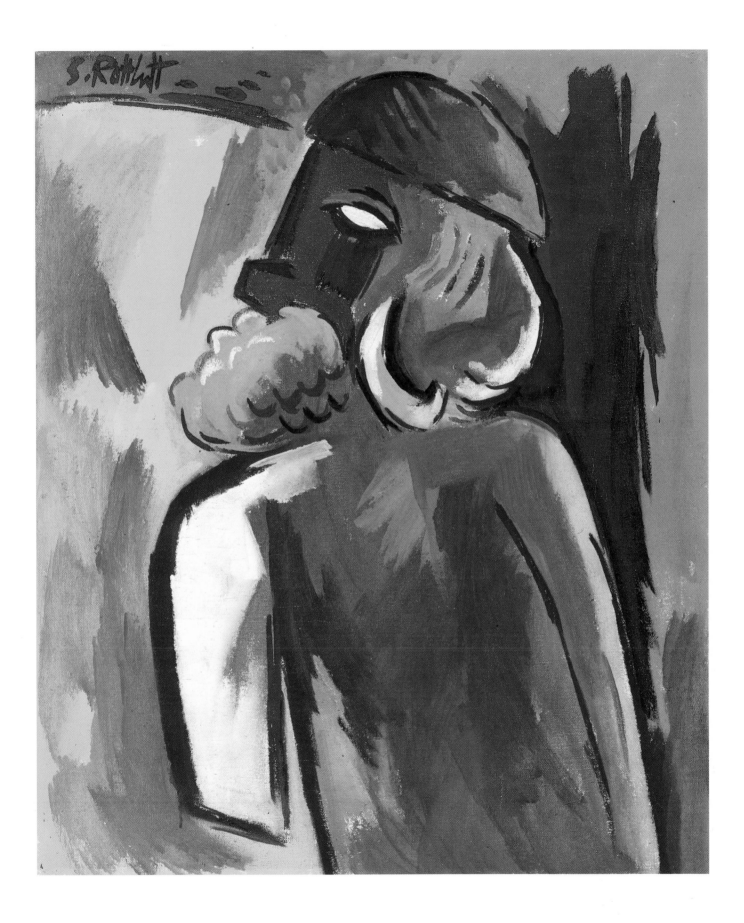

Schmidt-Rottluff's woodcut portrait of Valentiner, the second of two versions and most likely a token of gratitude following Valentiner's publication of the first monograph on the artist in 1920, is one of three woodcuts of eminent art historians, all done at approximately the same time. The earliest dates from 1922 and depicts Wilhelm Niemeyer, one of the artist's most fervent admirers and author of several articles on his work. The second, like the Valentiner portrait, was done in 1923 and is of Rosa Schapire, who had given support to Schmidt-Rottluff since 1908 and published a catalogue of his early prints in 1924.

As in almost all Schmidt-Rottluff's portraits and self-portraits, attention is focused upon the head as the quintessential embodiment of the spiritual being of the sitter. Yet, of the portraits of the three art historians, the image of Valentiner appears not only unusually detached but—with the possible exception of the exaggeratedly large and penetrating eyes—also the most objective. The bony features of the thin face have been carefully observed, while the manner in which the head turns away from the viewer safeguards Valentiner's characteristically reserved demeanor and the reticence which many who did not know him well were wont to mistake for coldness or arrogance. The portrait is further differentiated from the other two prints—their backgrounds are entirely abstract—by the decorative treatment of the space surrounding Valentiner, which competes with the main image for the viewer's attention. Functioning in the manner of traditional attributes, the flower still life in the upper left and the statue in the lower right, both reminiscent of Schmidt-Rottluff's own work, are undoubtedly intended to identify the sitter as a collector and connoisseur.

Although graphics played an important part in the work of all members of Die Brücke, the woodcut has come to be recognized as Schmidt-Rottluff's most personal means of expression, largely because the medium was unusually well-suited to his tendency to construct his compositions on the basis of a few large and simple forms. The Valentiner portrait, however, is interesting for the manner in which it signals a change in Schmidt-Rottluff's style, which manifested itself in his work more fully beginning in the mid-1920s. The large contrasting areas of relatively unrelieved patterns of black and contrasting white which characterize the earlier prints have been replaced by a repetitive network of white striations. This reveals not only a concern on the part of the artist for modulations of tone and atmosphere, and thus a greater approximation to nature, but also a more relaxed approach to emotional content which developed at almost the same time in the work of both Kirchner (p. 105) and Heckel (p. 83).

Woodcut, image 50 x 39.5 cm (19⅝ x 15⁹⁄₁₆ in.), sheet 66.5 x 54.5 cm (26³⁄₁₆ x 21⁷⁄₁₆ in.)

Signed and inscribed in pencil: lower right, *SRottluff*; lower center, *To my sincere friend/Ralph H. Booth/with best wishes/To Ralph Booth/W. R. Valentiner*

Gift of Mrs. Ralph H. Booth (51.107)

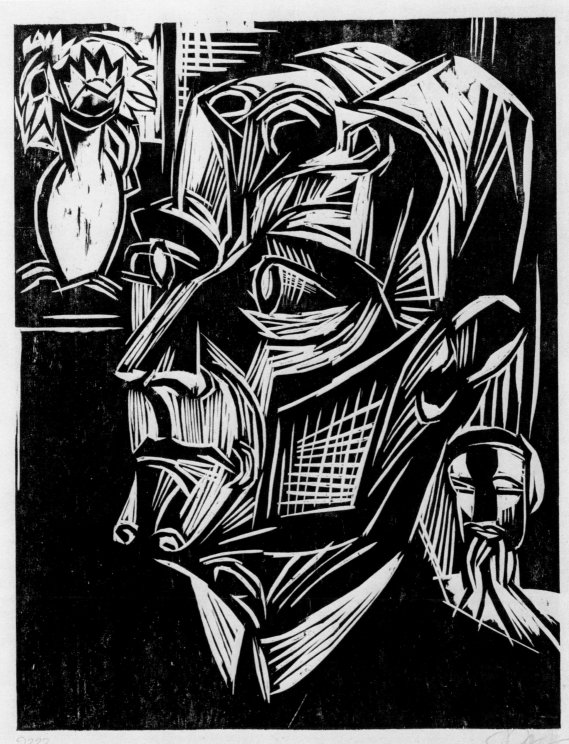

2333

To my sincere friend
Ralph H Booth
with best wishes
W R Valentiner

To Ralph H. Booth

RAIN CLOUDS, LAGO DI GARDA 1927

Considering Schmidt-Rottluff's lifelong affection for the simple beauty of the plain and undifferentiated countryside along the coast of the Baltic and the North Sea, it is not surprising that mountain landscapes are relatively rare in his work. Only in the late 1920s, after his highly simplified style had gradually given way to a more objective rendering, as can be seen in his portrait of Valentiner of 1923, did the depiction of mountains become for the painter a viable problem in pictorial form.

In *Rain Clouds, Lago di Garda*, one of two mountain landscapes painted in the spring of 1927 while he was vacationing in the north Italian lake district, Schmidt-Rottluff sought to resolve the inevitable tension between the portrayal of volume and space and the integrity of the flat surface of the canvas. Having selected—as Cézanne often did in his views of Mont Sainte-Victoire—a high vantage point that gave him command of a vast space, the artist explored the topography of the terrain with a sense of joyous discovery. Without any paths or human figures to guide or distract it, the eye sweeps across the valley from the trees in the lower left to the magnificent mountains in the far distance. At the same time Schmidt-Rottluff managed to integrate the pictorial structure of the composition by allowing the various strata of the landscape to interlock in a cohesive pattern of angular and curvilinear forms. To the simplified and ornamental dark brown trees in the foreground, the blue clouds respond in rhythmic counterpoint, as the little houses in the valley below glitter like orange and yellow tesserae in a mosaic of cool green and blue. By weaving corporeal forms such as the massive mountains into the surface design, Schmidt-Rottluff achieved an equilibrium between representation and abstraction reminiscent of contemporary pictures by Kirchner, who, at approximately the same time, arrived independently at a similar synthesis (p. 107). While the simplicity and architectonic clarity of Schmidt-Rottluff's picture recall his earlier compositions, the notably decorative character of the landscape heralds the non-Expressionist manner that henceforth dominated his work. A remarkable calm and strength emanate from this painting, as does a true feeling for ancient and unspoiled nature.

Oil on canvas, 87.6 x 112.4 cm (34½ x 44¼ in.)
Signed, lower left: *S. Rottluff*
Gift of Mr. and Mrs. Henry Reichhold (37.2)

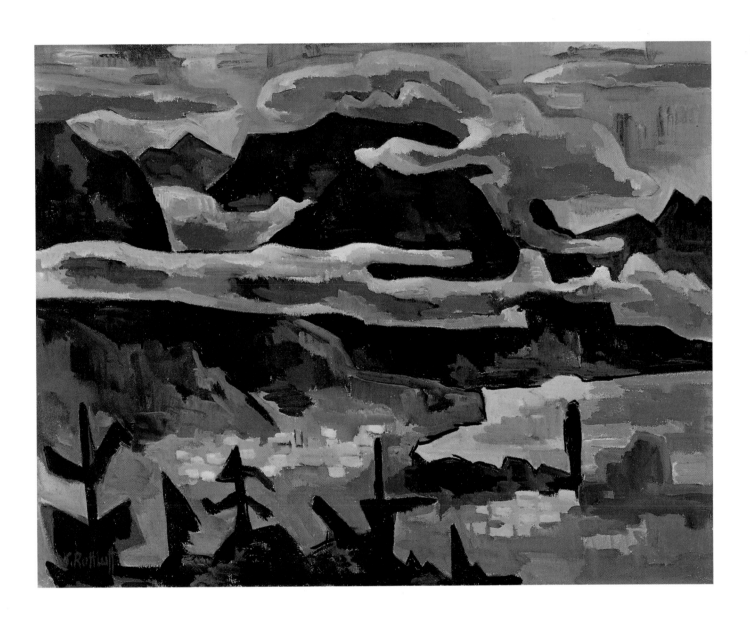

BLOSSOMING TREES c. 1935

Schmidt-Rottluff's watercolors not only show the same development as his oil paintings, but are also noteworthy for having extended the artist's productivity into the tenth decade of his life. Beginning in 1964, presumably for reasons of advancing age, he decided to devote himself exclusively to this medium. *Blossoming Trees* dates from about 1935 and is an outstanding example of the fully developed naturalism that had begun to make itself felt in his work in the mid-1920s. In contrast to the artist's earlier, simplified landscapes, painted in broad planes of bold color (p. 205), the Detroit watercolor conveys its meaning in a soft and gentle pictorial language and embodies a relationship with nature which, though still profound, typifies the later, more relaxed and dispassionate attitude of the German Expressionist artists. Indeed, in both form and feeling *Blossoming Trees* shows a remarkable affinity to Impressionism. Flat areas of pure color have given way to mixed hues—subtly balanced modulations of the three primaries, red, yellow, and blue—which have been applied loosely and with a delicate touch, capturing the scintillating light and atmosphere of a sunny spring day. Light, in fact, pervades everything, dissolving even the contours of the branches of the trees and the edges of the broad, gabled roofs. Schmidt-Rottluff's characteristic feeling for a clear and well-ordered pictorial structure, on the other hand, has been preserved in the judicious contrast between the rhythmic ascent of the houses and the random disposition of the blossoming trees, whose diaphanous forms are echoed in the billowing shape of the large white cloud.

The watercolor was done in Hofheim, a small resort town on the southern slopes of the Taunus Mountains, just west of Frankfurt where, as a guest of the art dealer Hanna Bekker vom Rath, the painter spent every spring between 1932 and 1943 and then again from 1950 on. Nothing in the composition indicates that it dates from the dark years of defamation and curtailment of the artist's professional activities by the Nazi regime. Rather, it reflects the seclusion and peace that Bekker vom Rath's villa, hidden amidst a spacious garden of magnificent old trees, provided him. Though he was able to explore fully the idyllic beauty of the Taunus range only after the end of World War II, the pictures from these earlier years, window views for the most part, in which blooming trees, symbols of growth and renewal, lie palpably close to the painter's touch, appear radiant with joy. Like Kirchner, whose last paintings are pervaded by a similarly timeless spirit, Schmidt-Rottluff managed to sublimate his personal sorrow in landscapes that bear witness to his faith in the indestructibility of nature.

Watercolor over pencil, 50 x 70 cm (19¾ x 27½ in.)
Signed in black watercolor, lower left: *SRottluff*
Bequest of Robert H. Tannahill (70.327)

NOTES

1. August Endell, "Formenschönheit und dekorative Kunst," *Dekorative Kunst* 1, 2 (November 1897), p. 75; quoted in Peg Weiss, *Kandinsky in Munich: The Formative Jugendstil Years* (Princeton, N.J.: Princeton University Press, 1979), p. 34.

2. Quoted in Herschel B. Chipp, ed., *Theories of Modern Art: A Source Book by Artists and Critics* (Berkeley and Los Angeles: University of California Press, 1968), pp. 132, 135.

3. Quoted in Alfred H. Barr, Jr., James Johnson Sweeney, and Julia and Lyonel Feininger, *Paul Klee* (New York: The Museum of Modern Art, 1945), p. 8.

4. Peter Selz, *Max Beckmann* (New York: The Museum of Modern Art, 1964), p. 61.

5. Charlotte Berend-Corinth, *Lovis* (Munich: Albert Langen-Georg Müller Verlag, 1958), pp. 43–44.

6. From a letter to Alfred Vance Churchill, dated March 13, 1913; published in Ernst Scheyer, *Lyonel Feininger: Caricature and Fantasy* (Detroit: Wayne State University Press, 1964), p. 170.

7. Hans Hess, *George Grosz* (London: Studio Vista, 1974), p. 51.

8. *Ibid.*, p. 98.

9. *Ibid.*, p. 183.

10. *Ibid.*, p. 232.

11. The letters *KG* preceding the word *Brücke* are the abbreviation for Künstlergruppe (Artists Group). The names of the owner of the Emil Richter Gallery and of the printer of the poster have also been indicated.

12. Wassily Kandinsky, "Text Artista," in *Wassily Kandinsky Memorial* (New York: Solomon R. Guggenheim Foundation, 1945), p. 59.

13. L. de Marsalle [E. L. Kirchner], "Zeichnungen von E. L. Kirchner," *Genius* 2, 2 (1920), p. 217.

14. *Ibid.*

15. Kirchner expressed this opinion in a letter to the famous collector of German Expressionist prints Gustav Schiefler, dated December 31, 1912; see Annemarie Dube-Heynig, *E. L. Kirchner: His Graphic Art* (Munich: Prestel, 1961), p. 51.

16. Quoted in Donald E. Gordon, *Ernst Ludwig Kirchner* (Cambridge, Mass.: Harvard University Press, 1968), p. 116.

17. *Ibid.*, p. 110.

18. *Ibid.*, p. 30.

19. *Ibid.*, p. 31.

20. Felix Klee, ed., *The Diaries of Paul Klee, 1898–1918* (Berkeley and Los Angeles: University of California Press, 1964), p. 232.

21. Quoted in Chipp, *Theories*, p. 185.

22. *Ibid.*, p. 182.

23. *Ibid.*

24. *Ibid.*

25. Quoted in Klaus Lankheit, *Franz Marc* (Berlin: Konrad Lemmer, 1950), p. 18.

26. *Ibid.*

27. J. Diane Radycki, ed. and trans., *The Letters and Journals of Paula Modersohn-Becker* (Metuchen, N.J., and London: The Scarecrow Press, 1980), p. 56.

28. *Ibid.*, p. 286.

29. *Ibid.*, pp. 151–152.

30. *Ibid.*, p. 33.

31. *Ibid.*, p. 216.

32. J. van Gogh-Bonger and V. W. van Gogh, eds. and trans., *The Complete Letters of Vincent van Gogh* (Greenwich, Conn.: New York Graphic Society, 1958), vol. 3, p. 25, letter no. 531.

33. Lothar Günther Buchheim, *Otto Mueller: Leben und Werk* (Feldafing: Buchheim, 1963), p. 266.

34. Quoted in *Emil Nolde: Gemälde, Aquarelle, Zeichnungen und Druckgraphik* (Cologne: Wallraf-Richartz-Museum, 1973), p. 39.

35. Emil Nolde, *Jahre der Kämpfe* (Berlin: Rembrandt-Verlag, 1934), p. 104.

36. Quoted in *Emil Nolde*, p. 37.

37. Emil Nolde, *Das eigene Leben* (Flensburg: Christian Wolff, 1949), p. 200.

38. Quoted in *Emil Nolde*, p. 40.

39. *Ibid.*, p. 38.

40. "MUIM" is the abbreviation for Moderner Unterricht in Malerei (Modern Instruction in Painting).

41. "Das Neue Program: Vorwort der Redaktion," *Kunst und Künstler* 22, 6 (February 1914), p. 308.

SELECTED BIBLIOGRAPHY

GENERAL REFERENCES

EXPRESSIONISM

Buchheim, Lothar Günther. *The Graphic Art of German Expressionism*. New York: Universe Books, 1960.

Dube, Wolf-Dieter. *Expressionism*. New York and Toronto: Oxford University Press, 1972.

Expressionism: A German Intuition 1905–1920. New York: The Solomon R. Guggenheim Foundation, 1980.

German Realism of the Twenties: The Artist as Social Critic. Minneapolis: The Minneapolis Institute of Arts, 1980.

Hartlaub, G. F. *Die Graphik des Expressionismus in Deutschland*. Stuttgart: Gerd Hatje, 1947.

Miesel, Victor H., ed. *Voices of German Expressionism*. Englewood Cliffs, N.J.: Prentice-Hall, 1970.

Myers, Bernard S. *The German Expressionists: A Generation in Revolt*. New York: Praeger, 1957.

Reed, Orrel P., Jr. *German Expressionist Art: The Robert Gore Rifkind Collection*. Los Angeles: Frederic S. Wight Art Gallery, University of California, 1977.

Samuel, Richard, and Thomas, R. Hinton. *Expressionism in German Life, Literature and the Theatre*. Cambridge: W. Heffer & Sons, Ltd., 1939.

Selz, Peter. *German Expressionist Painting*. Berkeley and Los Angeles: University of California Press, 1957.

Vogt, Paul. *Expressionism: German Painting 1905–1920*. New York: Harry N. Abrams, 1980.

DIE BRÜCKE

Buchheim, Lothar Günther. *Die künstlergemeinschaft Brücke*. Feldafing: Buchheim, 1956.

DER BLAUE REITER

Buchheim, Lothar Günther. *Der Blaue Reiter*. Feldafing: Buchheim, 1959.

Lankheit, Klaus, ed. *The Blaue Reiter Almanac*. New York: Viking and Munich: R. Piper, 1974.

INDIVIDUAL ARTISTS

BARLACH

Barlach, Ernst. *Ein Selbsterzähltes Leben*. Berlin: Paul Cassirer, 1928.

Carls, Carl Dietrich. *Ernst Barlach*. New York: Praeger, 1969.

Schult, Friedrich. *Ernst Barlach: Das Plastische Werk*. Hamburg: Dr. Ernst Hauswedell & Co., 1960.

_____. *Ernst Barlach: Werkkatalog der Zeichnungen*. Hamburg: Dr. Ernst Hauswedell & Co., 1971.

_____. *Ernst Barlach: Das Graphische Werk*. Hamburg: Dr. Ernst Hauswedell & Co., 1972.

Werner, Alfred. *Barlach*. New York, London, Toronto, and Sydney: McGraw-Hill, 1966.

BECKMANN

Beckmann, Max. *Briefe im Kriege*. Berlin: Bruno Cassirer, 1916.

_____. *On My Painting*. New York: Buchholz Gallery-Curt Valentin, 1941.

Buchheim, Lothar Günther. *Max Beckmann*. Feldafing: Buchheim, 1959.

Fischer, Friedhelm W. *Max Beckmann*. London: Phaidon, 1973.

Gallwitz, Klaus. *Max Beckmann: Die Druckgraphik*. Karlsruhe: Badischer Kunstverein, 1962.

Göpel, Erhard, and Erffa, Hans Martin Freiherr von, eds. *Blick auf Beckmann: Dokumente und Vorträge*. Schriften der Max Beckmann Gesellschaft, vol. 2. Munich: R. Piper, 1962.

Göpel, Erhard, and Göpel, Barbara. *Max Beckmann: Katalog der Gemälde*. 2 vols. Bern: Kornfeld & Cie., 1976.

Jannasch, Adolf. *Max Beckmann als Illustrator*. Neu-Isenburg: Wolfgang Tiessen, 1969.

Kessler, Charles S. *Max Beckmann's Triptychs*. Cambridge, Mass.: Harvard University Press, 1970.

Lackner, Stephan. *Max Beckmann*. New York: Harry N. Abrams, 1977.

Selz, Peter. *Max Beckmann*. New York: The Museum of Modern Art, 1964.

Wiese, Stephan von. *Max Beckmanns zeichnerisches Werk 1903–1925*. Düsseldorf: Droste Verlag [c. 1978].

CAMPENDONK

Biermann, Georg. *Heinrich Campendonk*. Junge Kunst, vol. 17. Leipzig: Klinkhardt & Biermann, 1921.

Engels, Mathias T. *Campendonk: Holzschnitte*. Stuttgart: W. Kohlhammer, 1959.

_____. *Campendonk als Glasmaler*. Krefeld: Scherpe, 1966.

Wember, Paul. *Heinrich Campendonk*. Krefeld: Scherpe, 1960.

CORINTH

Berend-Corinth, Charlotte. *Die Gemälde von Lovis Corinth*. Munich: F. Bruckmann, 1958.

_____. *Lovis*. Munich: Albert Langen-Georg Müller Verlag, 1958.

Corinth, Lovis. *Selbstbiographie*. Leipzig: S. Hirtzel, 1926.

Kuhn, Alfred. *Lovis Corinth*. Berlin: Propyläen, 1925.

Müller, Heinrich. *Die späte Graphik von Lovis Corinth*. Hamburg: Lichtwarkstiftung, 1960.

Schwarz, Karl. *Das graphische Werk von Lovis Corinth*. 1st ed. Berlin: Fritz Gurlitt, 1917; 2d ed. 1922.

Uhr, Horst. "*Pink Clouds, Walchensee:* The 'Apotheosis' of a Mountain Landscape," *Bulletin of The Detroit Institute of Arts* 55, 4 (1977), pp. 209–215.

DIX

Karsch, Florian. *Otto Dix: Das graphische Werk*. Hanover: Fackelträger Verlag Schmidt-Küster, 1970.

Löffler, Fritz. *Otto Dix: Leben und Werk*. 2d rev. ed. Vienna and Munich: Anton Schroll, 1967.

Schmidt, Diether. *Otto Dix im Selbstbildnis*. Berlin: Henschel, 1978.

FEININGER

Hess, Hans. *Lyonel Feininger*. London: Thames and Hudson, 1961.

Kokkinen, Eila. *Lyonel Feininger: The Ruin by the Sea*. New York: The Museum of Modern Art, 1968.

Ness, June. *Lyonel Feininger*. New York: Praeger, 1974.

Prasse, Leona E. *Lyonel Feininger. A Definitive Catalogue of His Graphic Work*. Cleveland: Cleveland Museum of Art and Berlin: Gebrüder Mann, 1972.

Scheyer, Ernst. *Lyonel Feininger: Caricature and Fantasy*. Detroit: Wayne State University Press, 1964.

GROSZ

Baur, John I. *George Grosz*. London: Thames and Hudson [1954].

Bittner, Herbert. *George Grosz*. New York: Art Inc., 1959.

Hess, Hans. *George Grosz*. London: Studio Vista, 1974.

Lewis, Beth Irwin. *George Grosz: Art and Politics in the Weimar Republic*. Madison and Milwaukee: University of Wisconsin Press, 1971.

HECKEL

Buchheim, Lothar Günther. *Erich Heckel*. Feldafing: Buchheim, 1957.

Dube, Annemarie, and Dube, Wolf-Dieter. *Erich Heckel: Das graphische Werk*. 3 vols. New York: Ernest Rathenau and Berlin: Euphorion, 1964–74.

Kohn, Heinz. *Erich Heckel: Aquarelle und Zeichnungen*. Munich: F. Bruckmann [1959].

Rathenau, Ernest, ed. *Erich Heckel: Handzeichnungen*. New York: Ernest Rathenau and Berlin: Euphorion, 1973.

Vogt, Paul. *Erich Heckel*. Recklinghausen: Aurel Bongers, 1965.

HOFER

Hofer, Karl. *Aus Leben und Kunst*. Berlin: Rembrandt-Verlag, 1952.

Martin, Kurt. *Karl Hofer*. Karlsruhe: Akademie der bildenden Künste, 1957.

Rathenau, Ernest, ed. *Karl Hofer: Das graphische Werk*. New York: Ernest Rathenau and Berlin: Euphorion, 1969.

Rigby, Ida K. *Karl Hofer*. New York: Garland, 1976.

KANDINSKY

Grohmann, Will. *Wassily Kandinsky: Life and Work*. New York: Harry N. Abrams, 1958.

Hanfstaengl, Erika. *Wassily Kandinsky: Zeichnungen und Aquarelle*. Munich: Prestel, 1974.

Kandinsky, Wassily. *Concerning the Spiritual in Art*. Documents of Modern Art, vol. 5. New York: Wittenborn, Schultz, 1947.

_____. *Point and Line to Plane*. New York: Solomon R. Guggenheim Foundation, 1947.

Overy, Paul. *Kandinsky: The Language of the Eye*. New York: Praeger, 1969.

Roethel, Hans K., with Benjamin, Jean K. *Kandinsky*. New York: Hudson Hills Press, 1979.

Wassily Kandinsky Memorial. New York: Solomon R. Guggenheim Foundation, 1945.

Weiss, Peg. *Kandinsky in Munich: The Formative Jugendstil Years*. Princeton, N.J.: Princeton University Press, 1979.

KAUS

Reidemeister, Leopold. *Max Kaus: Gemälde von 1917 bis 1970*. Berlin: Brücke-Museum, 1971.

KIRCHNER

Dube, Annemarie, and Dube, Wolf-Dieter. *Ernst Ludwig Kirchner: Das graphische Werk*. 2 vols. Munich: Prestel, 1967.

Dube-Heynig, Annemarie. *E. L. Kirchner: His Graphic Work*. Munich: Prestel, 1961.

Ernst Ludwig Kirchner. 1880–1938. Berlin: Nationalgalerie [c. 1979].

Gordon, Donald E. *Ernst Ludwig Kirchner*. Cambridge, Mass.: Harvard University Press, 1968.

Kornfeld, Eberhard W. *Ernst Ludwig Kirchner. Nachzeichnung Seines Lebens*. Katalog der Sammlung von Werken von Ernst Ludwig Kirchner im Kirchner-Haus Davos. Bern: Eberhard W. Kornfeld and Roman Norbert Ketterer, 1979.

L. de Marsalle [E. L. Kirchner]. "Zeichnungen von E. L. Kirchner," *Genius* 2, 2 (1920), pp. 216–234.

Schiefler, Gustav. *Das graphische Werk von Ernst Ludwig Kirchner*. 2 vols. Berlin-Charlottenburg: Euphorion, 1924–31.

Valentiner, Wilhelm R. *E. L. Kirchner: German Expressionist*. Raleigh: North Carolina Museum of Art, 1958.

KLEE

Geelhaer, Christian. *Paul Klee and the Bauhaus*. Greenwich, Conn.: New York Graphic Society, 1973.

Giedion-Welcker, Carola. *Paul Klee*. New York: Viking, 1952.

Glaesemer, Jürgen. *Paul Klee: Handzeichnungen I*. Bern: Kunstmuseum, 1973.

Grohmann, Will. *Paul Klee: Handzeichnungen*. Cologne: M. DuMont Schauberg [c. 1959].

————. *Paul Klee*. New York: Harry N. Abrams, 1967.

Haftmann, Werner. *The Mind and Work of Paul Klee*. New York and Washington: Praeger, 1967.

Klee, Felix, ed. *The Diaries of Paul Klee, 1898–1918*. Berkeley and Los Angeles: University of California Press, 1964.

Klee, Paul. *On Modern Art*. London: Faber and Faber [1948].

————. *Pedagogical Sketchbook*. New York: Praeger [c. 1953].

————. *The Thinking Eye: The Notebooks of Paul Klee*. New York: Wittenborn, 1961.

Kornfeld, Eberhard. *Verzeichnis des graphischen Werkes von Paul Klee*. Bern: Kornfeld und Klipstein, 1963.

Paul Klee: Das Frühwerk, 1883–1922. Munich, Städtische Galerie im Lenbachhaus [1981].

Soby, James Thrall. *The Prints of Paul Klee*. New York: Curt Valentin [c. 1945].

KOKOSCHKA

Hodin, J. P. *Oskar Kokoschka: The Artist and His Time*. Greenwich, Conn.: New York Graphic Society, 1966.

Hoffmann, Edith. *Kokoschka: Life and Works*. London: Faber and Faber, 1947.

Kokoschka, Oskar. *My Life*. London: Thames and Hudson, 1974.

Wingler, Hans Maria. *Oskar Kokoschka: The Work of the Painter*. Salzburg: Galerie Welz, 1958.

Wingler, Hans Maria, and Welz, Friedrich. *Oskar Kokoschka: Das druckgraphische Werk*. Salzburg: Galerie Welz, 1975.

KOLBE

Binding, Rudolf G. *Vom Leben der Plastik: Inhalt und Schönheit des Werkes von Georg Kolbe*. 2d enl. ed. Berlin: Rembrandt-Verlag, 1933.

Kolbe, Georg. *Auf Wegen der Kunst: Schriften, Skizzen, Plastiken*. Berlin-Zehlendorf: Konrad Lemmer [1949].

Pinder, Wilhelm. *Georg Kolbe: Werke der letzten Jahre*. Berlin: Rembrandt-Verlag [c. 1937].

Valentiner, Wilhelm R. *Georg Kolbe: Plastik und Zeichnung*. Munich: Kurt Wolff, 1922.

KOLLWITZ

Bittner, Herbert. *Käthe Kollwitz: Drawings*. London: Thomas Yoseloff, 1959.

Bonus-Jeep, Beate. *Sechzig Jahre Freundschaft mit Käthe Kollwitz*. Boppard: K. Rauch [1948].

Klein, Minna C., and Klein, Arthur. *Käthe Kollwitz: Life in Art*. New York, Chicago, and San Francisco: Holt, Rinehart & Winston, 1972.

Klipstein, August. *Käthe Kollwitz: Verzeichnis des graphischen Werkes*. Bern: Klipstein & Cie., 1955.

Kollwitz, Hans, ed. *Diaries and Letters of Käthe Kollwitz*. Chicago: H. Regnery Co., 1955.

Nagel, Otto. *Käthe Kollwitz*. Greenwich, Conn.: New York Graphic Society, 1971.

Nagel, Otto, ed., with Schallenberg-Nagel, Sibylle, and Timm, Werner. *Käthe Kollwitz: Die Handzeichnungen*. Berlin: Henschelverlag, 1972.

LEHMBRUCK

Heller, Reinhold. *The Art of Wilhelm Lehmbruck*. Washington, D.C.: National Gallery of Art, 1972.

Hoff, August. *Wilhelm Lehmbruck: Life and Work*. New York: Praeger, 1969.

Petermann, Erwin. *Die Druckgraphik von Wilhelm Lehmbruck*. Stuttgart: Gerd Hatje, 1964.

MACKE

Busch, Günter. *August Macke: Handzeichnungen*. Mainz-Berlin: Florian Kupferberg [1966].

Engels, Mathias. *August Macke*. Recklinghausen: Aurel Bongers, 1958.

Vriesen, Gustav. *August Macke*. Stuttgart: W. Kohlhammer, 1957.

MARC

Bünemann, Hermann. *Franz Marc: Zeichnungen und Aquarelle*. Munich: F. Bruckmann, 1960.

Franz Marc 1880–1916. Munich: Städtische Galerie im Lenbachhaus and Prestel Verlag, 1980.

Lankheit, Klaus. *Franz Marc*. Berlin: Konrad Lemmer, 1950.

————. *Franz Marc: Skizzenbuch aus dem Felde*. Berlin: Gebrüder Mann, 1956.

————. *Franz Marc: Watercolors, Drawings, Writings*. New York: Harry N. Abrams, 1960.

————. *Franz Marc: Katalog der Werke*. Cologne: M. DuMont Schauberg, 1970.

Levine, Frederick S. *The Apocalyptic Vision: The Art of Franz Marc as German Expressionism*. New York: Harper & Row, 1979.

Marc, Franz. *Briefe, Aufzeichnungen, und Aphorismen.* 2 vols. Berlin: Paul Cassirer, 1920.

Schardt, Alois. *Franz Marc.* Berlin: Rembrandt-Verlag, 1936.

MODERSOHN-BECKER

Busch, Günter. *Paula Modersohn-Becker: Malerin-Zeichnerin.* Frankfurt: S. Fischer Verlag, 1981.

Gallwitz, Sophie Dorothee, ed. *Paula Modersohn: Briefe und Tagebuchblätter.* Berlin: Der Neue Geist, 1949.

Murken-Altrogge, Christa. *Paula Modersohn-Becker, Leben und Werk.* Cologne: M. DuMont Schauberg, 1980.

Pauli, Gustav. *Paula Modersohn-Becker.* Berlin and Leipzig: Kurt Wolff, 1919.

Perry, Gillian. *Paula Modersohn-Becker: Her Life and Work.* New York: Harper & Row, 1979.

Radycki, J. Diane, ed. and trans. *The Letters and Journals of Paula Modersohn-Becker.* Metuchen, N.J. and London: The Scarecrow Press, 1980.

Stelzer, Otto. *Paula Modersohn-Becker.* Berlin: Rembrandt-Verlag, 1958.

Werner, Wolfgang. *Paula Modersohn-Becker: Oeuvre Verzeichnis der Graphik.* Bremen: Graphisches Kabinett Wolfgang Werner, 1972.

MUELLER

Buchheim, Lothar Günther. *Otto Mueller: Leben und Werk.* Feldafing: Buchheim, 1963.

Karsch, Florian. *Otto Mueller: Zum hundertsten Geburtstag, Das graphische Gesamtwerk.* Berlin: Galerie Nierendorf, 1974.

NOLDE

Haftmann, Werner. *Emil Nolde.* New York: Harry N. Abrams, 1959.

_____. *Emil Nolde: Unpainted Pictures.* New York: Praeger [c. 1965].

Nolde, Emil. *Jahre der Kämpfe.* Berlin: Rembrandt-Verlag, 1934.

_____. *Das eigene Leben.* Flensburg: Christian Wolff, 1949.

_____. *Welt und Heimat; die Südseereise, 1913–1918.* Cologne: M. DuMont Schauberg [1965].

_____. *Reisen. Achtung. Befreiung.* Cologne: M. DuMont Schauberg [1967].

Schiefler, Gustav, and Mosel, Christel. *Emil Nolde: Das graphische Werk.* 2 vols. Cologne: M. DuMont Schauberg, 1966–67.

Selz, Peter. *Emil Nolde.* New York: The Museum of Modern Art, 1963.

Urban, Martin. *Emil Nolde: Flowers and Animals.* New York and Washington, D.C.: Praeger, 1966.

_____. *Emil Nolde: Landscapes.* New York, Washington, D.C., and London: Praeger, 1970.

PECHSTEIN

Biermann, Georg. *Max Pechstein.* Junge Kunst, vol. 1. Leipzig: Klinkhardt & Biermann, 1919.

Fechter, Paul. *Max Pechstein: Das graphische Werk.* Berlin: F. Gurlitt, 1921.

Osborn, Max. *Max Pechstein.* Berlin: Propyläen, 1922.

Reidemeister, Leopold. *Max Pechstein: Erinnerungen.* Munich: List, 1963.

ROHLFS

Scheidig, Walter. *Christian Rohlfs.* Dresden: VEB Verlag der Kunst, 1965.

Vogt, Paul. *Christian Rohlfs: Aquarelle und Zeichnungen.* Recklinghausen: Aurel Bongers, 1958.

_____. *Christian Rohlfs: Das graphische Werk.* Recklinghausen: Aurel Bongers, 1958.

_____. *The Best of Christian Rohlfs.* New York: Atlantis Books [1965].

SCHMIDT-ROTTLUFF

Brix, Karl. *Karl Schmidt-Rottluff.* Vienna [c. 1972].

Grohmann, Will. *Karl Schmidt-Rottluff.* Stuttgart: W. Kohlhammer, 1956.

Rathenau, Ernest, ed. *Karl Schmidt-Rottluff: Das graphische Werk seit 1923.* New York: Ernest Rathenau and Berlin: Euphorion, 1964.

Schapire, Rosa. *Karl Schmidt-Rottluffs graphisches Werk bis 1923.* Berlin: Euphorion, 1924.

Thiem, Gunter. *Karl Schmidt-Rottluff: Aquarelle und Zeichnungen.* Munich: F. Bruckmann [c. 1963].

Valentiner, Wilhelm R. *Karl Schmidt-Rottluff.* Junge Kunst, vol. 16. Leipzig: Klinkhardt & Biermann, 1920.

Wietek, Gerhard. *Schmidt-Rottluff Graphik.* Munich: Karl Thiemig, 1971.

INDEX

PAGE NUMBERS IN *ITALICS* REFER TO ILLUSTRATIONS.

Altdorfer, Albrecht, 61
Amiet, Cuno, 12
Armory Show, 10
Azbé, Anton, 88

Bach, Johann Sebastian, 66
Barlach, Ernst, 24, 26, 30–37, 142, 146, 148; *The Avenger* (1914), 32, *33*, 34; *Ecstatic Woman (Procuress*, c. 1920), 34, *35*; *Episode from a Modern Dance of Death* (1916), 32; *The First Day* (1920), 36, *37*; *Holy War* (c. 1914), 32; *The Transformations of God* (published 1921), 36
Barr, Alfred H., Jr., 28
Barrison sisters, 80
Bauhaus, 25, 26, 65, 89, 111, 114
Becker, Paula, *see* Modersohn-Becker, Paula
Beckmann, Max, 11, 24, 25, 26, 28, 38–47, 54, 60, 72, 84, 198; *Carnival*, 40; *City Night*, 40; *Hell*, 40; *Old Woman with a High Hat* (1920), 40, *41*; *Sacrificial Meal* (1947), 46, *47*; *Self-Portrait in Olive and Brown* (1945), 44, *45*; *Still Life with Fallen Candles* (1929), 42, *43*
Bekker vom Rath, Hanna, 214
Berend, Charlotte, 58
Berlin Secession, 10, 12, 13, 21, 38, 54, 162, 189
Bernini, Gianlorenzo, 130
Black Anna, 136
Blauen Vier, Die (The Blue Four), 89
Blaue Reiter, Der (The Blue Rider), 10, 11, 13, 14, 15, 16, 23, 24, 26, 48, 49, 50, 62, 65, 72, 89, 110, 150, 152, 154
Blaue Reiter, Der (yearbook), 15, 89, 154
Bleyl, Fritz, 11, 12, 76, 96, 202
Boccioni, Umberto, 156
Booth, Ralph H., 28
Bosch, Hieronymus, 40
Bouguereau, William, 54
Braque, Georges, 97, 112, 154
Brecht, Bertolt, 72, 208
Brücke, Die (The Bridge), 10, 11, 12, 13, 16, 17, 19, 21, 22, 23, 24, 26, 40, 62, 72, 76, 78, 92, 96, 98, 124, 163, 164, 170, 171, 188, 189, 190, 195, 196, 202, 210
Brueghel, Pieter, the Elder, 40, 126
Burliuk, David, 14, 15
Burliuk, Vladimir, 14
Buxtehude, Dietrich, 66

Campendonk, Heinrich, 14, 23, 25, 26, 48–53; *In the Forest* (c. 1919), 50, *51*, 52; *Nude with Fish and Birds* (c. 1920), 52, *53*
Carus, Karl Gustav, 100
Cassirer, Paul, 32, 36, 164
Cézanne, Paul, 10, 48, 84, 85, 122, 158, 159, 160, 212
Corinth, Lovis, 26, 28, 38, 42, 44, 54–59, 92, 126, 150, 200, 206; *Pietà* (1889), 54; *Pink Clouds. Walchensee* (1921), 58, *59*; *Still Life with Lilacs* (1917), 56, *57*
Corot, Camille, 122
Cranach, Lucas, the Elder, 61

Cubism, 10, 11, 14, 26, 50, 64, 66, 112, 151, 154, 155, 204; *see also* Synthetic Cubism

Dadaism, 71, 143
Dante Alighieri, 148
Debschitz, Wilhelm von, 18, 96
Degenerate "Art" exhibition, 26, 28, 39, 55, 77, 85, 97, 120, 171, 203; *Entartete "Kunst" Austellungsführer (Degenerate "Art" Exhibition Guide*, 1937), *26, 27*
Delaunay, Robert, 14, 66, 110, 151, 155, 156; *A Window* (1912), *14*
Diez, Wilhelm, 154
Dix, Otto, 25, 26, 40, 60–63, 72, 84, 198; *Self-Portrait* (1912), 27, 62, *63*; *Trench Warfare* (1920–23), 61; *War* (1924), 61
van Dongen, Kees, 12, 188
Dostoevsky, Feodor, 11
Duncan, Isadora, 80
Dürer, Albrecht, 62, 96, 176, 192

El Greco, 126
Ende, Hans am, 158
Endell, August, 18
Ernst Heinrich, Prince, 135
van Eyck, Jan, 122

Fauvism, 10, 12, 19, 26, 55, 151, 188
Fechter, Paul, 10, 11, 78
Fehr, Hans, 178
Feininger, Lyonel, 14, 15, 25, 26, 27, 28, 64–69, 89; *Cathedral of Socialism* (1919), *25*; *Ruin by the Sea I* (1934), 68, *69*; *Sidewheeler* (1913), 66, *67*
Flechtheim, Alfred, 32, 34
Fra Angelico, 49
Friedrich, Caspar David, 21, 68, 100, 106, 156; *Woman Contemplating the Setting Sun* (c. 1818), *22*
Fuller, Loie, 80
Futurism, 60, 70, 155, 156

Gallén-Kallela, Axel, 12
Gauguin, Paul, 10, 16, 19, 22, 150, 158, 159, 160, 168; *Fatata te Miti (By the Sea*, 1892), *16*
Giotto di Bondone, 49, 188
van Gogh, Vincent, 10, 11, 16, 17, 19, 48, 77, 158, 159, 160, 180, 194; *La Berceuse* (1889), 17, *17*
Grisebach, Eberhard, 102
Grohmann, Will, 106
Gropius, Walter, 25, 208
Grosz, George, 25, 26, 38, 40, 60, 61, 70–75, 84, 198; *Conversation* (c. 1928), 72, *73*; *Love above All* (1930), 72; *New York* (1934), 74, *75*
Grünewald, Matthias, 23; *Crucifixion* (c. 1525), *24*
Gujer, Lise, 104
Gurlitt, Fritz, 12
Gussmann, Otto, 188

Hackl, Gabriel, 154

Hals, Frans, 54
Hansen, Emil, *see* Nolde, Emil
Hasenclever, Walter, 20, 120; portrait of, *27, 120, 121*
Hauptmann, Carl, 162
Hauptmann, Gerhart, 134, 162
Heartfield, John, 71
Heckel, Erich, 11, 12, 13, 17, 20, 27, 76–83, 92, 94, 96, 164,
 188, 189, 190, 198, 202, 203, 208, 210; *Die Brücke Exhibition
 Poster* (1908), 78, *79*; *Dance* (1911), 80, *81*; *Woman* (1920),
 82, *83*
Heckel, Siddi, 82
Herbig, Otto, 92
Herterich, Ludwig, 134
Hitler, Adolf, 26, 31, 62, 93, 135
Hoelzel, Adolf, 170
Hofer, Carl, 25, 28, 84–87; *Stormy Sea* (1911), 86; *Wind* (1937),
 86, *87*
Hofmann, Ludwig von, 162

Impressionism, 19, 60, 88, 126, 150, 154, 194, 214

Jawlensky, Alexey, 15, 24, 89
John, Saint, 192
Jugend (periodical), 18
Jugendstil, 18, 30, 78, 96, 118, 162

Kamperman, Dr. and Mrs. George, 28
Kandinsky, Wassily, 11, 13, 14, 15, 18, 24, 25, 48, 65, 78, 88–91,
 150, 152, 154; *Der Blaue Reiter* (1911), *15*; *Concerning the
 Spiritual in Art* (book), 15, 18, 89; *Dusk* (c. 1901), *15*; "On the
 Problem of Form" (essay), 89; *Painting with White Form*
 (1913), 90, *91*
Kaus, Max, 17, 92–95; *Man in a Fur Coat* (c. 1918), 94, *95*
Kerschbaumer, Anton, 92
Kirchner, Ernst Ludwig, 11, 12, 13, 18, 20, 22, 24, 27, 28, 62, 76,
 77, 78, 80, 90, 96–109, 164, 188, 189, 190, 194, 198, 202,
 203, 208, 210, 212, 214; *Berlin Street Scene* (1913), *20*; *Café*
 (1928), 104, *105*; *Cemetery in the Forest* (1933), 108, *109*;
 Coastal Landscape on Fehmarn (c. 1913), 100, *101*; *A Group of
 Artists: Otto Mueller, Kirchner, Erich Heckel, Karl Schmidt-
 Rottluff* (1926–27), *13*; *Künstlergruppe Brücke (Brücke
 Artists' Group*, 1906), *12*; *Manifesto of Die Brücke* (1906), *12*;
 Mountain Lake (c. 1930), 106, *107*; *Smoker and Dancer* (1912),
 80, 98, *99*; *Winter Landscape in Moonlight* (1919), 27, 102,
 103
Klee, Paul, 15, 22, 23, 25, 28, 65, 89, 97, 110–117, 151;
 "Concerning Modern Art" (lecture), 111; "Creative Credo"
 (essay), 110–111, 112; *Garden* (1915), 112, *113*; *Pedagogical
 Sketchbook* (book), 111; *Reclining* (c. 1937), 116, *117*;
 Tightrope Walker (1923), 114, *115*
Klein, César, 24, 189
Klimt, Gustav, 118
Klinger, Max, 134
Knirr, Heinrich, 110
Kokoschka, Oskar, 25, 26, 27, 55, 118–127, 198; *The Dreaming
 Youths* (1908), 118; *Dresden Neustadt II* (c. 1921), 122, *123*;

Girl with a Doll (c. 1921–22), 124, *125*; *Murderer, Hope of
 Women* (play), 118; *View of Jerusalem* (1929–30), 126, *127*;
 Walter Hasenclever (1917), *27, 120, 121*
Kolbe, Georg, 27, 128–133; *Assunta* (1921), 132, *132, 133*;
 Dancer (1914), 130, *130, 131*, 132; *Resurrection* (1920), 132
Kollwitz, Karl, 134
Kollwitz, Käthe, 20, 72, 134–141; *Battlefield*, 136; *Burial*
 (c. 1903), 138, *139*; *Death* (1934–35), 138; *Outbreak* (1902),
 134, 136, *137*, 138; *The Peasants' War* (1902–08), 134, 136,
 138; *The Prisoners*, 136; *Self-Portrait* (1920), 140, *141*; *The
 Weavers' Revolt* (1893–97), 134, 136
Kollwitz, Peter, 135, 138
Kreis, Wilhelm, 76, 78
Kriegszeit (*War Time*, propaganda broadsheet), 32
Kubin, Alfred, 15, 89, 110
Kunst und Künstler (publication), 202

Lehmbruck, Wilhelm, 82, 132, 142–149, 162, 164; *Head of a
 Woman* (1913–14), 144, *145*; *Kneeling Woman* (1911), 142;
 Pensive Woman (bronze, 1913–14), 144; *Pensive Woman*
 (etching, 1912), 146; *Rising Youth* (1913), 146; *Seated Girl*
 (1913–14), 146, *147*; *Two Wounded Men* (c. 1916–17), 148,
 149
Lepel, Joachim von, 182
Liebermann, Max, 54
Löfftz, Ludwig von, 54
Lübke, Elsbeth, 162
Luther, Martin, 192

Macke, August, 14, 15, 24, 48, 110, 150–153, 154, 155; *Nude
 Standing before a Mirror* (c. 1911), 152, *153*
Macke, Helmut, 48
Mackensen, Fritz, 158, 160
Maillol, Aristide, 142
Mann, Heinrich, 20
Marc, Franz, 13, 14, 15, 22, 24, 27, 38, 48, 49, 50, 64, 66, 89,
 112, 150, 152, 154–157, 194; *Animals in a Landscape* (1914),
 156, *157*
Marcks, Gerhard, 28
Marées, Hans von, 21, 38, 84, 164; *The Golden Age* (1879–85),
 21
Matisse, Henri, 10, 19, 104, 150, 152, 188, 190; *The Open
 Window, Collioure* (1905), 19, *19*
Meunier, Constantin, 142
Meyerhofer, Maschka, 162, 166
Modersohn, Otto, 158, 159
Modersohn-Becker, Paula, 17, 158–161, 168; *Old Peasant Woman*
 (c. 1905–06), 27, 160, *161*
Moilliet, Louis, 110, 151
Monet, Claude, 54, 88, 180
Moreau, Gustave, 10
Mueller, Otto, 12, 13, 21, 22, 25, 26, 27, 92, 146, 156, 162–169;
 Bathers (c. 1920), 164, *165*; *Gypsy Encampment* (c. 1925),
 168, *169*; *Gypsy Portfolio* (1927), 168; *Self-Portrait with
 Model and Mask* (c. 1922), 166, *167*
MUIM-Institut, 189

Munch, Edvard, 11, 17, 186; *Melancholy* (1889), 17, *17*
Munich Secession, 21, 54
Münter, Gabriele, 14, 89

Nabis, 159
National Socialism, 11, 26, 31, 65, 71, 77, 111, 129, 171; *see also* Nazism
Nazism, 26, 31, 38, 39, 44, 49, 55, 61, 62, 65, 70, 85, 89, 97, 102, 106, 119, 120, 129, 135, 160, 189, 195, 203, 214; *see also* National Socialism
Neide, Emil, 134
Neo-Impressionism, 96
Neue Künstlervereinigung (New Artists' Association), 14, 89
Neue Sachlichkeit (New Objectivity), 40, 71
Neue Sezession (New Secession), 12, 163, 189
Newberry, John S., 28
Niemeyer, Wilhelm, 210
Nietzsche, Friedrich, 11, 20, 160
Nijinsky, Waslaw, 130
Nolde, Emil, 11, 12, 22, 24, 26, 27, 30, 34, 54, 55, 56, 97, 124, 135, 160, 168, 170–187, 188, 190, 195, 198, 202, 204, 208; *Apparitions* (1922), 178, *179*; *Before Sunrise* (1901), 178; *Forest Children* (1911), 178; *Hamburg: Landing Pier* (1910), 172, *173*; *The Last Supper* (1909), 176; *The Mocking of Christ* (1909), 176; *Mr. Sch.*, 186; *Pentecost* (1909), 176; *Reflections*, 184, *185*; *Scribes* (1911), 176, *177*; *Self-Portrait*, 186, *187*; *The Steamer* (c. 1910), 174, *175*; *Strange Beings (Flying and Walking*, 1922), 178; *Sunflowers* (1932), 180, *181*; *Two Peasants*, 23, 182, *183*
Novalis (Baron Friedrich von Hardenberg), 156
Novembergruppe (November group), 24, 25, 27, 128, 189, 208

Obrist, Hermann, 18, 96; *Whiplash (Cyclamen*, c. 1895), 18, *18*
Orphism, 66, 110, 151, 156
Osthaus, Karl Ernst, 194
Overbeck, Fritz, 158

Patinir, Joachim, 126
Pechstein, Max, 11, 12, 13, 21, 22, 24, 25, 26, 27, 132, 156, 164, 168, 188–193, 196, 204; *"And Forgive Us Our Debts"* (1921), 192, *193*; *Under the Trees* (1911), 190, *191*
Phalanx, 14, 89
Picasso, Pablo, 10, 97, 112, 154, 204
Piero della Francesca, 38
Post-Impressionism, 10, 15, 19, 60, 76, 96, 154, 194, 202, 204

Reinhardt, Max, 80
Rembrandt van Rijn, 54, 55, 88
Richter, Emil, 12, 78
Rilke, Rainer Maria, 158
Robert-Fleury, Tony, 54
Rodin, Auguste, 32, 128, 130, 142, 144
Rohlfs, Christian, 24, 28, 132, 194–201; *Men in Silk Hats* (1935), 198, *199*, 200; *The Sermon on the Mount* (1916), 196, *197*; *Violet Moonlight II* (1935), 200, *201*
Rot-Blau Gruppe, Die (The Red-Blue Group), 97

Rouault, Georges, 19
Rousseau, Henri, 14, 50

Schapire, Rosa, 210
Schelling, Friedrich von, 21, 156
Schiefler, Gustav, 186
Schilling, Erna, 96, 97, 100
Schmidt, Karl (father of Käthe Schmidt Kollwitz), 134
Schmidt, Karl, *see* Schmidt-Rottluff, Karl
Schmidt, Käthe, *see* Kollwitz, Käthe
Schmidt-Rottluff, Karl, 11, 12, 13, 24, 25, 26, 27, 28, 76, 77, 96, 97, 128, 132, 135, 156, 164, 189, 190, 196, 202–215; *Blossoming Trees* (c. 1935), 214, *215*; *Cactus in Bloom* (1919), 206, *207*; *Evening by the Sea* (1919), 22, 204, *205*; *Man with a Green Beard* (c. 1920–23), 208, *209*; *Portrait of Wilhelm R. Valentiner, II* (1923), 210, *211*, 212; *Rain Clouds, Lago di Garda* (1927), 212, *213*
Schönberg, Arnold, 14, 15
Seurat, Georges, 150
Shakespeare, William, 148
Signorelli, Luca, 38
Slevogt, Max, 54
Sonderbund exhibition (Cologne, 1912), 10, 13
Stauffer-Bern, Karl, 134
Storm, Theodor, 194
Stuck, Franz von, 89, 110, 162
Sturm, Der (periodical), 10, 12, 118
Symbolism, 10, 26
Synthetic Cubism, 97, 104

Tannahill, Robert H., 28
Thorn-Prikker, Johann, 48

Unknown artist, Bavaria, *Saint George* (19th century), *23*
Unknown artist, Palau Islands, *Carved Roof Beam*, *23*

Valentiner, William R. (Wilhelm R.), 27, 28, 42, 208, 210; portrait of, 210, *211*, 212
Velde, Henry van de, 194
Vermeer, Jan, 94, 122
Vildstrup, Ada, 170, 180
Vogeler, Heinrich, 158

Walden, Herwarth, 10, 15, 118
Wedekind, Frank, 20
Weill, Kurt, 72, 208
Werefkin, Marianne von, 15, 89
Westhoff, Clara, 158
Whitman, Walt, 11
Wigman, Mary, 80
Wolgemut, Michael, 62
Worringer, Wilhelm, 24

Zimmermann, Wilhelm, 136
Zola, Emile, 136